Gothic Art

Author: Victoria Charles and Klaus H. Carl
Translator: Andrea Hacker

Layout:
BASELINE CO LTD
33 Ter - 33 Bis Mac Dinh Chi St.,
Star Building; 6th Floor
District 1, Ho Chi Minh City
Vietnam

ISBN: 978-1-84484-461-6

Printed in China

Victoria Charles and Klaus H. Carl

Gothic Art

PARKSTONE
INTERNATIONAL

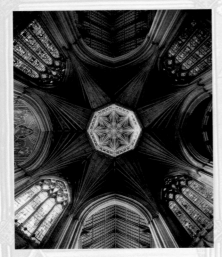

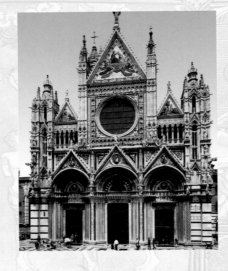

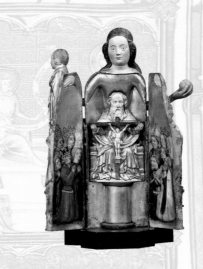

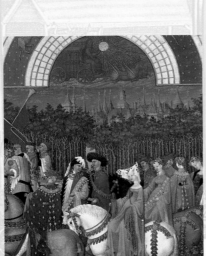

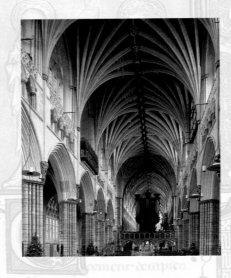

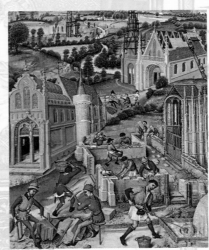

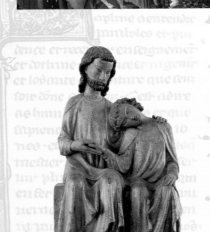

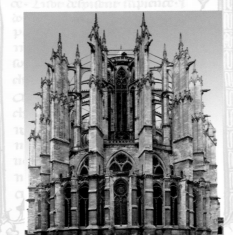

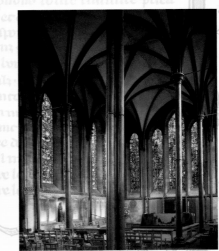

Contents

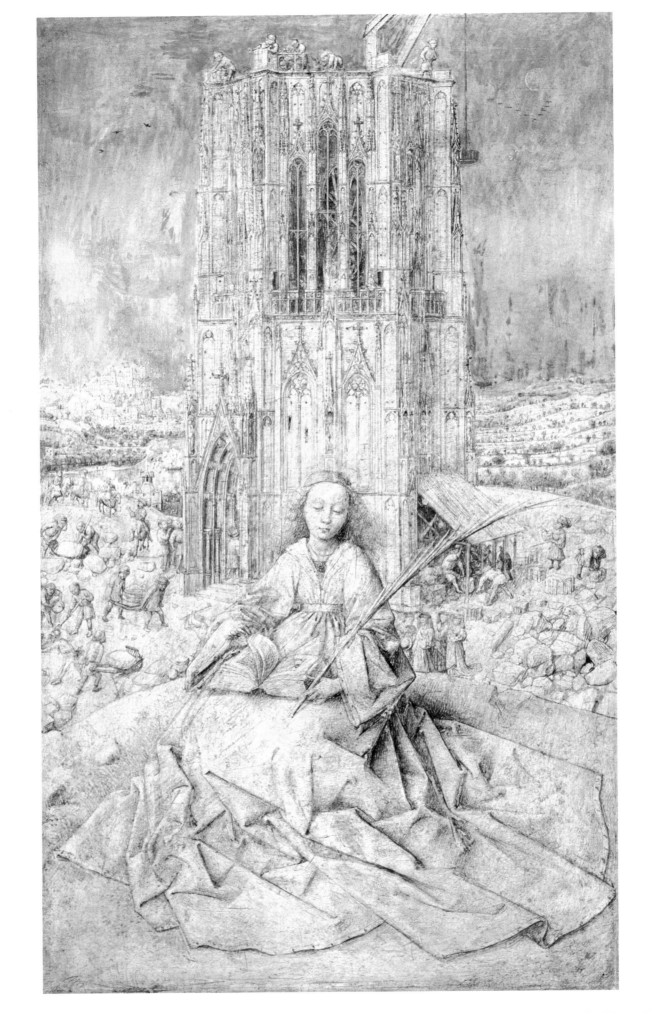

6

Introduction

The beginning of the Gothic age cannot be dated precisely; it lies sometime in the mid-twelfth century and slowly replaced the Romanesque age. Its end is likewise indefinable but is believed to be sometime at the beginning of the fifteenth century. Some time later the Italian painter, master builder and writer Giorgio Vasari used the term "gothic" (which means "barbaric") to describe the new way of building that came to Italy over the Alps. No matter how much the Italians tried to resist, the "Gothic" would soon supplant at least the exterior of their Romanesque style, which had been informed by Antiquity. It was spread predominantly by German stonemasons and foremen. From the invasions and pillaging by both the Visigoths and Ostrogoths, and their long domination in Italy, the Italians remembered all too well that "German" and "Gothic" meant one and the same thing. But, just as the Romanesque was truly a German style, the Gothic style is of French origin, as the foundation of Gothic architectural art developed first in the northern part of France, around Paris.

However, Gothic architecture's apex of artistic creation and strength was displayed with its last development in the cathedrals of Cologne (see p. 68, 70, 71), Ulm, Freiburg (see p. 73), Strasbourg (see p. 26, 27, 28, 29), Regensburg and Vienna (see p. 69). By the time the Gothic reached this stage, its power was exhausted. Any number of Gothic churches could be built, once a perfect system existed that could be followed – all that was needed were sufficient means and inclination. But new formations could not emerge from this locked, continuous system that no longer offered any starting point for further development. While the Romanesque style displayed great freshness and flexibility in its final phase, the Gothic style ended in decrepitude. Still, the merit of the most refined Gothic works lies in their harmonious merging of courageous imagination with intelligent calculation: the former knows no obstacle, while the latter is testimony to a practical, deliberating mind. However, the early Gothic creations, in which the bravery of discoverers and inventors made its first,

1. **Jan Van Eyck**, *St. Barbara*, 1437. Silverpoint on paper, 31 x 18 cm. Koninklijk Museum voor Schone Kunsten, Antwerp (Belgium).

tempestuous attempts, are artistically more stimulating. Subsequently, the irregular, purely picturesque aspect of Gothic buildings, and particularly the richness of their plastic ornamentations, is likewise more interesting than the perfect, yet cold regularity of those constructions that represented the highest achievements of Gothic architectural art.

The young poet and natural scientist, Johann Wolfgang von Goethe, viewed Strasbourg Cathedral with passionate enthusiasm (see p. 26, 27, 28, 29). After him, the German Romantics gazed at the majestic creations of the Gothic style and considered them to be art's highest achievements. This enthusiasm was replaced by a cooler perspective since research of archival documents determined that the roots of the Gothic are French. Not only were French master builders called abroad to introduce the new building style, German master builders and stonemasons also went to France, mainly to Paris, where, from the end of the eleventh century, cultural conditions emerged to which Gothic architecture owes the best part of its growth and development.

The most important of these cultural conditions was the strengthening of the townsfolk and the blossoming of cities. Citizens sought an expression of their wealth and subsequent power in the construction of towering places of worship. Far and wide, they were testimony to both the maturation and greatness of cities. Just as the French court ceremony and chivalrous gallantry gradually suffused fashion, language, poetry, and eventually all aspects European life, Gothic architecture flourished in all those countries which had been penetrated by French culture. The Gothic style

accommodated the abovementioned cities' impulses to display their growing power, as well as the practical need for bright, spacious churches that came with incremental population growth. Additionally, there were religious reasons, namely the deep piety that constituted the ethical foundation of medieval man and his yearning for the bliss of Heaven, which is visible externally in the towers reaching for Heaven and internally in the pillar constructions that lift the vaults up to vertiginous heights.

This "longing for heights", this "yearning for Heaven" is not the only, but is certainly one of the decisive reasons for the vertical tendency in the development of Gothic architecture, which is so unlike the horizontal tendency of the Romanesque style. Still, the influence of this spiritual element on the development of the Gothic should not be overestimated. It was always purely technical rather than aesthetic considerations that were at the forefront of Gothic craftsmanship. In the same way that the French masters had devised a new system of vaulted ceilings for purely practical reasons, building technology moved forward with similarly practical concerns. The medieval architects already knew that a building could be turned into an organic work of art, but only from the inside out. That is why the creation of the exterior was the least of their worries, as long as there were no pressing construction concerns; it was the task of the stonemasons, who executed the plans of the highest church-foreman (the architect in the modern sense). This is the reason why, during the reign of this style, the tall spires which give each Gothic church its aesthetic completion were often only finished in smaller scale buildings.

2. **Ugolino di Vieri**, *Reliquary of the Corporal of Bolsena,* Orvieto Cathedral, Orvieto (Italy), 1337-1338. Enamelled and gilded silver, h: 139 cm. In situ.

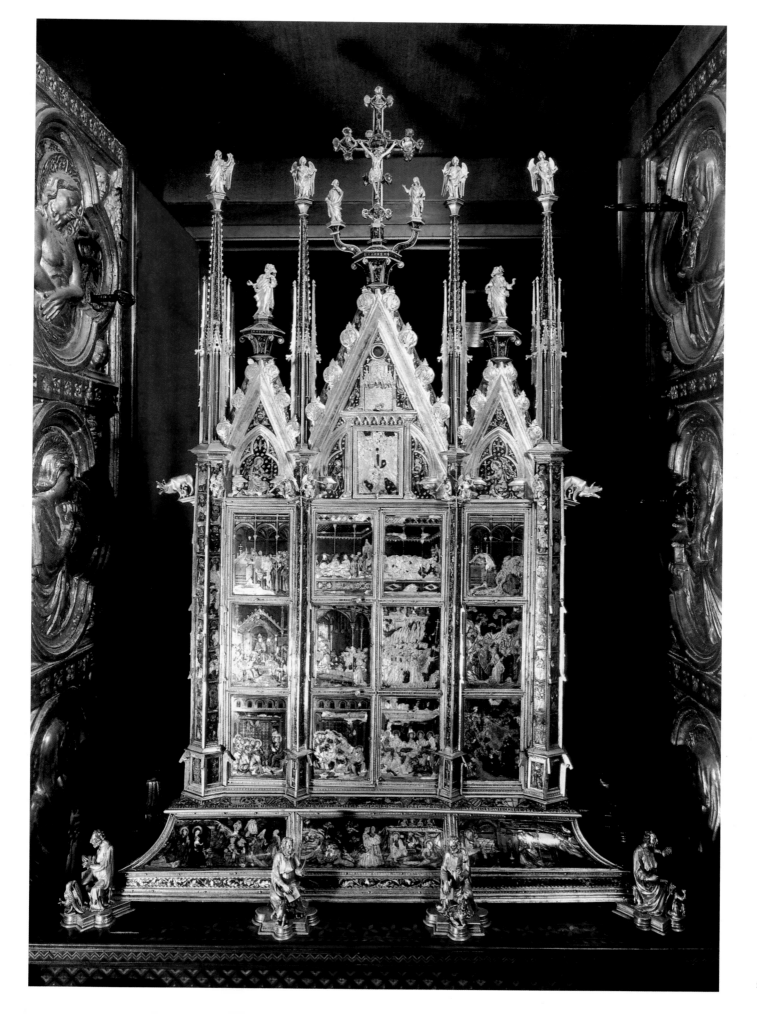

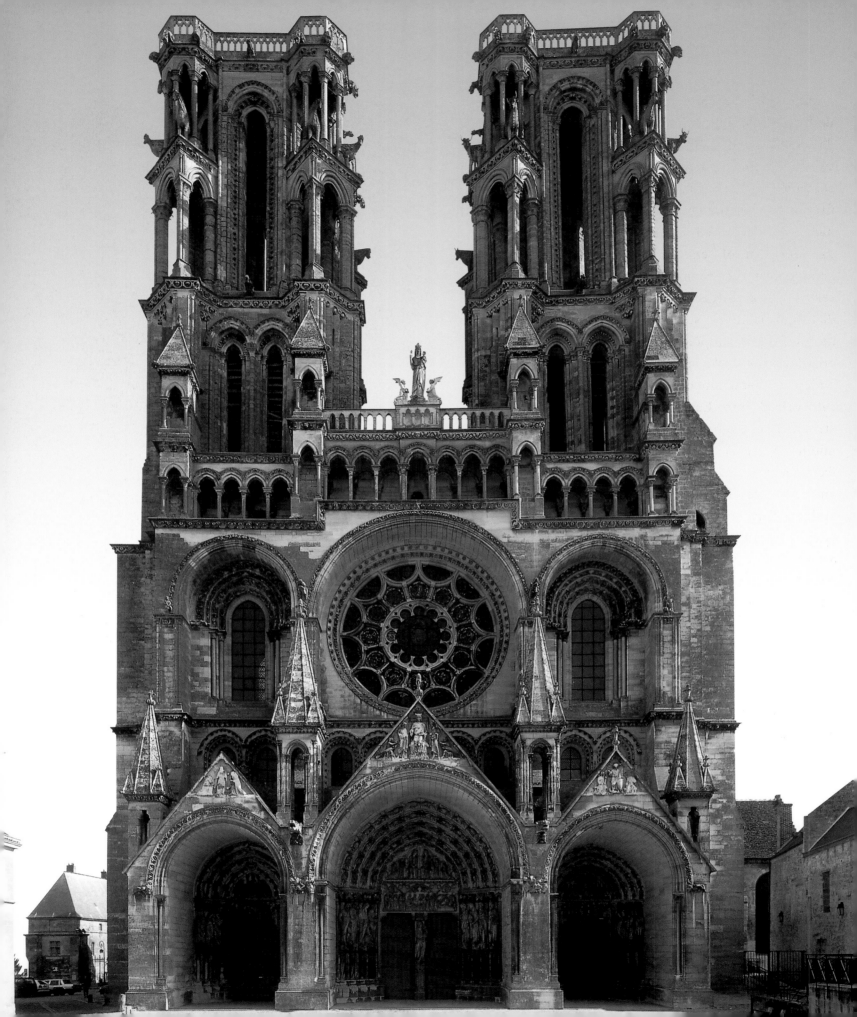

The Gothic architectural style did not emerge as a unified whole, but gradually developed into a system. The artistic and architectural Gothic style, which, in the twelfth century immediately followed, and in parts even coincided with, the final flourish of the Romanesque, at first continued the system of the vaulted basilica, as it had been developed in the Romanesque period. The ground plan of church monuments and the main arrangement of rooms remained the same. Only in terms of architecture is the Gothic style clearly distinguishable. In sculpture or painting such a clear distinction is impossible to make. Therefore, the architectural works specifically have a varied character, which is determined by chronology. Buildings are categorised into Early, High and Late Gothic. The structures of highest Gothic perfection are placed in the middle. In terms of dates, the French Early Gothic lasts from 1140 to 1200, the High Gothic from 1200 to 1350, and the Late Gothic from 1350 to 1520. In Italy, the style begins only in 1200. In England the so-called "Early English" with its characteristic narrow lancet arches is considered to last from 1170 to 1250. The *Flamboyant* or Perpendicular style followed from 1350 to 1550. In Germany the Early Gothic took place in the short interval from 1220 to 1250, which was followed by the High Gothic from 1250 to 1350 and the Late Gothic from 1350 to 1530.

The Gothic style differs from country to country in many details, particularly in its decoration. Just as with Romanesque architecture, the Gothic developed national idiosyncrasies. But the essential features, the actual constructive elements, are the same in all countries that seriously adapted Gothic architecture. Therefore, speaking of a Gothic architectural system is more justified than a Romanesque system.

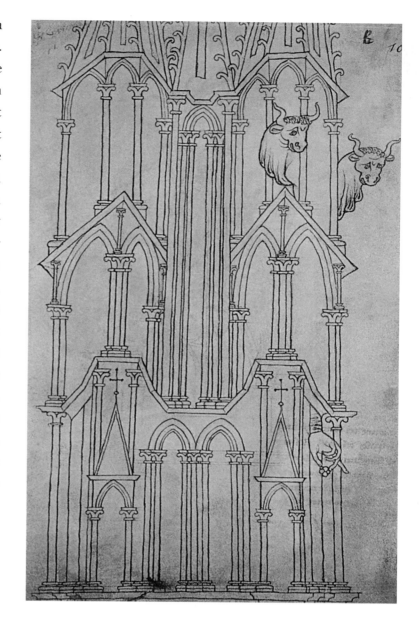

3. Western Façade, Notre-Dame Cathedral, Laon (France), begun before 1200. In situ.
4. **Villard de Honnecourt**, Sketch of the Laon Cathedral bell tower, c. 1230-1240. Ink on parchment. Bibliothèque nationale de France, Paris (France).

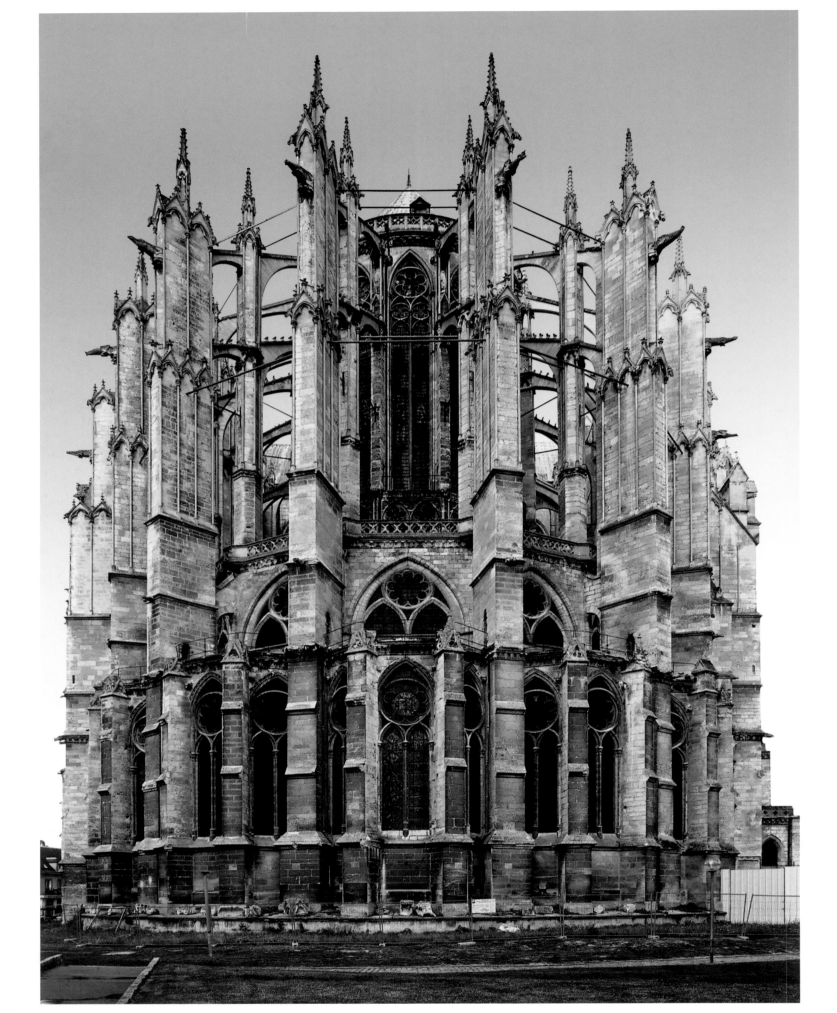

Gothic Architecture

The System of Gothic Architectural Art

The most striking external feature of Gothic architecture is the pointed arch, yet it is part of a larger development, which created a new kind of vaulted ceiling and gradually transformed the Romanesque method of construction. This development met the erstwhile massiveness of construction with a skeletal structure, ultimately resulting in the joist system. These joists gave an appearance of complete stability and security, even to the most daring creations of architectural imagination.

The groin vault rises between pointed supporting arches and is sectioned into parallel ribs that gather in a keystone in the vertex of the vault. Since these ribs were made of stone, the coping of the vault between them and the supporting arches only required light walls. Therefore, ribs were originally of greatest importance to construction, but over the course of the Gothic era their role became more and more decorative. Raising their number to three and four created six- or eight-part vaults. Eventually, the increase of ribs covering the copings of the vaults created the star vault, the net vault, and finally the fan vault with its low hanging keystones. The English Gothic in particular developed the latter with extravagance and rich imagination.

From the ribs of the groin vault the pressure was relayed onto the pillars of the nave, which also carried the supporting arches. Since these pillars had replaced walls in carrying the main weight, while also having to resist the lateral forces of the vault, they were reinforced not only in terms of circumference, but also externally with abutments, the so-called buttresses, which were weaker at the upper wall of the nave, but larger at the outer walls of the aisles. For additional securing, the buttresses extended beyond the walls of the aisles and climbing arches connected them to the flying buttresses of the nave. These flying buttresses anchored the construction securely.

5. Apse, St. Pierre Cathedral, Beauvais (France), begun in 1225 and renovated in 1284 and 1573 after its collapse. In situ.

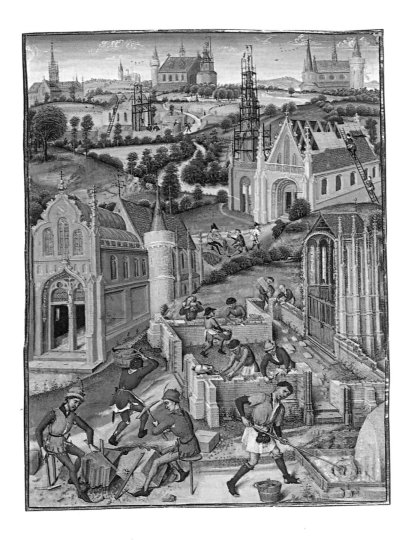

The combination of the interior rib vaulting and supporting pillars with the external system of flying buttresses is most pronounced in Amiens Cathedral (see p. 32, 33). The walls of the nave no longer show any closed mass because Gothic architecture avoids large surfaces and aims to display the frame of the construction as clearly as possible. The lower wall of the nave is interrupted by arcades with pointed arches; likewise, the upper parts of the wall below the windows are set off by a narrow aisle, the triforium, which opens onto the nave with arcades.

The formation of pillars, which fulfil various tasks, also differs completely from the Romanesque method of construction. Their cylindrical core is reinforced with half or three-quarter columns. Along the longitudinal axis they carry the arcades; along the crossways axis they carry the vaults of the aisles on one side and the central vault on the other. The result is a cluster of pillars, which is a characteristic and innovation of Gothic style. This new formation of pillars is still kept together by a common capital, which, however, consists only of a wreath of loosely strung leaves and no longer represents the actual end of the pillar. The half and three-quarter pillars climb above the roof to carry the supporting arches and ribbed vaulting.

To demonstrate that the Gothic architectural principle had found its perfection, its "keystone", in these flying buttresses, their tops were adorned with small, slender spires, so-called pinnacles, which consisted of a lower, four-sided base (the body) topped by a pyramid form (the giant). These pinnacles were eventually sectioned and decorated like the main spires, while the edges of the pyramids were trimmed with crockets, or leafy, bulbous formations; finally, their tips were crowned with a finial of four leaves.

The introduction of naturalistic foliage to the ossified forms of medieval ornamentation was a further essential innovation of the Gothic style. All these new designs proved to be very fruitful and would later lead to a renewal of the ornamental style, which had grown rigid from its relentless study of Antiquity. The overall delight in nature was awakened in the hearts of medieval people by courtly minnesong and commoners' didactic poetry.

6. **Girart de Roussillon**, *Chanson de Geste: Construction Site,* second half of the 15th century. Nationalbibliothek, Vienna (Austria).
7. Western Façade, former Notre-Dame Cathedral, Senlis (France), c. 1151/1153-1191. In situ.

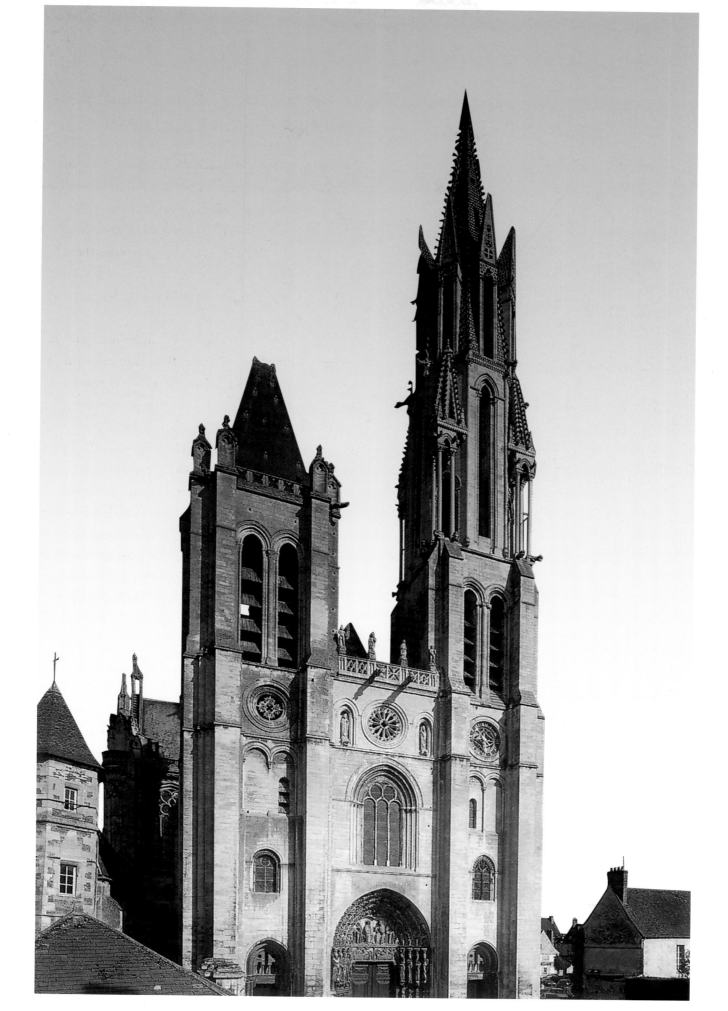

8. *The Parement de Narbonne* (altar-hanging), c. 1375. Ink on silk, 77 x 286 cm. Musée du Louvre, Paris (France).

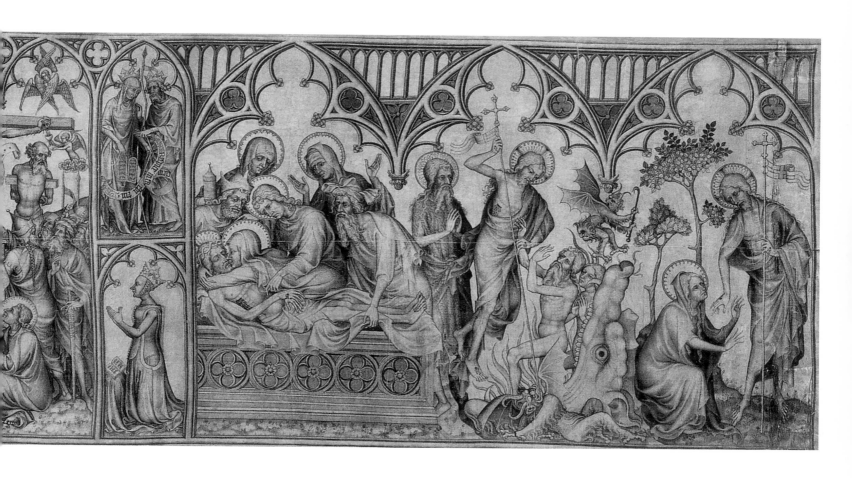

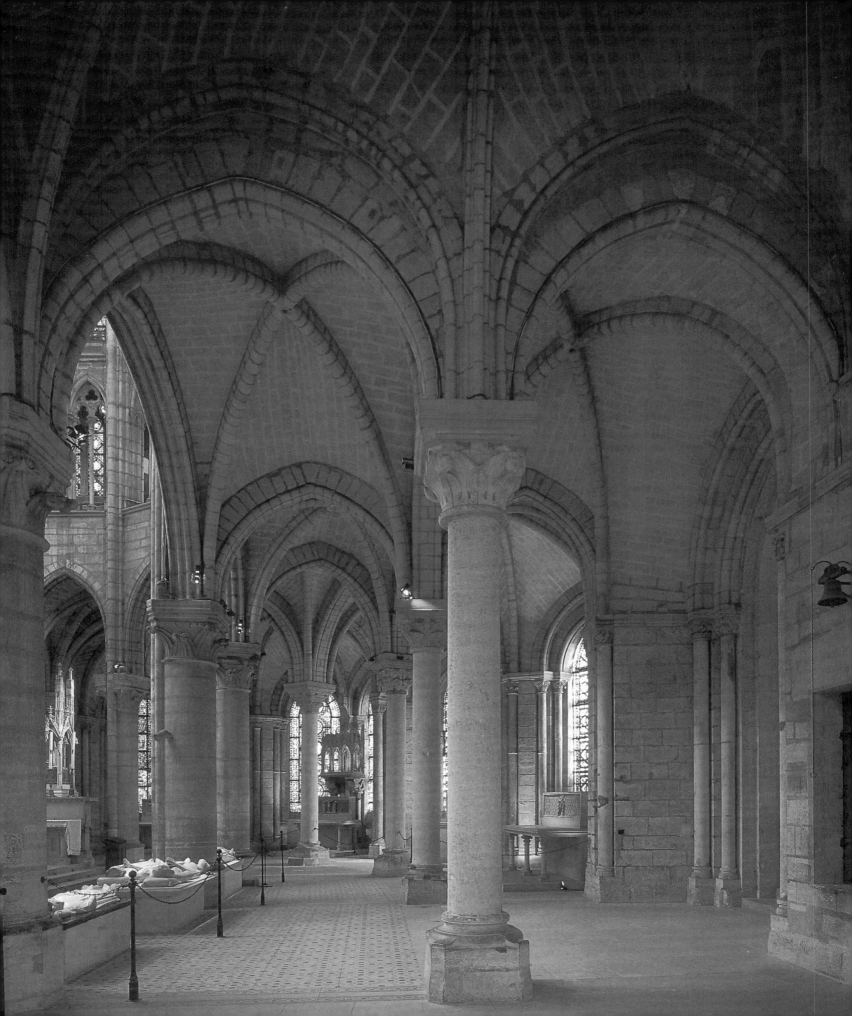

Both influenced stonemasons, too, who wanted to test their skills with chisel and hammer in the imitation of local leaf and plant formations. Oak, ivy, acorn and vine leaves were complemented by flowers that were particularly dear to the stonemasons. These leaf and plant ornamentations, which were further refined by being painted naturalistically, spread not only over the capitals, but also over ledges and portal walls; they also framed empty surfaces. However, over the course of the Gothic period, this study of nature diminished. Once accomplished, the ornamentation forms were thoughtlessly repeated until bulbs and buds appeared only in outlines and finally the memory of their model, which had been culled from nature, completely vanished.

Similar was the fate of the shafts and bars that structured the window openings and gave them outward closure. Originally, these window ornaments had only been a web of stone poles, but with time they developed into a well ordered system. Within the outer pointed arch that encompassed the entire window opening, stone bars rose from the window ledges. They sectioned the window into two to six fields and rejoined the top of the outer arch. The free space between these inner pointed arches and the outer main arch was filled with what is known as tracery, which consisted of stone circles and segments and was contained within a circumference. This technique created geometrical figures of great variety. The segments were at first arranged around a circle like three- and four-leafed clovers. The latter is called a quatrefoil. However, towards the end of the Gothic era, the number of leaves increased to six and eight. The outer arches were further heightened with pointed ornamental gables, known as Wimpergs, the sloping rims of which were studded with crockets and peaked in a finial. The surface

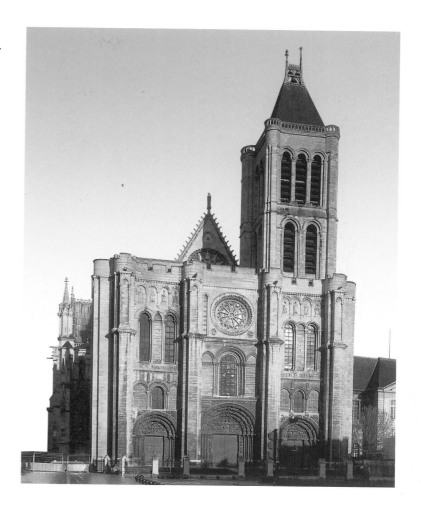

of the gable was also filled with tracery. The richest tracery designs can be found in the round windows that are usually located above the central portal of the western façades between the towers. These rose windows were the centre pieces of decoration. The rose window of Strasbourg Cathedral is particularly famous.

The changes that Gothic architecture brought to the ground plans of churches are less drastic and revolutionary. The basic form of the basilica was adopted from the previous Romanesque style and only expanded in

9. Ambulatory, Basilica of St. Denis (former Benedictine abbey church), Saint-Denis (France), 1140-1144. In situ.
10. Western Façade, Basilica of St. Denis (former Benedictine abbey church), Saint-Denis (France), before 1140. In situ.

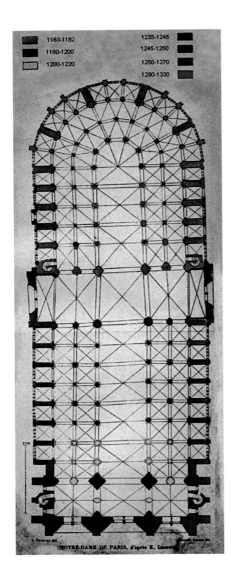

1163-1182
1180-1200
1200-1220
1235-1245
1245-1250
1250-1270
1290-1330

NOTRE-DAME DE PARIS, d'après E. Lassus

The Gothic really only reinvented the formation of the choir. Since crypts were no longer built, the choir was no longer separated from the nave, but instead considered to be a continuation. The choir no longer ended in a half circle, but in a polygon. If the aisles led around the choir, they created an ambulatory. However, this was extended even further in the French Gothic: around the entire choir end, a series of chapels was added to the outer wall of the ambulatory. This chevet rendered the choir the most important part of the entire construction. The master builders of Cologne Cathedral also adopted such a chevet. When a new Gothic cathedral was built or a Romanesque one rebuilt, the first concern was usually the choir. The master builders and their clients invested most of their enthusiasm in it, not least because their main worry was housing the main altar as well as the local, often numerous clergy. Particularly in the initial, exuberant phase the funds provided by the princes of the Church flowed freely. Later, when these funds dried up, citizens were also forced to contribute. Consequently, the enthusiasm strongly diminished under the pressure of ecclesiastical or political turmoil. This explains why the choir structures often far surpass the naves in their richness of creation and artistic decoration. Also, the two sides of the nave are frequently uneven in design, one being more lavish, the other more sober and humble, which may be another indication of the decrease of overall wealth and artistic stamina. Very rarely did Gothic architectural works actually achieve complete balance, even though the law of symmetry was at the spiritual core of the style. The buildings that were completed in the nineteenth century came closest to this ideal.

some details. The cross-shaped ground plan was the norm; only the arms of the transepts did not always reach beyond the side walls of the nave. In the Late Gothic the transept was often discarded altogether. The nave was usually three aisled and even five aisled during the highest developmental stage of the Gothic. The best example is Cologne Cathedral (see p. 68, 70, 71).

11. Plan of Notre-Dame Cathedral, Paris (France).
12. Western Façade, Notre-Dame Cathedral, Paris (France), 1190-1250. In situ.

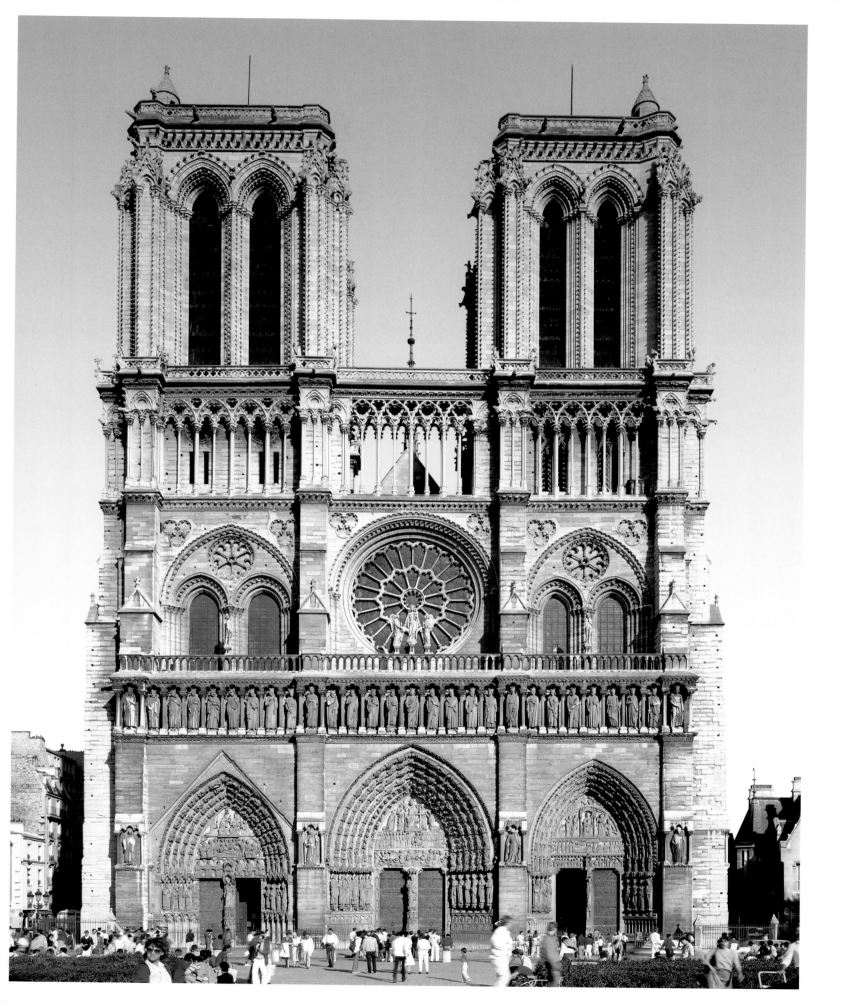

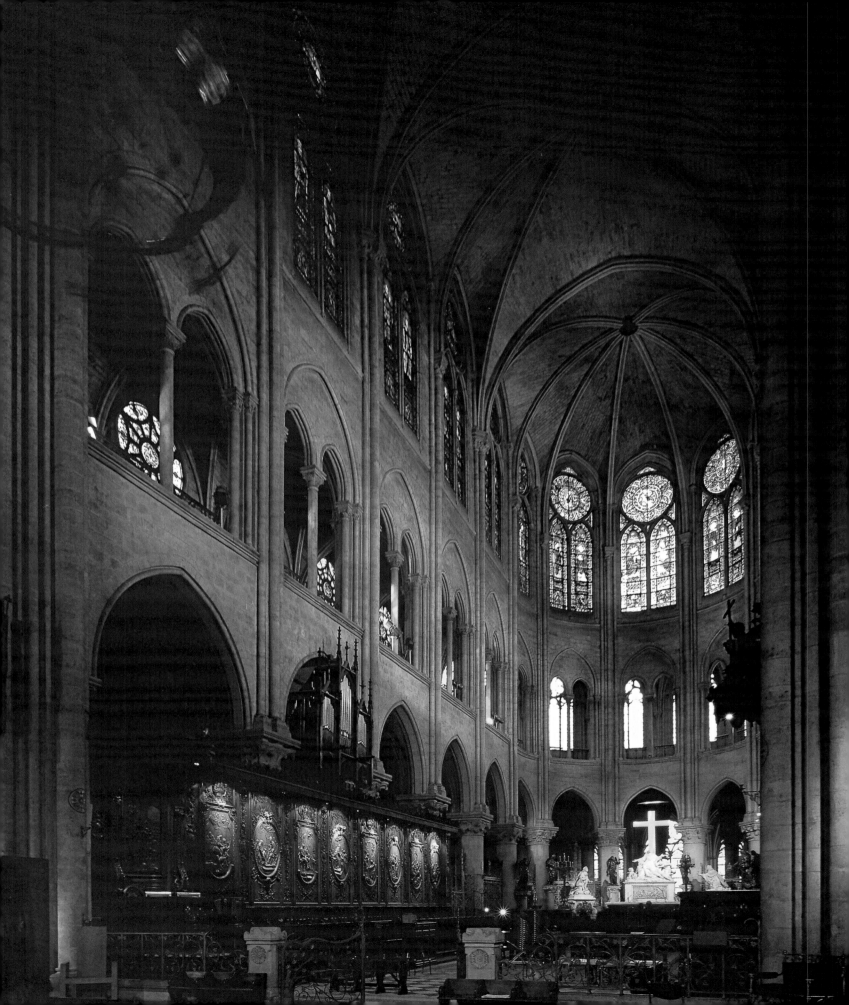

When a Gothic church construction had progressed to the stage where the nave needed to be concluded with a façade, the artistic spirit usually recovered no matter how difficult the external circumstances. Surely all Gothic master builders intended to perfect a house of God with a pair of mighty towers, or a single, but even more gigantic tower. However, executing their own original ideas, or at least witnessing their implementation, was not granted to all. Lengthy work on the towers dragged on from one artistic family to the next and slackened in proportion to the dwindling enthusiasm of devout donators. Beginning in the mid-sixteenth century, public building interest shifted to different objects altogether. Every successor to construction leadership tried to outshine his predecessor, without worrying whether the first plans had contextualised the façade and the tower in a well considered organism. The most famous example of master builders' artistic egocentricity is Strasbourg Cathedral, where artistic unity is sacrificed for ambition. Its single northern tower stands in stark contrast to the façade. As such, the tower is a work of art that no one would want to exchange for perfect regularity.

It is possible that the architectural artists of the later Gothic period recognised the inner law of the Gothic – symmetry – as a constraint which tried to break their liberated imagination. This could explain certain, often reoccurring differences, such as the uneven handling of nave façades or pairs of towers that were begun at the same time, yet completed one after another. Naturally, the richer is not always the later example: often it was the hardship of the times that forced master builders to employ simplicity and economise. However, the essential feature of the Late Gothic is nonetheless the propensity to the picturesque and a desired liberation from norms, which in the end deviated into empty play with mathematical formulae. In their creative joy the old masters did not feel that this would be the end of the Gothic. The artist who strides ahead in the stream of time always courageously looks ahead, never back with fear.

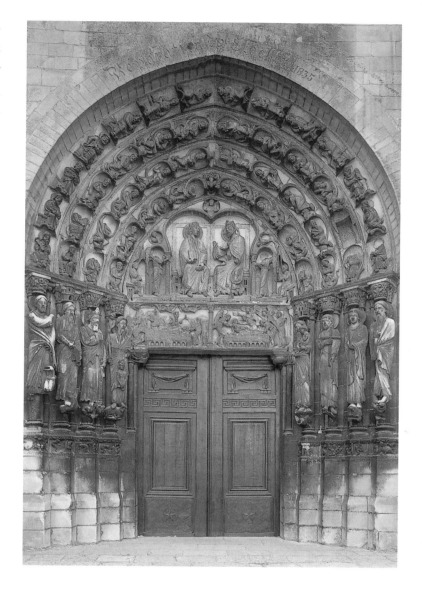

13. Choir, Notre-Dame Cathedral, Paris (France), begun in 1163.
14. "Sainte-Anne Portal", western façade, Notre-Dame Cathedral, Paris (France), before 1148. In situ.

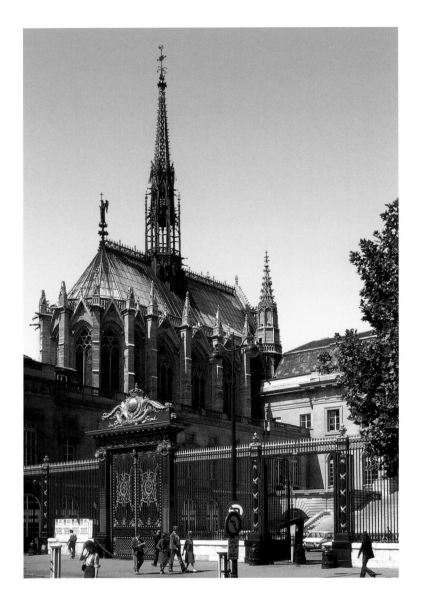

The full extent of the daring imagination that Gothic master builders placed in their high-flown plans only became fully apparent when the towers of Cologne Cathedral (see p. 68, 70, 71) were completed according to the original plans: their proud height of 156m exceeds the Great Pyramid of Giza by almost twenty metres. The French master builders had similar plans. The ridge turret of Rouen Cathedral reaches the respectable height of 151m (see p. 44, 45); its towers remained incomplete as with most cathedrals. The ambition of Ulm Cathedral's master builder, Matthias Böblinger, reached even higher: he calculated a height for his tower that, once his plans were accomplished, had risen to the tallest of all towers built so far: 161m. The tower of Strasbourg Cathedral with its 142m proves that the old master builders were able to achieve equal results, despite their lack of mechanical aid with which the modern builders finished many of their towers. In other words, the merit of later times is mostly due to increased material wealth. The towers of St. Stephen's Cathedral in Vienna (see p. 69) and Freiburg (see p. 73) Cathedral, at 137m and 125m respectively, came closest to Strasbourg among the towers that were completed in the Middle Ages.

Therefore, the towers flanking the western façade rarely embody the perfection of its artistic composition. Most often the *pièce de résistance* of the entire building is the façade itself and in its design the master builders of different countries expressed their individuality most distinctly. As a rule, a façade with two taller towers would feature three portals that lead into the interior – one for each aisle. Usually a gable marking the nave rose above the sculpturally and architecturally most sophisticated middle portal. Its visible part was also richly decorated. The most elaborate decorations could be found on the side walls and the portals' gable surfaces. Some English and Italian churches in particular extended the sculptures above the portals across the entire western façade.

15. Sainte-Chapelle (former Royal chapel), Paris (France), 1241/1244-1248. In situ.
16. Upper Chapel, Sainte-Chapelle (former Royal chapel), Paris (France), 1241/1244-1248. In situ.

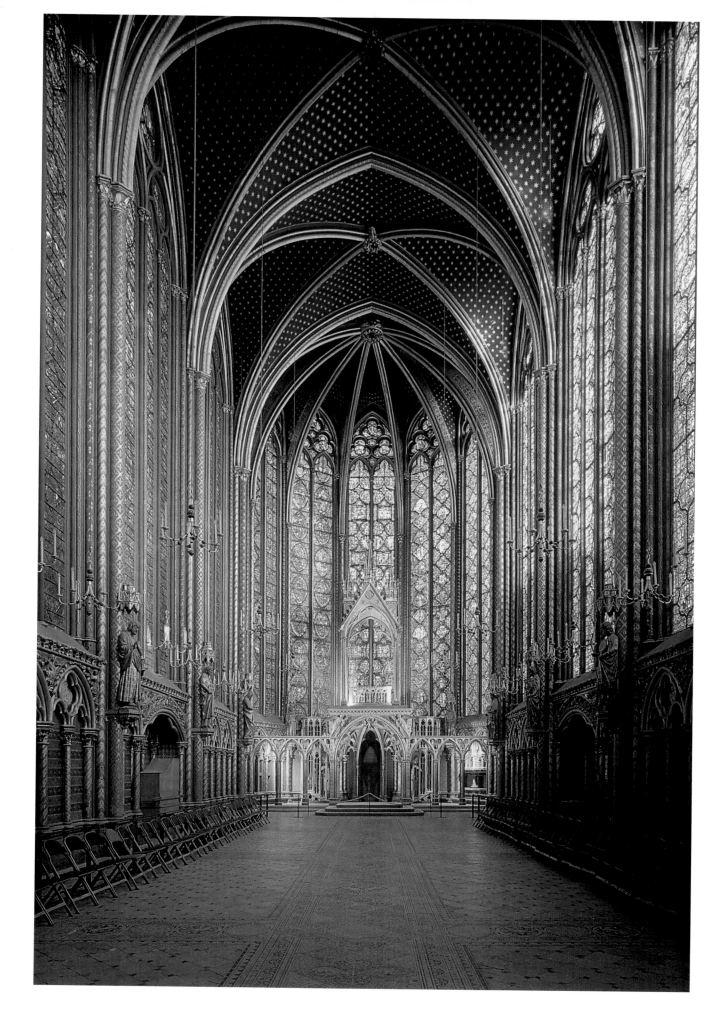

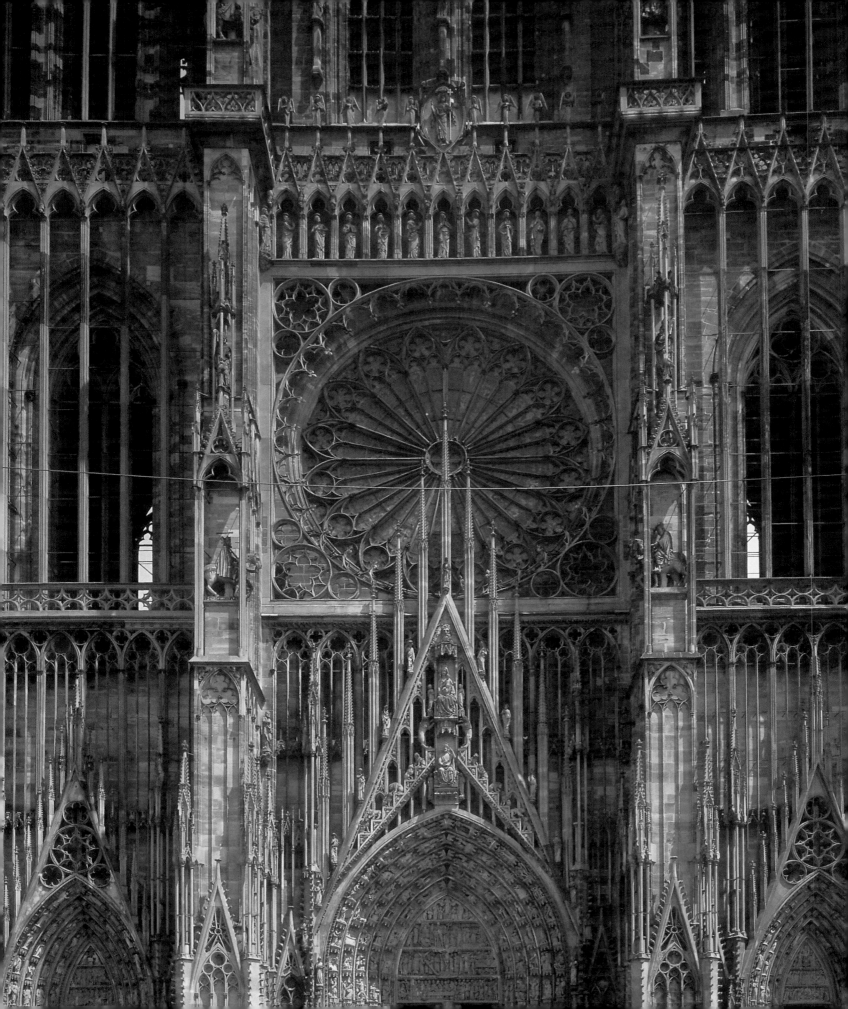

Gothic Architectural Monuments

During the crusades, traffic among occidental peoples grew and facilitated an easier, faster spread of artistic forms. For the most part the Gothic style owes its spread to this global traffic and its constructive advantages. French building masters first carried seeds to England and into the west of Germany. The seedlings were then transplanted from Germany to the north, east and south of Europe. The pupils often surpassed their masters, but the cradle of the Gothic is unequivocally in France.

The Gothic in France

The Basilica of St. Denis

The innovations at the heart of the French Gothic style, reach back to the eleventh century; but only in the basilica's choir, built near Paris by statesman and abbot Suger around 1130-1140, did the Gothic appear as a unified system (see p. 18, 19). The basilica already contains all elements of the Gothic style: pointed arches, pillars and ribbed vaulting. The church of Saint-Denis is considered to be the "founding construction of the Gothic". The façade with its double towers, which were erected between 1137 and 1340; the vertical sectioning into three parts with protruding buttresses; the small rose window; and the spires, which were erected after 1144, all carry clear Gothic features. The absence of partitioning walls between the choir chapels offered a new, harmonious, spatial feel – a characteristic that would point to the vastness of later cathedrals. The rose window in the Basilica of St. Denis is the first of its kind. The upper part of the choir and the nave were built from 1231 to 1281.

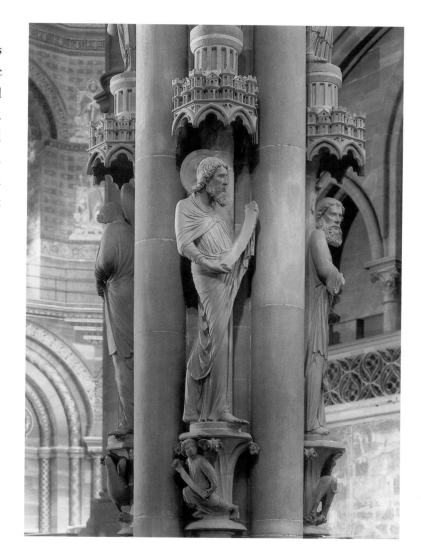

While the Basilica of St. Denis and a few of its contemporary edifices represent the preparatory stage, the new building method reached a decisive breakthrough in Notre-Dame in Paris (see p. 20, 21, 22, 23) and Laon (see p. 10) Cathedral.

17. **Erwin von Steinbach**, Western Façade (detail), Notre-Dame Cathedral, Strasbourg (France), begun in 1176. In situ.
18. *The Evangelists*, detail of the "Pillar of the Angel", Notre-Dame Cathedral, Strasbourg (France), c. 1225-1230. In situ.

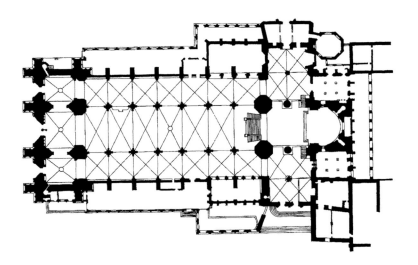

Notre-Dame Cathedral in Paris

The system of the French Gothic found its first complete expression in Notre-Dame in Paris (see p. 20, 21, 22, 23) Building commenced in 1163 and the church, which was completed at the beginning of the thirteenth century, except for its two towers, served as a model for most French cathedrals. In particular its façade proved very typical. It consists of three tiers, which are strictly separated by horizontal sectioning: above the three portals is a row of arches adorned with statues. This is the "gallery of kings", so called because it depicts the kings of Israel; then, above the second tier, runs an open gallery. This strict emphasis on the horizontal line, which actually contradicts the essence of typical Gothic, is a feature specific to French Gothic style and may explain at least partially why the towers of several French cathedrals remain incomplete. Others remained unfinished because the master builders simply could not conclude them, probably for a variety of reasons. When the architects realised the contradiction between the proclivity for heights, which lay at the core of the Gothic style, and the horizontal sectioning inherited from the Romanesque period, the two could no longer be reconciled. Among their works are many creations, the artistic appeal of which lies especially in the rich formation of the façades.

Sainte-Chapelle in Paris

Sainte-Chapelle is the most mature and splendid creation of the French Gothic and a jewel of medieval art (see p. 24, 25). Situated in the court of the Palais de Justice, its incredibly beautiful stained-glass windows create a very special light. Considering the exceptional grace, lightness and slenderness of the holy chapel, this building illustrates the transition to the High Gothic. It was in order to protect the relics retrieved from the Holy Land in 1243 and 1251, that Louis IX, the Holy, hired master builder Pierre de Montereau, who had also built the western façade of Notre-Dame in Paris (see p. 21). The palace chapel consists of a lower church with three aisles and an upper church with one. It consists almost exclusively of a frame of slender pillars with magnificent stained-glass windows replacing the walls. The higher space, created as a monumental shrine housing the relics was used for royal service, while the lower space served for the comon people service.

Church of St. Germain l'Auxerrois in Paris

At times, strict laws of style were also observed in the late Gothic period. Proof is the Church of St. Germain l 'Auxerrois in Paris. Its tower is not connected to the church proper, but was erected in the ancient Christian

19. Plan of Notre-Dame Cathedral, Strasbourg (France).
20. Nave, seen from the West, Notre-Dame Cathedral, Strasbourg (France), begun in 1176. In situ.

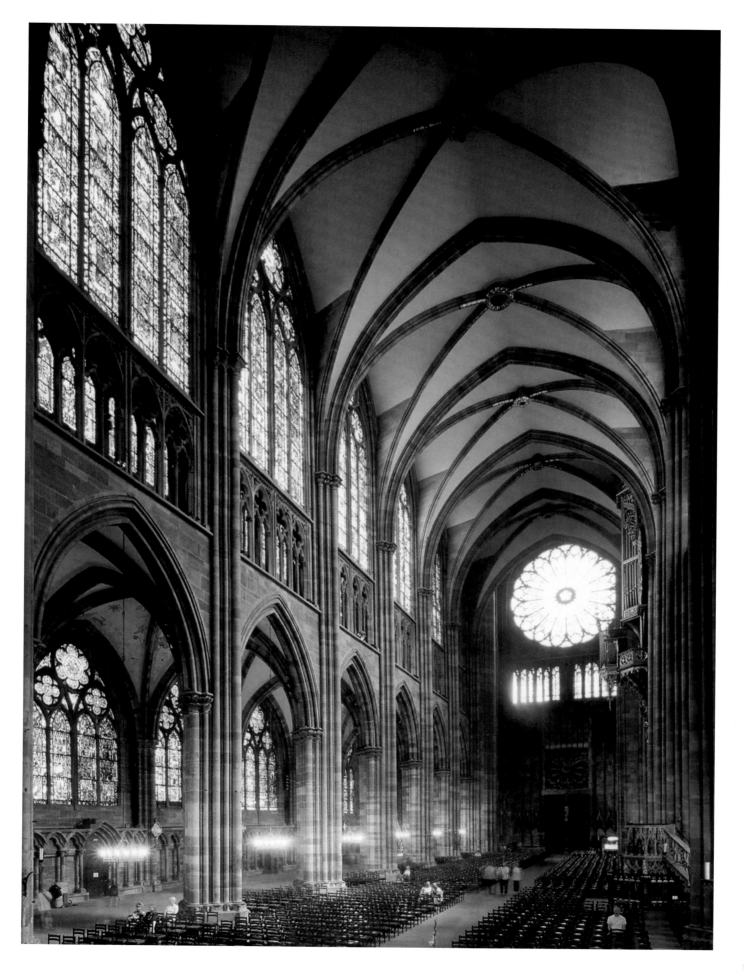

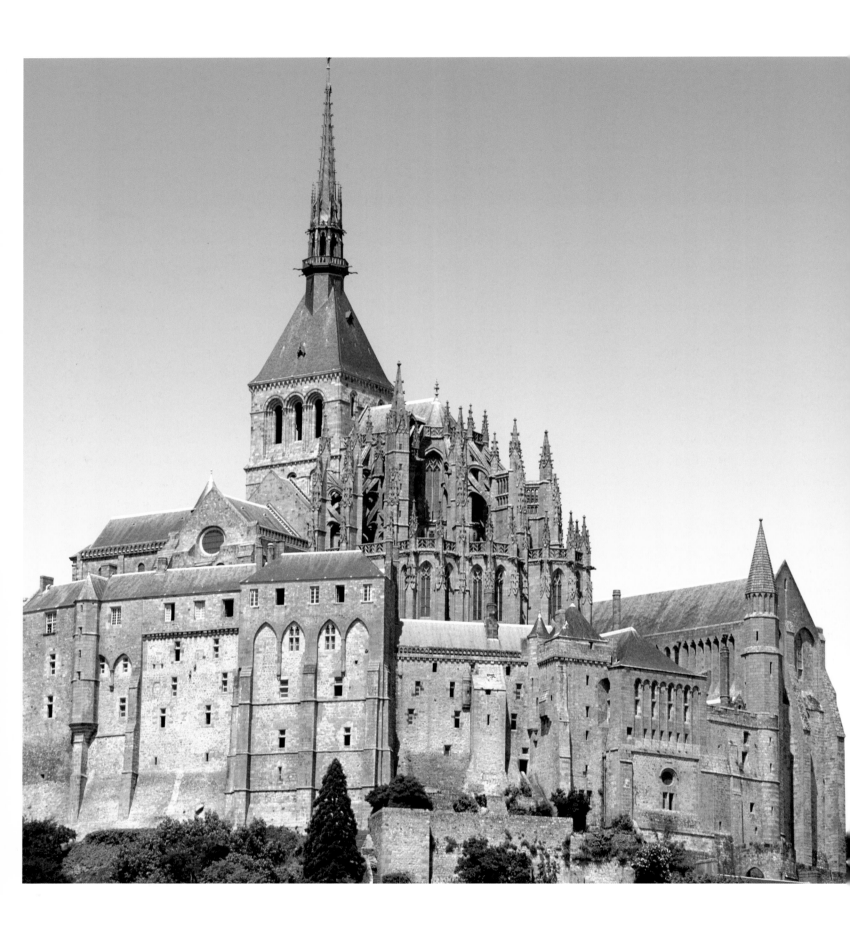

tradition of the free-standing belfry. From this belfry the sign for the massacre and persecution of the Huguenots was issued on the night of St. Bartholomew, the night of the Paris blood wedding, on 24 August, 1572.

Notre-Dame Cathedral in Strasbourg

While little is known about the master builders of the Freiburg Cathedral, there is some information about those that built the Strasbourg Cathedral with its three-aisle structure (see p. 26, 27, 28, 29). However, this only holds true after 1280, when Master Erwin (Erwin of Steinbach) began his work. Erwin is celebrated as the creator of the façade, the entire building 's *pièce de résistance*. He was influenced significantly by the French Gothic, yet he far surpassed his models with courageous construction, as well as splendid and tasteful decoration. Although, after his death, his son Johannes continued the construction until 1339, Erwin's plans only reached the completion of the second tier. This is why only the lower part of the façade constitutes a harmonious composition with its almost freely crafted, as it were, lace-covered tier and its unique rose window in the centre. The third tier began to deviate from Erwin's plan, and by the time building of the northern tower commenced, it was all but forgotten. The latter eventually received its crowning finish from Master Johannes Hütz, who executed the groundbreaking stone pyramid between 1419 and 1439. It is an artwork in itself because it aims to shine intrinsically and because of the hitherto unheard-of audacity of construction, with which the master from Cologne far superseded Freiburg Cathedral (see p. 73). After that, construction of the cathedral slowly ground to a halt and no one ever dared to undertake the construction of a southern tower.

Mont-Saint-Michel Abbey Church

The magnificent fortified abbey lies in the sandy bay of Mont-Saint-Michel, Normandy (see p. 30). Located on an island 160 metres above the sea, it rises above the entire landscape in a unique harmony with nature. At low tide it is even possible to reach the island on foot. The abbey was founded in 709 by the Bishop of Avranches, who was probably later canonised as St. Aubertus, after he had a vision of Archangel Michael at this spot. A single alley leads to the abbey church, which was begun 1022 in the Romanesque style. The construction was continuously enlarged with battlements, buttresses and encirclements until the 87m high belfry was finally added. In the thirteenth century the monks refashioned the three-tiered northern wing (1211-1228) called "La Merveille" in the Gothic style by adding 220 little polished granite pillars, sculptures and inscriptions. The dormitory lies on the upper floor; the splendid cloister, which is 25m long and 12m wide, is on the second floor. Both date back to the twelfth century, as do the refectory and the great hall. Mont-Saint-Michel is still a destination for pilgrims as it was a thousand years ago, and up to one million faithful and tourists are drawn there every year. Because of its unique beauty the entire island is considered to be the eighth wonder of the world and was declared a world heritage site by UNESCO in 1984.

21. Mont-Saint-Michel Abbey Church, Mont-Saint-Michel (France), 1446-1500/1521. In situ.

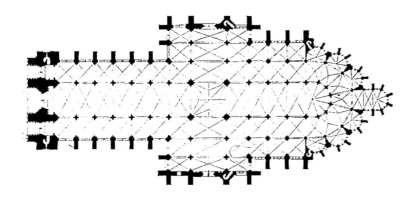

Of particularly high artistic value are the cathedral's sculptures, especially the *Vierge dorée* (the golden virgin) located at the trumeau of the southern portal, and the *Beau Dieu* (The Beautiful God). Both rank among the most remarkable masterpieces of the thirteenth century.

Notre-Dame Cathedral in Chartres

Chartres Cathedral is one of French Gothic's most beautiful monuments (see p. 34, 36, 37, 38, 39). It is 130m long, has 37m high rib vaulting, an old tower, 105m high, dating from the twelfth century, and a newer 115m high tower from the sixteenth century. Thanks to the new building technology of buttresses, the walls could be relieved of their supporting function and no longer had to consist of massive masonry. Thus the large, colourful window panes (often in the famous Chartres blue) and rose windows could punctuate them. Discarding the second gallery and retaining the triforium resulted in yet another simple three-tier structure.

At least five churches, all of which burnt to the ground, had previously stood in the same place. In 1194 the older cathedral, which is stricter in its details, was begun on the foundations of an earlier basilica. Finished in 1233, but consecrated only in 1260 in the presence of Louis IX, it surpassed the cathedrals in Reims (see p. 40, 41, 42-43) and Amiens (see p. 32, 33) simply by having two completed, if dissimilar, towers. Chartres Cathedral is the first example of high Gothic architecture. It was also here in Chartres that frescos were substituted with typical Gothic glass paintings for the first time.

Notre-Dame Cathedral in Amiens

The cathedrals of Reims (see p. 40, 41, 42-43) and Amiens were intended to be the pinnacle of the French Gothic in terms of structural formation and decoration. They were supposed to surpass the human imagination of the time. Indeed, Amiens Cathedral features the longest nave in France (see p. 32, 33). Romert de Luzarches was the first architect of the building and his name can be found in the medallion of the labyrinth, which was laid out in 1288. However, it is not certain how extensive his contribution to the execution really was, but, allegedly, all significant technical and stylistic innovations and rationalisations, such as iron reinforcing in the tracery and the serial preparation of repetitive elements, are ascribed to him. Most of the building was finished only by the end of the thirteenth century; the remaining work would continue for centuries. The southern tower, for example, was only completed in the nineteenth century by Viollet-le-Duc.

22. Plan of Notre-Dame Cathedral, Amiens (France).
23. Western Façade, Notre-Dame Cathedral, Amiens (France), c. 1240-1245. In situ.
24. Nave, seen from the West, Notre-Dame Cathedral, Chartres (France), 1194-1233. In situ.
25. Choir, St. Pierre Cathedral, Beauvais (France), begun in 1225 and renovated in 1284 and 1573 after its collapse. In situ.

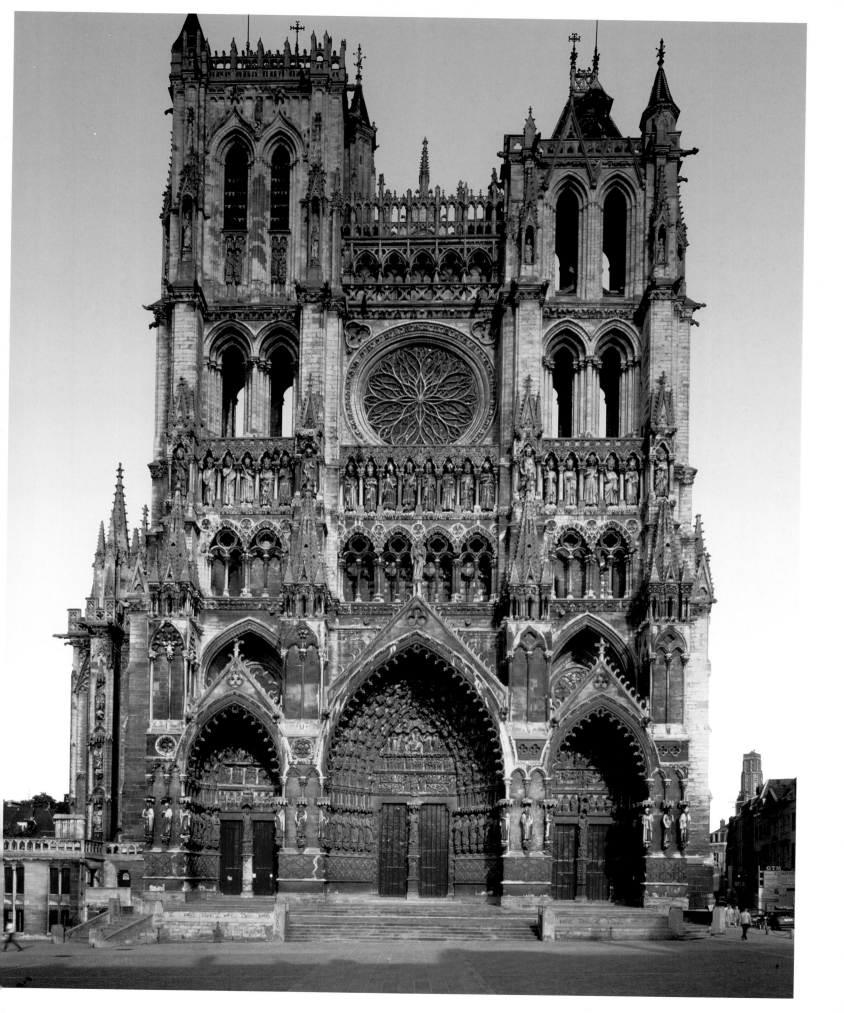

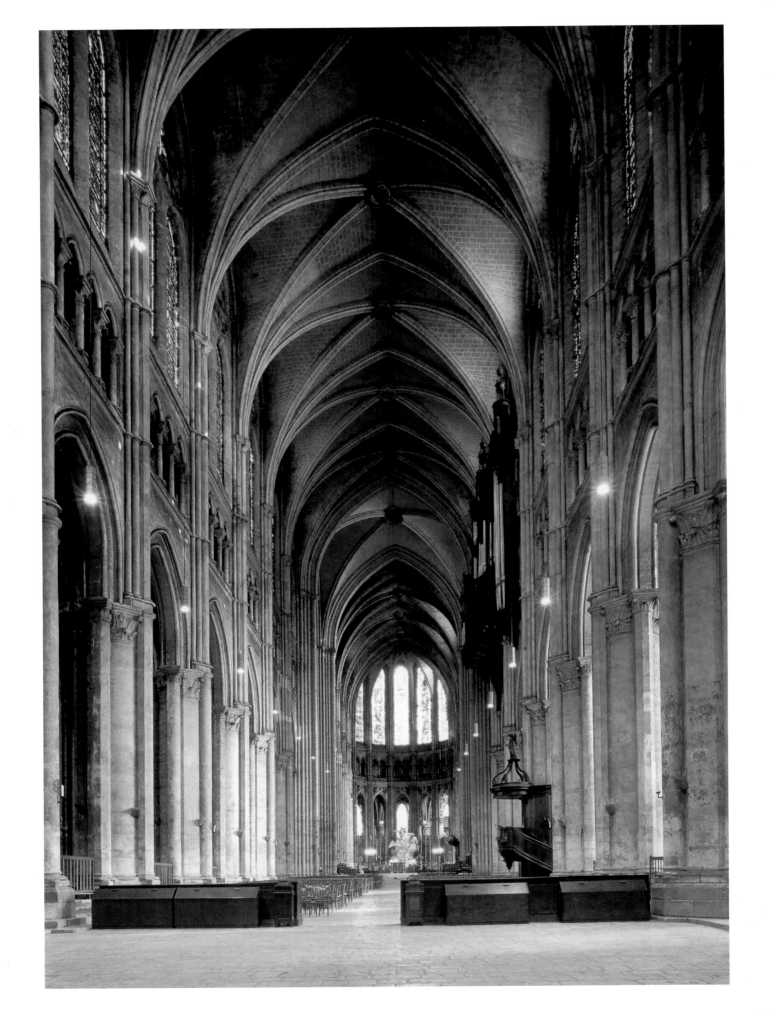

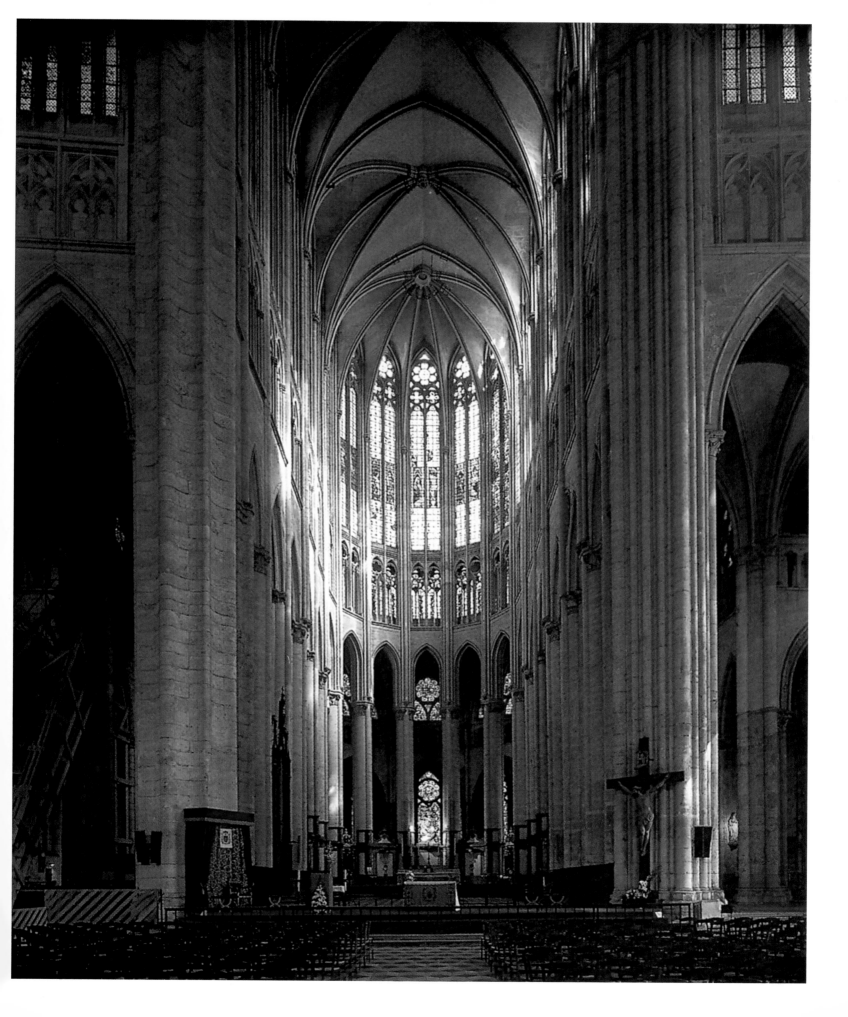

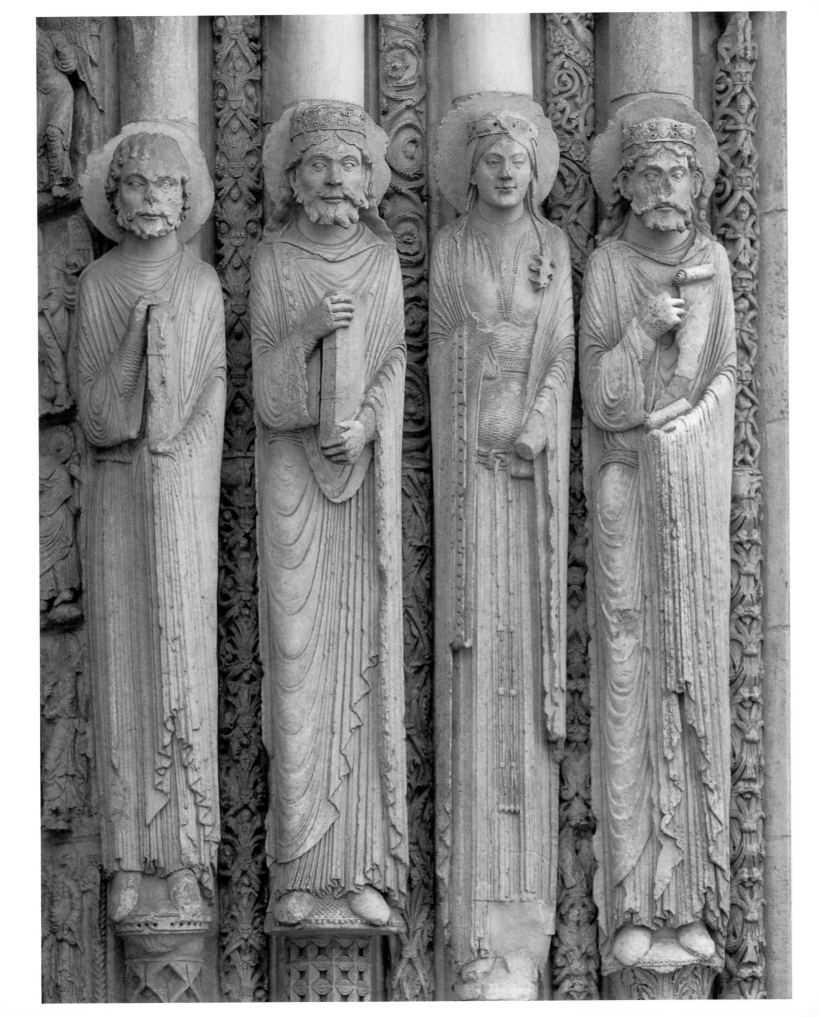

Notre-Dame Cathedral in Reims

Begun in 1211 by Robert de Coucy and completed in 1250, Reims Cathedral is one of the most striking creations of Gothic architecture and the most consistent example of the strict early Gothic style (see p. 40, 41, 42-43). It was erected on the ruins of a church that had been razed to the ground the previous year and was, naturally, intended to surpass the magnificence of Chartres Cathedral (see p. 34, 36, 37, 38, 39). Eventually, the kings of France would be crowned and blessed here with pomp and splendour as Christian rulers. It was finally completed in the fourteenth century. A striking characteristic of the cathedral is its western façade, which is richly decorated with reliefs and an excellent example of Gothic sculpture. The two towers are each 81m in height and were originally supposed to be topped with spires and reach a height of 120m.

Notre-Dame Cathedral in Rouen

The cathedral type that was introduced in Paris gradually prevailed in the north and south of France. Naturally, in Normandy and in the Languedoc local elements were added, which were intrinsic to the people's character and their building tradition. Built on the ruins of an earlier Romanesque church in the former capital of Normandy, from which hailed many famous people, the cathedral was started around 1145 under the overall control of several architects and master builders (see p. 44, 45). The measurements are impressive: The cathedral has an overall length of 144m; its highest tower, the *Tour Saint-Romain*, reaches up an imposing 82m; the *Tour Beurre*, or *Butter Tower*, is only insignificantly lower at 75m, and the crossing tower reaches up a sizeable 51m.

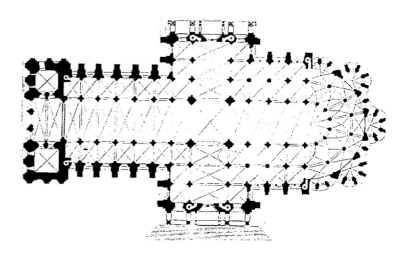

Sainte-Cécile Cathedral in Albi

From afar, the exterior of the particularly strange Albi Cathedral (Languedoc), which is located slightly above the city, resembles a fortress rather than a church, and is very reminiscent of the defensive constructions of the Romans. Begun in 1282, it was completed only at the beginning of the sixteenth century. Its interior and the decorative fashioning of the portals already demonstrate all characteristic peculiarities of the French Late Gothic. It is a typically southern French hall church. Its beginnings coincide with the end of the thirteenth century when the Inquisition ruled the area through murder and torture, which earned the cathedral its name "Cathedral of Hate". The Gothic constructive principles were neglected in this building; the extravagance of the ornaments, particularly the fantastically excessive tracery resembling flickering torches, brought the late Gothic style in France the name *style flamboyant*.

26. *Three Kings and One Queen of the Old Testament*, jamb figures, right side wall of the western portal called "Royal Gate", Notre-Dame Cathedral, Chartres (France), c. 1194-c. 1233. In situ.
27. Plan of Notre-Dame Cathedral, Chartres (France).

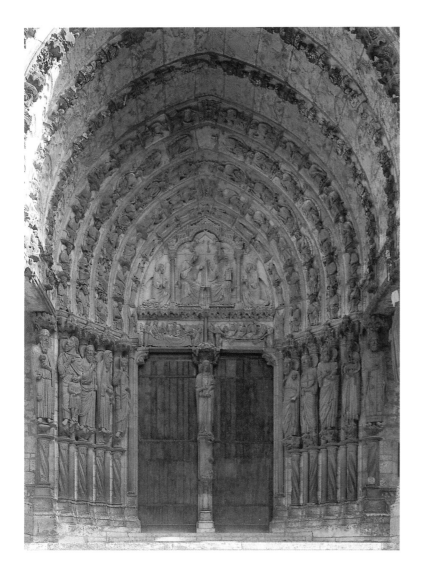

of Naples, Jeanne des Baux, who was charged with murdering her husband. After the deal was concluded, the countess was absolved of all guilt. Until that point the Palace of the Popes had been identical to the old palace of the bishop, which towered like a fortress above the old town of Avignon. With the papal election of 1316, John XXII came to power and began to enlarge the premises. The palace was eventually completed under popes Benedict XII with the Palais Vieux and Clement VI with the Palais Nouveau (see p. 46-47) The latter had a strong predilection for resplendent clothes. Once completed, the entire premises commanded a territory of 15,000m².

The Gothic in England

Canterbury Cathedral

The graceful delicacy of the Early Gothic left a lasting impression on England. When the main church of Canterbury burnt down in 1174, the French master builder, Willem of Sens, was entrusted with its reconstruction (see p. 48, 49). The eastern part, which was already completed in 1189, is the first work of the early Gothic French style. But the English were not yet ready to entirely embrace and follow it, and instead were content with applying Gothic forms on Norman foundations, or reshaping Romanesque forms in the spirit of the Gothic. They were particularly attracted to the external ornamentation, while the essential building principles became secondary. This provides the decisive reason for the special direction the development of the Gothic took in England. In essence, the Norman-Romanesque building principle and arrangement are retained and the Gothic forms merely serve as

The Palace of the Popes (*Palais des papes*) in Avignon
Of the seven popes who once lived and ruled in Avignon, only four (Clement V, Benedict XII, Clement VI and Urban V) strictly obeyed the rules of their orders. The rest (John XXII, Innocent VI and Gregory XI) lived a rather worldly life. Clement VI especially loved splendour and pomp and in 1348 managed to buy the town for 80,000 florins from the Countess of Provence and Queen

28. *The Coronation of the Virgin*, central portal, northern transept, Notre-Dame Cathedral, Chartres (France), c. 1194-c. 1233. In situ.
29. Western Façade, Notre-Dame Cathedral, Chartres (France), c. 1194-c. 1233. In situ.

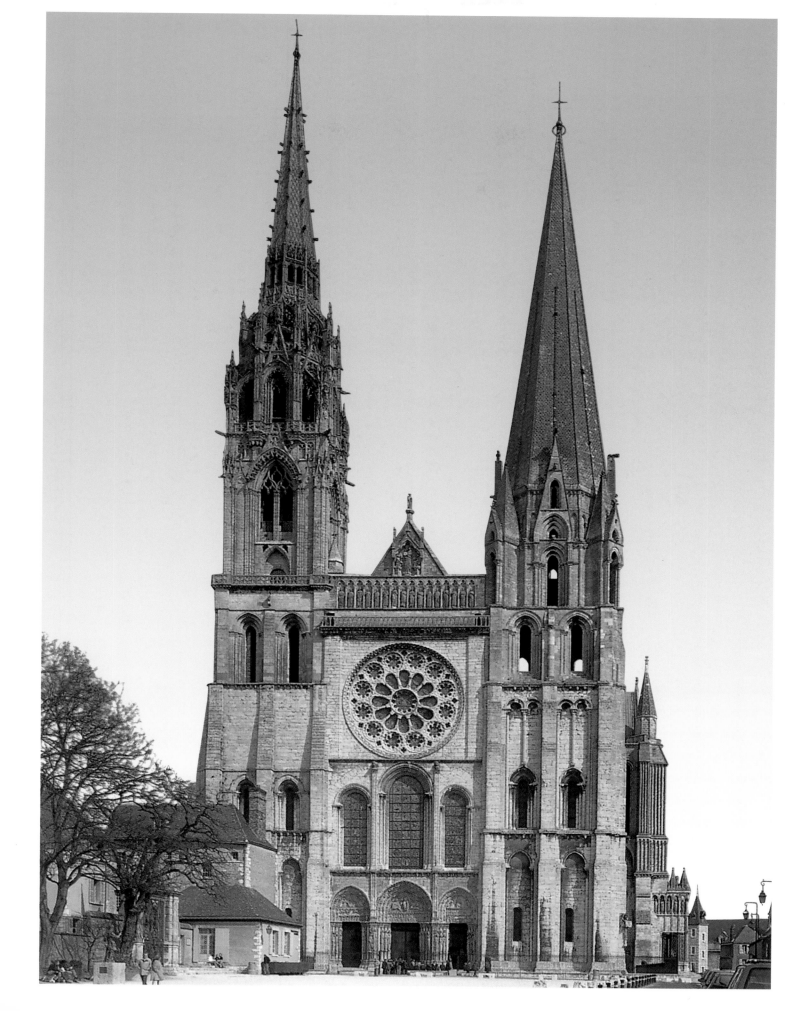

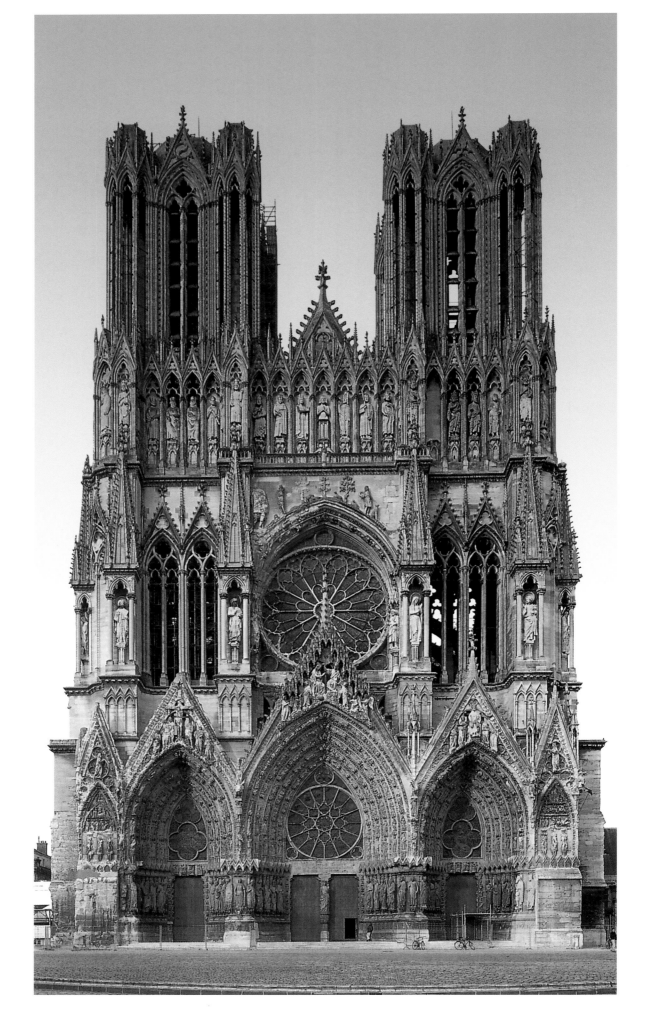

ornamentation. The lively consistency, the inner correlation of building principles and decoration are therefore lacking in the works of the Early English. The horizontal line dominates, but it is the vertical, the striving towards Heaven, that corresponds with the essence of the Gothic. The round pillars are surrounded with free standing pillars; the pointed arches taper very narrowly (lancet arch); at first, the rib vaults acquire one extra rib until eventually the star vaulting is introduced. In the ornamentation the slender and delicate are pushed to the utmost, at times even exaggerated. This style spread very quickly across the entire country, which is proof that it coincided with popular demand. But it also resulted in a certain uniformity of all buildings, which stands in contrast to the independent distinctiveness that marks each of the French works.

An example for the stylistic epoch of the Perpendicular Style is the nave of Canterbury Cathedral.

Westminster Abbey

The last great work of Willem of Sens is Westminster Abbey in London (see p. 50, 51). When building commenced in 1245, a pronounced Anglo-Gothic method of construction was already established practice. Its characteristic peculiarity was a straight ending choir without ambulatory, which often was extended into a square *Lady Chapel*. Above the crossing, a massive square tower replaced the ridge turret. Also typical are the two transepts, the arrangement of horizontal and vertical tendencies, as well as the exuberant creation of the vaults, which in the end would indulge in excessive extravagance (net, star and fan vaults with low hanging keystones).

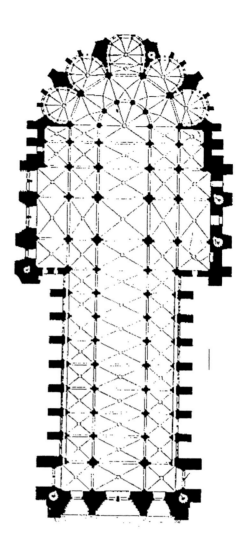

Salisbury Cathedral

Salisbury Cathedral in the English county of Wiltshire, which is situated near the stone circles of Avebury and Stonehenge, can be considered the purest and most significant creation in the Early English style (see p. 52, 53). Horizontal and vertical structures harmonise, while the Gothic forms are used merely as finery and not really related to the style's basic principle. Started in 1220 and completed in about 1258, the cathedral has the highest

30. Western Façade, Notre-Dame Cathedral, Reims (France), begun in 1211. In situ.
31. Plan of Notre-Dame Cathedral, Reims (France).

church tower in England at 123m. This church tower was only placed on top of the nave in the fourteenth century. However, the master builder overestimated the weight-bearing capacity of the foundations, which made later reinforcements necessary.

The construction of this cathedral was imitated by many major churches, which can be seen mostly in the older sections of their construction: Wells (see p. 56, 57, 58, 59), York (only the transepts), Lincoln, Southwell, Beverley, Rochester, and Peterborough, for example.

Lichfield Cathedral

Lichfield Cathedral's façade, which is completely covered with sculptural decoration and framed by two high spires, appears even more lavish. This and York Minster are the most beautiful examples of English Gothic and served as models for the extravagant or Decorated Style that began in the middle of the thirteenth century and lasted more than a century. As the name suggests, the constructive element is secondary to the decorative element, which covers all parts. However, the English master builders mainly indulged in the creation of the tracery, the lines of which dispersed, as if in soft waves.

Over the entire period of this Decorated Style (1250-1370), rich and imaginative decoration is the main feature of sacred buildings. The tracery becomes finer and hardly any surface remains smooth, or any window without fitted tracery. The vault ribs include more elaborate decorative motifs and join into star or web vaults.

32. *Annunciation* and *Visitation*, jamb figures,
 right wall of the central door, western façade,
 Notre-Dame Cathedral, Reims (France), begun in 1211. In situ.

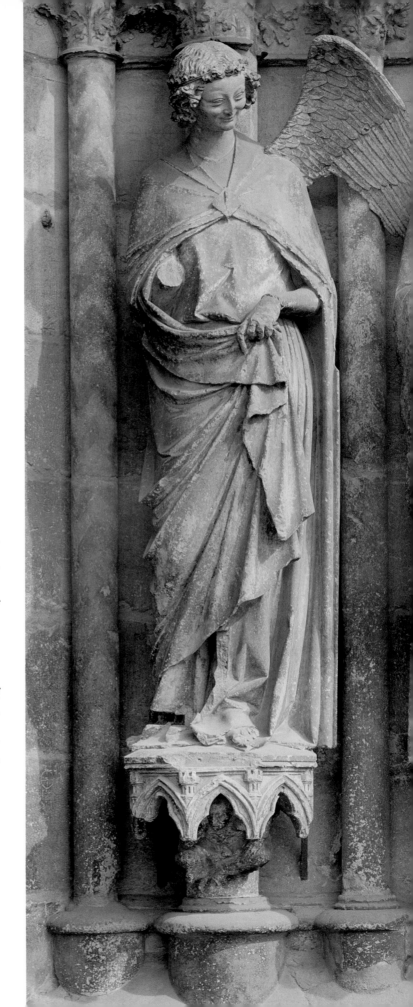

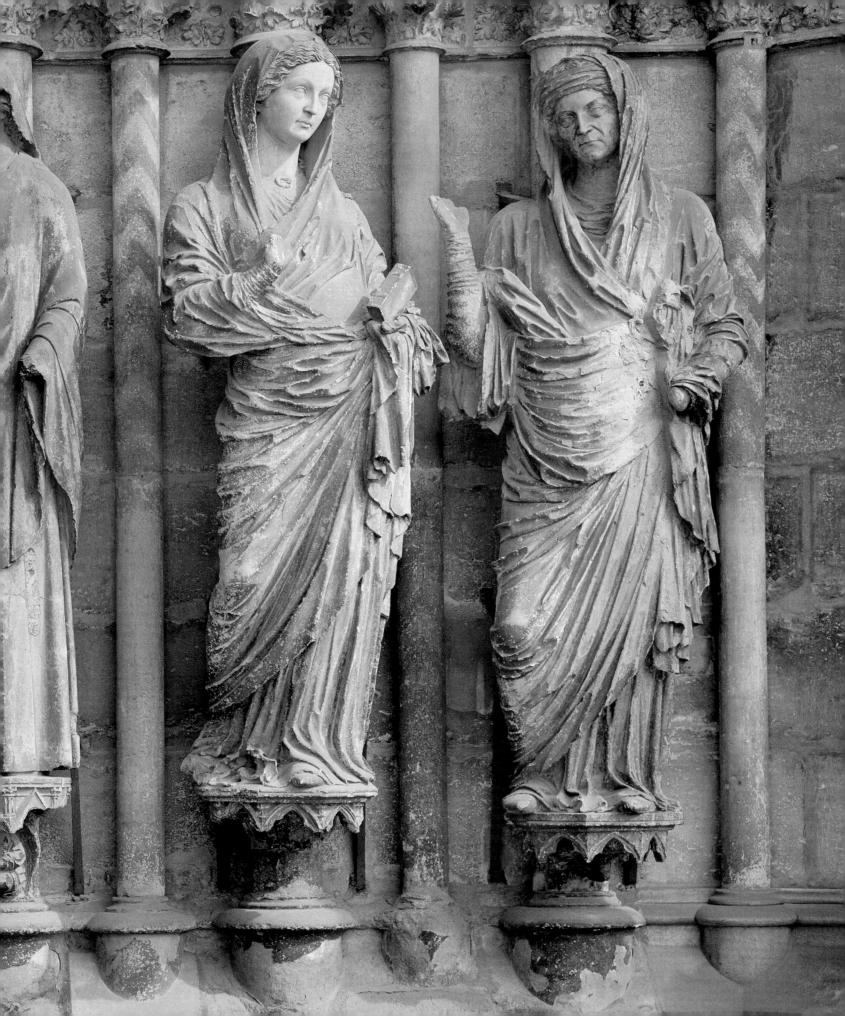

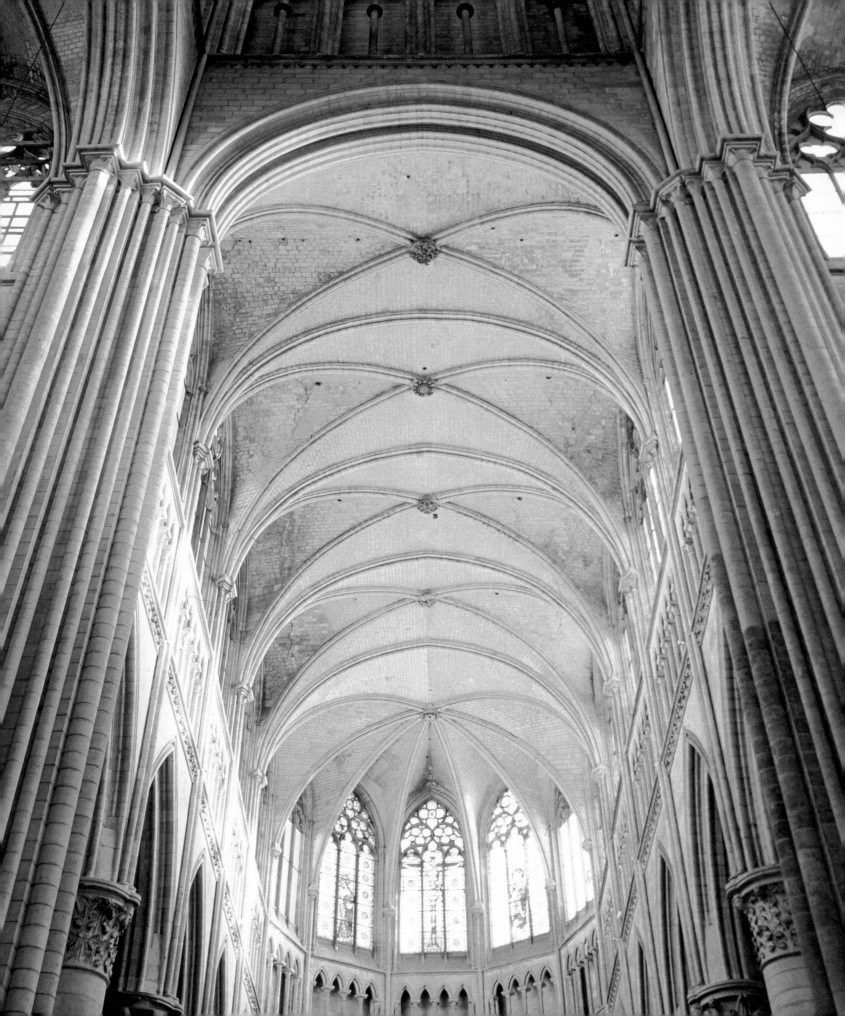

Ely Cathedral

The city of Ely, which is surrounded by flat moors that once separated it from the mainland, is dominated architecturally by its huge and imposing cathedral (see p. 55). This building is one of the most splendid creations of the Decorated Style. This magnificent edifice was begun in 1083 and rises on the ruins of an abbey that was dedicated to St. Etheldreda, but was destroyed by the Normans. In the twelfth century a Benedictine monastery was added to the building. On the night of 22 February 1322, the cathedral's belfry collapsed. It was replaced by the only octagonal tower in England, the so-called "crown of Ely", from original plans by Alan of Walsingham. This innovation, as well as the Lady Chapel that was added to the northern transept, represent the zenith of the Decorated Style.

Bristol Cathedral and Wells Cathedral

Also worthy of mention in regards to this style are the choirs of the cathedrals in Bristol and Wells (see p. 56, 57, 58, 59). From 1350 to 1520, the effusiveness of the Decorated Style was followed by the stricter geometrical Perpendicular Style with horizontal orientation. This was a completely independent English artistic expression, in some ways an English national style. The Perpendicular Style received its name from the use of vertical mullions for high, wide windows and walls, which gave the impression of a grid. A further feature of this style were the fan vault and, somewhat later, the lancet arches, ogee arches and the relatively flat Tudor arch, which made possible the wider windows that often covered the entire eastern side. The pointed arches were set into rectangular areas.

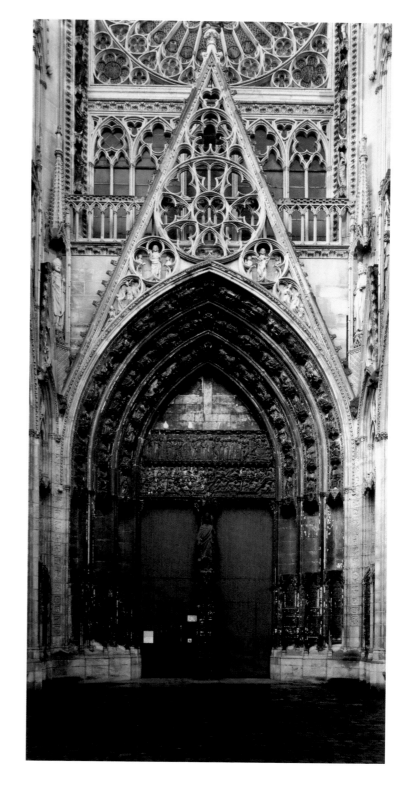

33. Nave, seen from the West, Notre-Dame Cathedral, Rouen (France), begun in 1145. In situ.
34. "Portail des libraires", Notre-Dame Cathedral, Rouen (France), begun in 1145. In situ.
35. Notre-Dame-des-Doms Cathedral and Palace of the Popes, Avignon (France), 1335-1352. In situ.

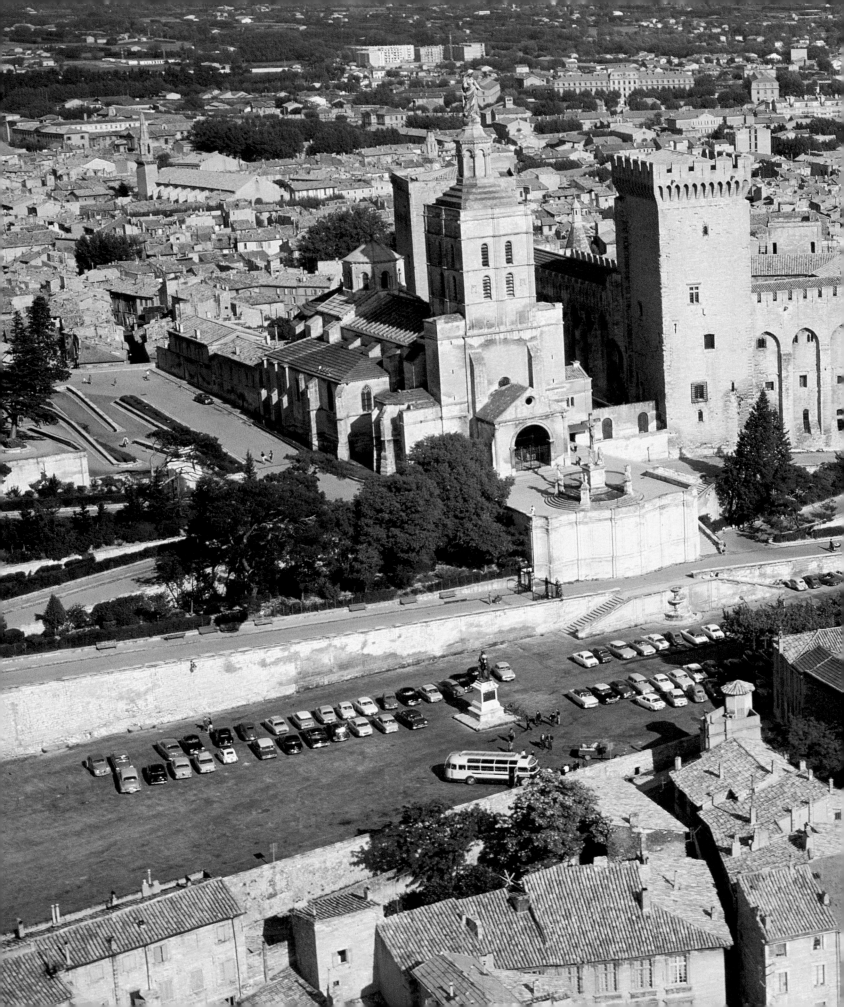

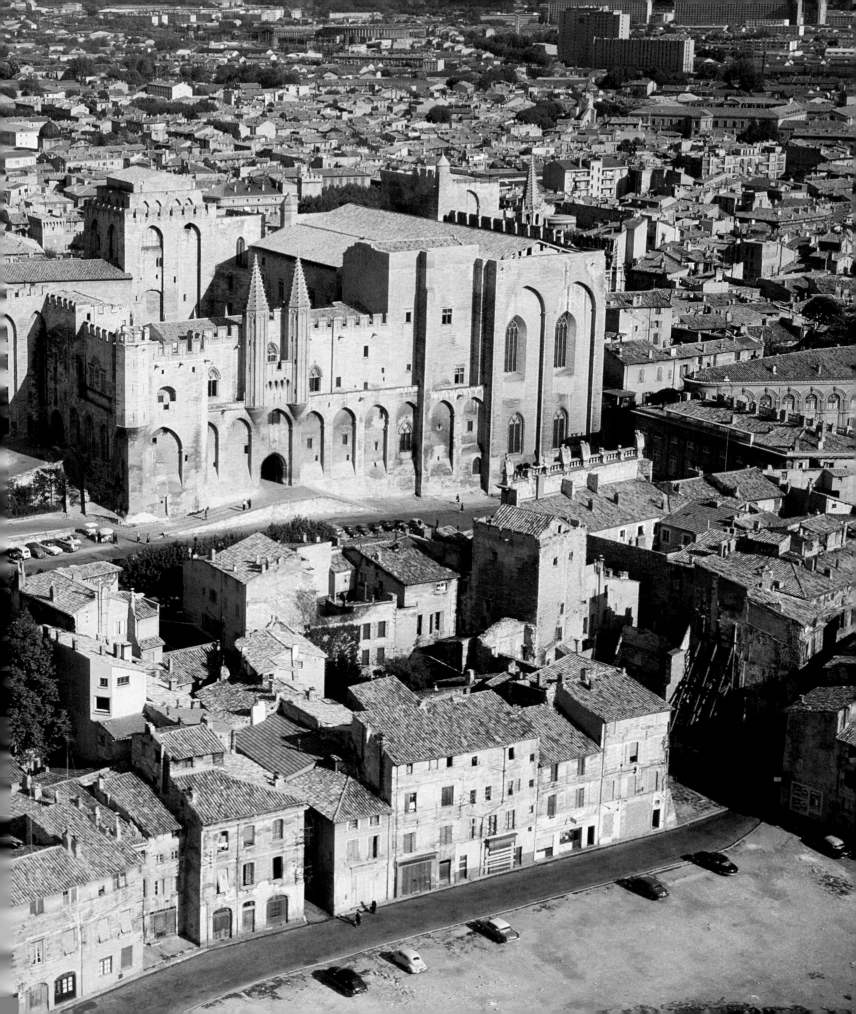

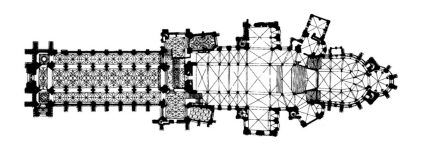

merely relegated to smaller rooms, to the chapter halls, which were added to the cathedrals, cloisters and smaller chapels. The most splendid building of this late period of English Gothic is the chapel of Henry VII in the choir at Westminster Abbey in London (1502-1526). Its fantastic vault shows the decorative abilities of the Gothic style at its highest level.

Gloucester Cathedral

The Perpendicular Style was first applied in the former Benedictine abbey at Gloucester in the fourteenth century (see p. 60, 61). The ambulatory shows the square grid that is so characteristic for this style. The eastern window, which is richly equipped with grid-like tracery, is the largest in England. Typical also is the fan vault of the cloister.

Winchester Cathedral

The end of the fourteenth century and the construction of Winchester Cathedral saw a movement that went against the stylistic excess that was so atypical for the English character – and aimed for sobriety. The Perpendicular Style, which was used here for the first time, got its name from the grid-like mullions and members that replaced the tracery, particularly in the windows. Just as characteristic was the use of new arch forms, such as the narrowing ogee arch, which was unknown on the mainland, as well as the specifically English Tudor arch, which is flatter than the ogee arch.

Despite the return to straighter lines in the tracery, the wealth of decoration was not at all diminished; it was

St. Peter Cathedral in Exeter

As so often in medieval buildings, the beautiful architecture of Exeter Cathedral demonstrates a mixture of building styles – a result of long lasting construction (see p. 63, 64). While the older towers of Norman style originate in the twelfth century, the western façade, which was built in the fifteenth century, is a typical example of Perpendicular Style. The cathedral was rebuilt between 1270 and 1369 as a Gothic monument with a Lady Chapel and a presbytery at the east end. Of the Norman construction only the two transepts were integrated into the high Gothic church. Particularly interesting is the western façade with an image screen in its lower part.

Gothic Secular Buildings

Many secular Gothic buildings were constructed in England as the population's wealth increased. Such buildings include the colleges of Oxford and Cambridge; Westminster Hall in London (1393-1399), which was built by an unknown master builder; Winchester Castle (1232-1240), of which only one hall remains, and Hampton Court Palace (as of 1520). Many fortresses and castles also profess the Gothic secular style, as does the Tower of London, which was begun in 1078 and

36. Plan of Canterbury Cathedral, Canterbury (United Kingdom).
37. Choir, Canterbury Cathedral, Canterbury (United Kingdom), 1174-1184. In situ.

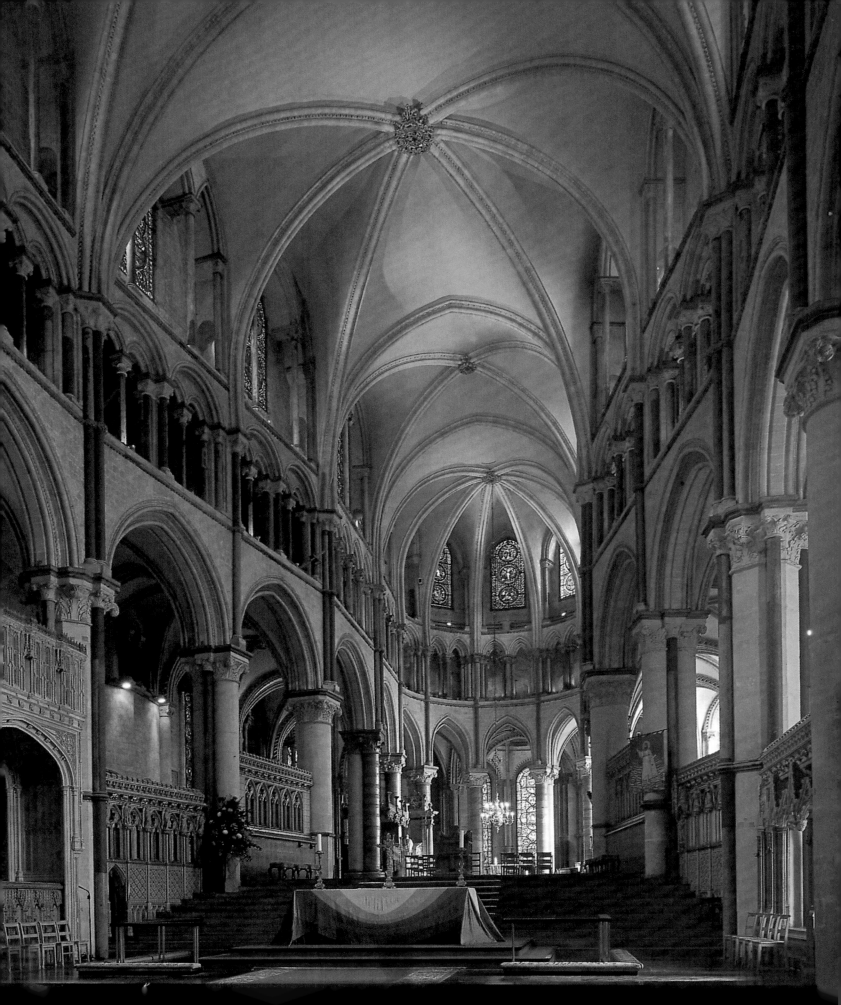

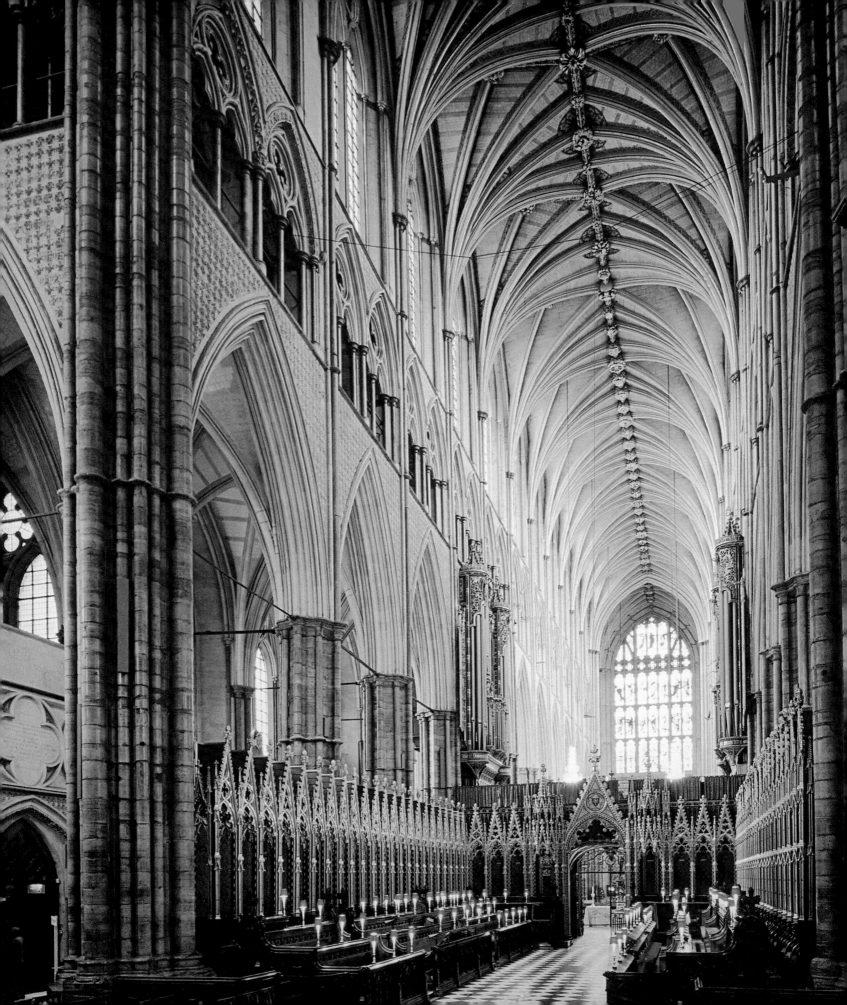

frequently enlarged, and declared a world heritage site of UNESCO in 1988.

The Gothic in Germany and Austria

The oldest major works of the Gothic architectural style in Germany are the choir of Magdeburg Cathedral (see p. 66), which was begun in 1208, the *Liebfrauenkirche* (Church of Our Lady) in Trier (1227-1243) and the *Elisabethkirche* (Elisabeth Church) in Marburg (1235-1283). However, these are by no means slavish imitations of the newly arrived French innovation; instead from the very beginning they show much independence in the way they use the foreign forms. For example, despite its French ground plan with an ambulatory and chevet, the choir of Magdeburg Cathedral (see p. 66) has national traits in its details. These traits become increasingly pronounced with the building of the longhouse, which was consecrated in 1363. The western façade, too, with its pair of towers completed in 1520, features distinctly national characteristics.

The master builder of the *Liebfrauenkirche* (Church of Our Lady) in Trier proceeded contrariwise: he only followed the French style in the details, while creating a completely innovative ground plan. Consisting of a centralised building around which a chevet was created, this church is a unique Gothic construction.

The master builder of the *Elizabethkirche* (Elisabeth Church) worked just as independently. Despite its lengthy construction period, the church appears as a unified

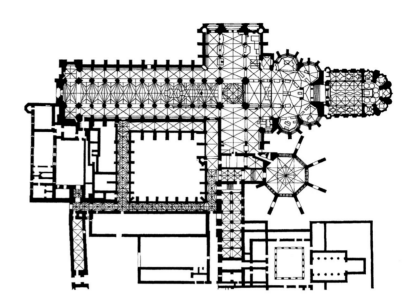

whole. The form of the hall church, as it had developed in Westphalia, was retained for the interior's design. Likewise, the creation of the façade with its slender uninterrupted climbing towers is a deviation from the French type. The master builder had already clearly understood that verticality, i.e. the strong emphasis of the vertical line, represents the most fertile basic Gothic idea.

The Gothic architectural style in Germany, which spread only from the start of the fourteenth century, found its most splendid development in the two cathedrals on the Rhine: Cologne (see p. 68, 70, 71) and Freiburg (see p. 73). They were accompanied by three other artistically equally valuable cathedrals, all of which are located at the shores of the Danube: Ulm Cathedral, Regensburg Cathedral in southern Germany and St. Stephen's Cathedral in Vienna, Austria (see p. 69).

8. Nave, seen from the East, Westminster Abbey Church, London (United Kingdom), 1245-1259. In situ.
9. Plan of Westminster Abbey Church, London (United Kingdom).

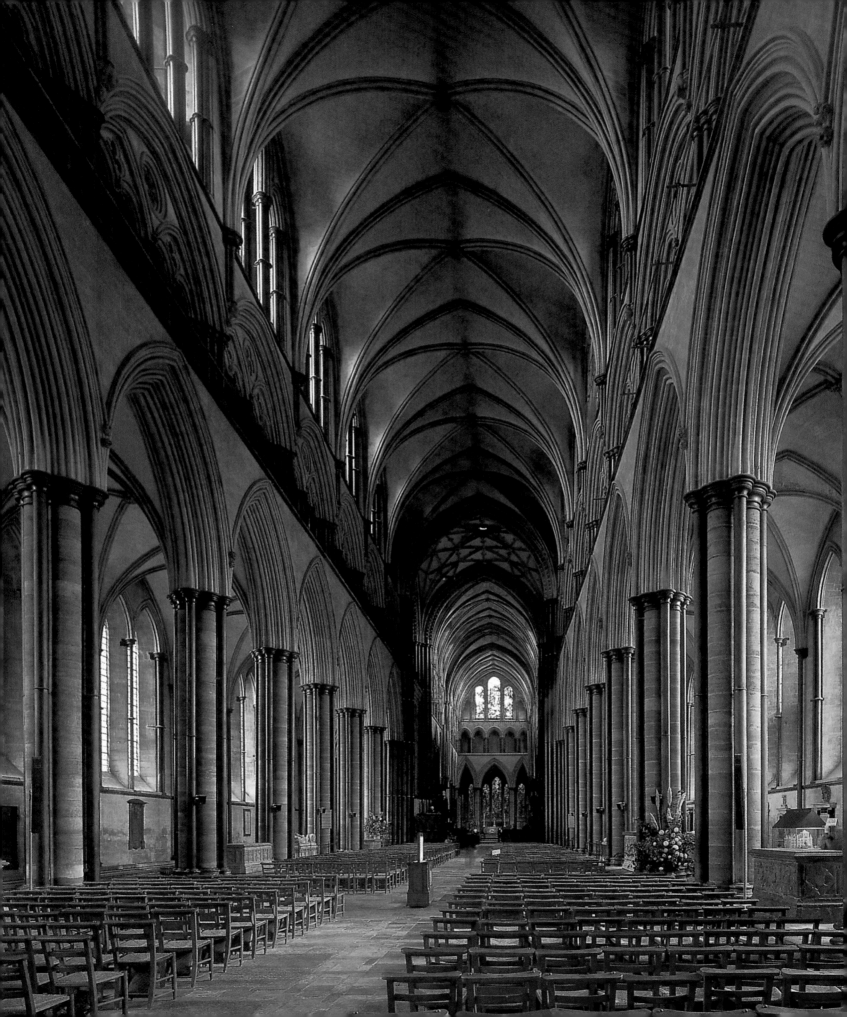

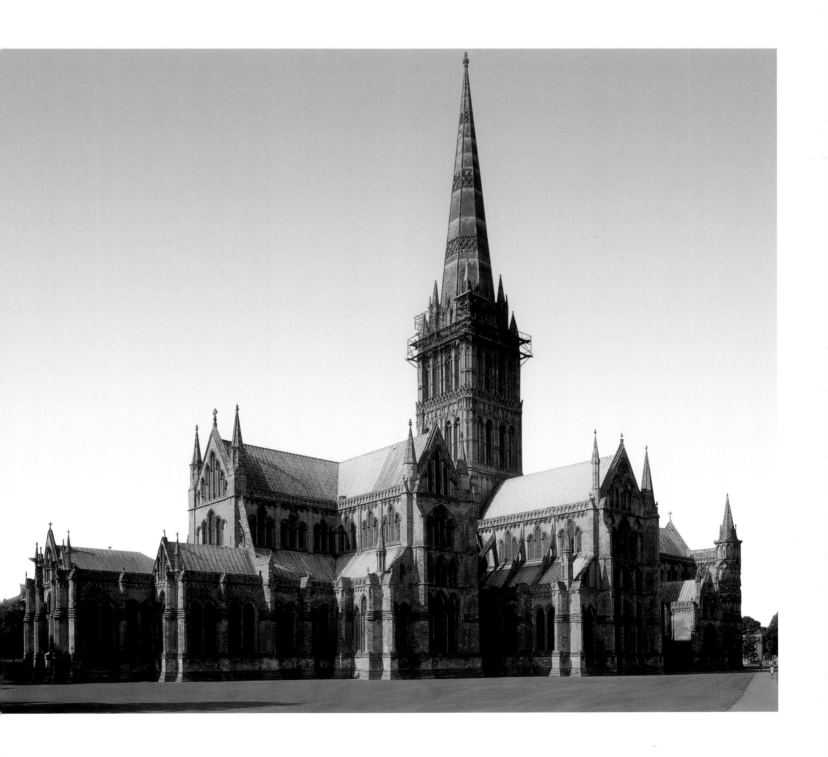

40. Nave, seen from the East, Salisbury Cathedral, Salisbury (United Kingdom), 1220-1258. In situ.
41. Salisbury Cathedral, Salisbury (United Kingdom), 1220-1258. In situ.

St. Peter and Mary Cathedral in Cologne

Cologne Cathedral is the only purely Gothic building (see p. 68, 70, 71). Its long construction period, which lasted over six centuries, did not impair the stylistic consistency. There is something sober about Cologne Cathedral, not only in its conception, but also in its execution. Here, imagination was dominated by reason, the roots of which are buried deeply in basic Gothic principles, which the master builders of Cologne only brought to their final conclusion. Therefore Cologne Cathedral, as it stands, can be seen as a kind of keystone to the entire Gothic architectural period. Here all driving forces of the Gothic converged to bring forth the last hidden seeds of its construction method and to execute the pure principle of verticality, the most essential idea of the Gothic.

As early as the fifth century, a lengthy, approximately 40m long apsidal building existed where the Cathedral stands today. This former building had a short life span: it was replaced at the end of the same century with a new building that was supposed to hold the tombs of the Frankian counts. In 1248, after the *Alte Dom* (Old Cathedral, also called "Hildebolddom", Hildebold Cathedral) had almost completely burnt down, the choir of the new Gothic building was begun. It was finished in 1322 and followed the architectural plans of master builder Gerhard von Riel (or Riele). The cathedral as it stands today was erected over the altar that had been consecrated in 873. It was designed to hold the ever increasing number of pilgrims and is, with its 4,000 seats, the second largest cathedral in Germany (after Ulm), as well as the third largest in the world. The relics of the Three Wise Men, which the archbishop of Cologne had brought from Milan, are housed here.

The first master builder, Master Gerhard, closely followed the French examples, particularly Amiens Cathedral (see p. 32, 33) and the steepest rising Gothic cathedral of Beauvais (see p. 12, 35). However, Master Gerhard perished in a deadly fall from the scaffolding in 1260. Among his successors were Master Arnold, who worked from 1295 to 1301, and Arnold's son Johannes (until 1330), who contributed the most to the continuation of the building and its artistic creation. After the choir was finished, these successors pursued their own artistic goals without disturbing the harmony of the overall building. While the five aisle conception of the choir was extended to the nave – thus the Gothic ground plan was brought to its highest perfection – the vertical tendency was increasingly emphasised as building progressed, until it found its highest expression in the western façade with its pair of towers. Only one sketched plan from the beginning of the fourteenth century has survived. With the help of this plan, which is justifiably attributed to Master Johannes, the building could be completed. Not only was construction completely dormant from 1515 to 1842, the centuries-long neglect had resulted in partial disintegration. The initial restoration efforts of Ernst-Friedrich Zwirner, which after 1861 were followed by those of Reinard Voigtel, assured that this "stone miracle" cathedral was renewed to complete harmony and has been so since 1880.

In 1998 the cathedral was added to the UNESCO list of world heritage sites.

42. **William Hurley**, Octogon Lantern Tower, Ely Cathedral, Ely (United Kingdom), begun in 1109. In situ.

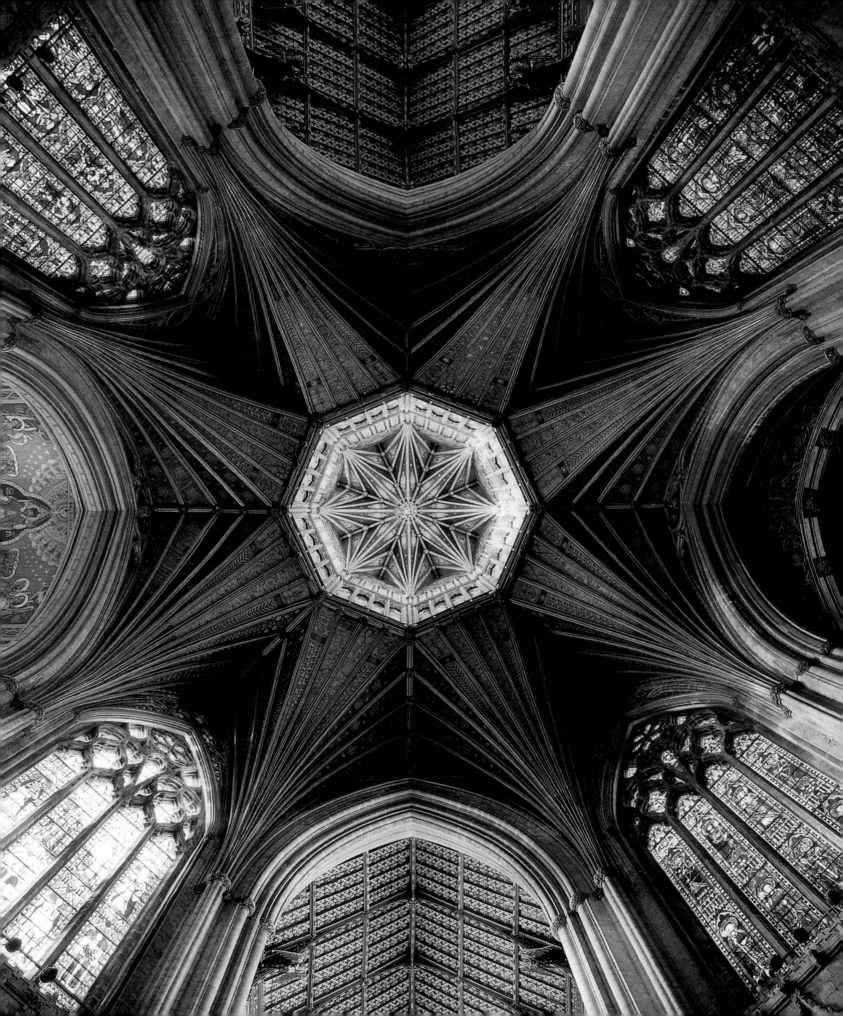

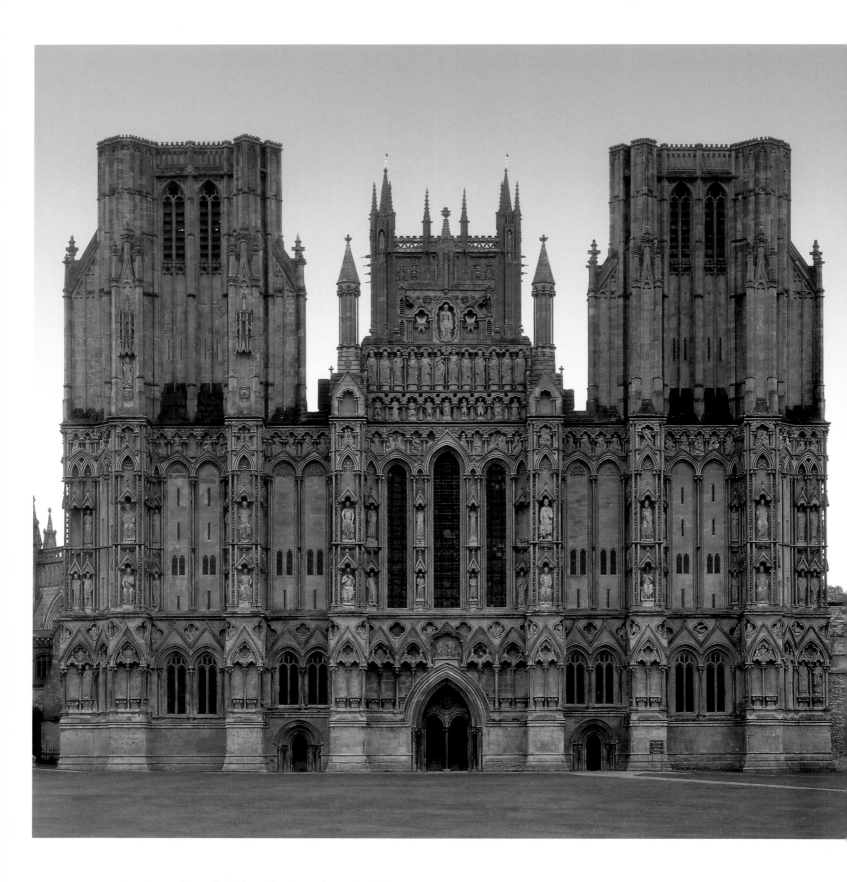

43. Western Façade, Wells Cathedral, Wells (United Kingdom), begun in 1180. In situ.
44. Chapter House, seen from the North, Wells Cathedral, Wells (United Kingdom), begun in 1180. In situ.

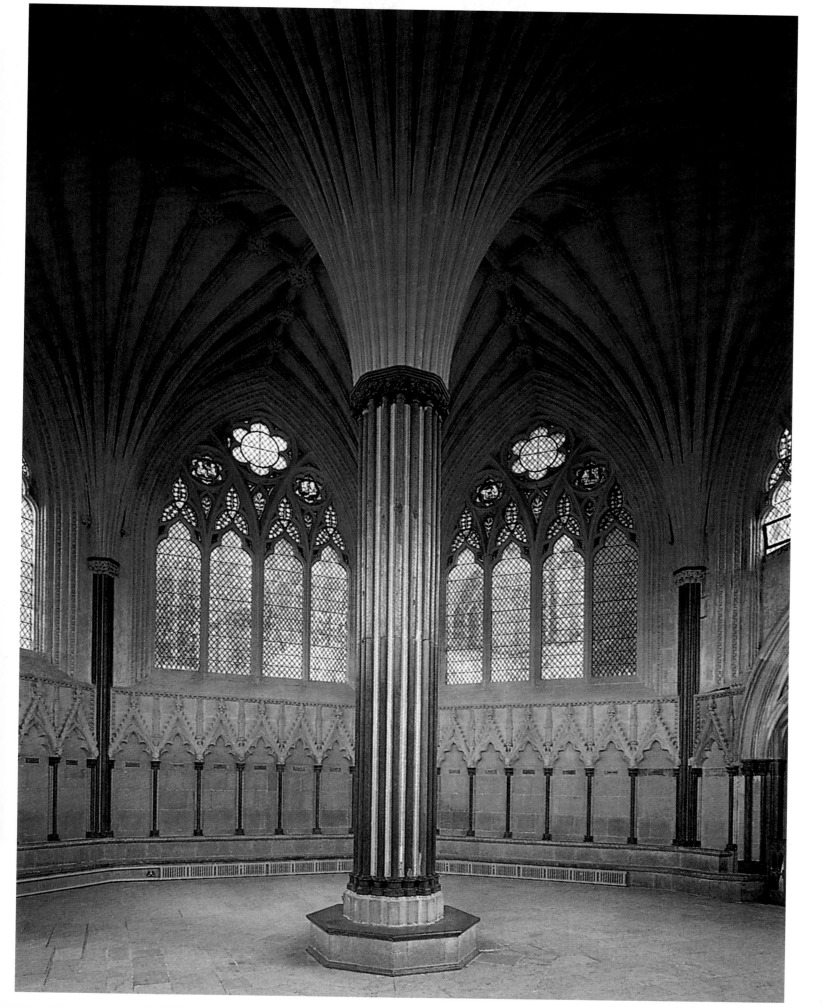

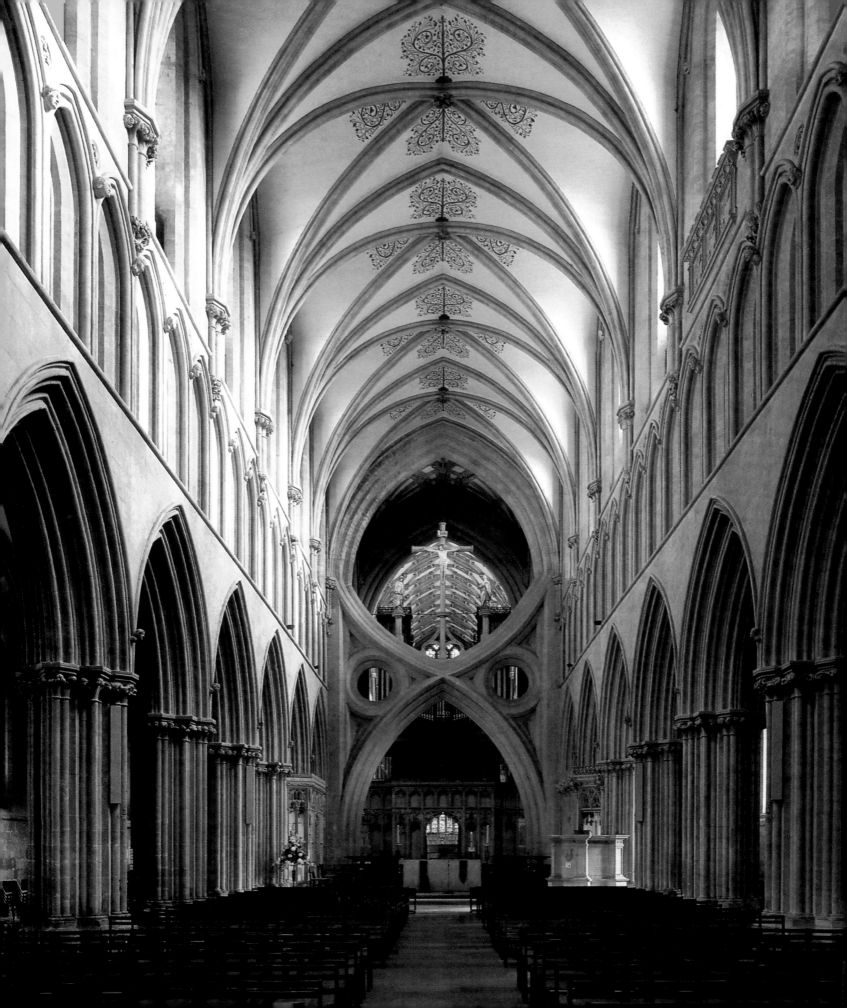

Freiburg Cathedral

The *Freiburg Münster* (Freiburg Cathedral) (see p. 73) was begun in the last quarter of the twelfth century, i.e. concurrently with Strasbourg Cathedral (see p. 26, 27, 28, 29). Its oldest part is a Romanesque transept to which a new nave was added in the Gothic style in 1250. The western façade of Freiburg Cathedral was concluded with a tower that rises in three, strictly separated, yet organically connected building parts: the square foundation with its magnificent portico, the octagonal bell cage, and the crowning open stone pyramid, which is the first as well as the most masterful of its kind. The new construction of the choir begun in 1354, but was only completed in 1514. It was the same length as the nave, and was concluded with a fourteen chapel chevet.

Regensburg Cathedral

The fates of the three southern German cathedrals were similar to that of their counterparts on the Rhine: the cathedrals in Regensburg and Ulm were completed only in the last third of the nineteenth century, but they at least received the artistic completion which had always eluded Vienna's St. Stephen's Cathedral. Construction of Regensburg Cathedral began in 1275 and continued until the beginning of the sixteenth century. The cathedral's peculiarity lies in the fact that it rises from a three-metre high terrace that circles the entire building. This increases the impression of the enormous building mass, which is intensified with a glance into the interior of the three aisle basilica. With an approximately 30m height, the central nave exceeds Strasbourg Cathedral (see p. 29). The designers of Regensburg sought their mastery by breaking away from the French models and instead

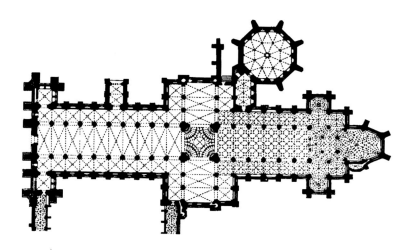

followed the local tradition of Romanesque building methods. The towers, the pyramids of which imitate those of Cologne Cathedral (see p. 68, 70, 71) were constructed from 1859 to 1871 under the master builder Ritter von Denzinger.

Ulm Cathedral

Ulm's citizens had an even greater desire to build and this manifested itself in their spectacular cathedral (minster). Begun a century later, in 1377, this is also a three aisle basilica. Its central nave was raised to a 42m height by the first main master builder, Ulrich von Ensingen. The structure's *pièce de résistance* is the tower protruding from the western façade. Matthias Böblinger from Esslingen worked on it from 1480. A brother or relative of his, Hans Böblinger, concurrently built the beautiful tower of the *Liebfrauenkirche* (Church of Our Lady) in his home town. The latter's open wall pyramid, which is one of the most charming creations of the Late Gothic, anticipated the end of the epoch. Matthias Böblinger was not quite as successful: after ten years of work his tower's walls began

45. Nave, seen from the West, Wells Cathedral, Wells (United Kingdom), begun in 1180. In situ.
46. Plan of Wells Cathedral, Wells (United Kingdom).

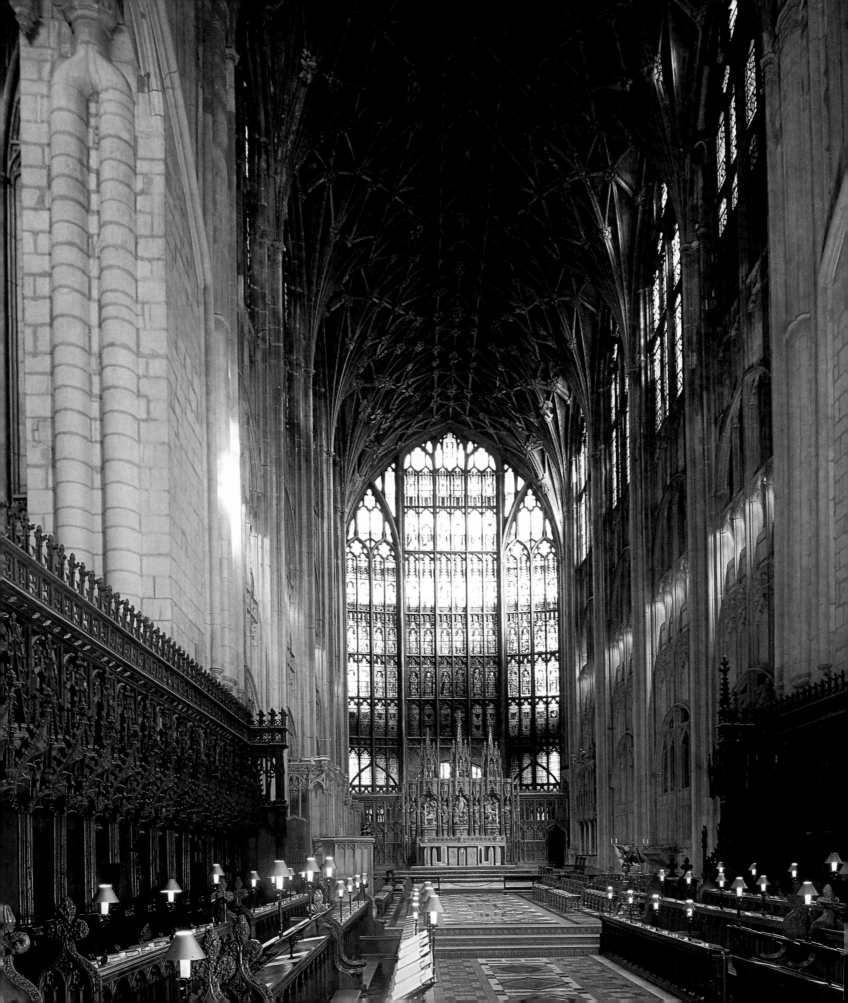

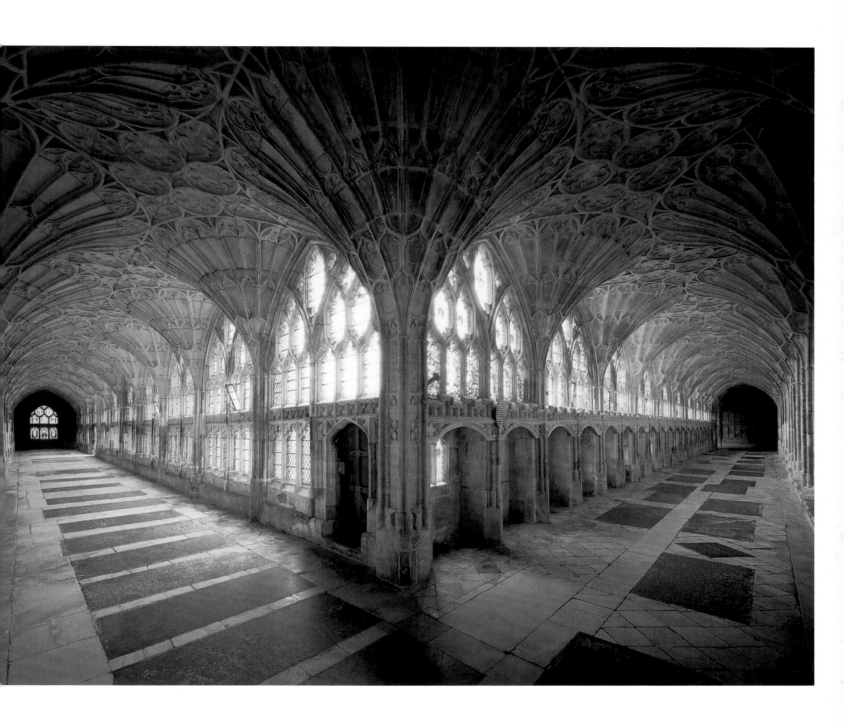

47. Choir, Gloucester Cathedral (former Benedictine abbey church), Gloucester (United Kingdom), c. 1337-1360. In situ.
48. Ambulatory, Gloucester Cathedral (former Benedictine abbey church), Gloucester (United Kingdom), 1360-1370. In situ.

to sway, the master had to flee the furious mob and was eventually replaced by Burkhart Engelberger from Augsburg. By reinforcing the foundations Engelberger succeeded in preventing the already 74m tall tower from collapsing. Similarly, the construction of the interior had to be secured with an additional row of pillars in the aisles, which ultimately resulted in the creation of a five aisle structure. The continuation of the tower, which resumed only much later, followed Böblinger's plans and was eventually finished under August Beyer in 1890. It reached its originally intended height of 162m, surpassing the spires of Cologne Cathedral by 5 metres (see p. 68, 70, 71), and became, thanks to August Beyer, the tallest church tower in the world.

Other Cathedrals, Minsters and Churches in Germany

In terms of splendour and magnificence the cathedrals in central Germany were unable to compete with these western and southern German buildings. Still, there are some churches in Saxony and Thuringia that are of monumental significance. The most voluminous and artistically significant are Magdeburg Cathedral (1209-1520) (see p. 66), Halberstadt Cathedral (1239-1492) with its towers that stem from the early building period and still bear Romanesque forms, and the Cathedrals of Meissen and Erfurt. The latter two are hall churches and feature a three aisle structure. The equal height of the aisles accommodates the need for spaciousness that had manifested itself in the reign of the Romanesque style. This stylistic feature is typical for Westphalia and remained dominant throughout the Gothic era (cf. Cathedrals of Minden, *Wiesenkirche* (Meadow Church) of Soest and *Lambertikirche* (Lamberti Church) of Muenster).

This need for spaciousness was apparently widespread, because the number of hall churches rose continuously in the south of Germany, too. For example, the three main churches of Nuremberg feature hall structures: The *Frauenkirche* (Lady Church) is a pure hall church featuring a remarkable façade, the upper part of which is completely covered with blind arcades; from its front above the portico protrudes the *Michaelskapelle* (Michael Chapel). The western façade of the *Lorenzkirche* (Laurence Church) is framed by two towers and represents the type of Rhine-Gothic that developed under the influence of the French Gothic. Together with the *Sebalduskirche* (Sebaldus Church) these buildings are creations of highest artistic appeal and represent a further idiosyncrasy of the Nuremberg Gothic.

Striking evidence for the decorative skill, which is characteristic for all of fifteenth century Nuremberg art and touches all branches of artistic craftsmanship, is the northern portal of the *Sebalduskirche*. This includes the famous bridal door with its finely crafted, freely suspended tracery; the equally famous *Chörlein* (little choir) by the presbytery, which is an oriel supported by a pillar; as well as the beautiful fountain (1383-1396). The portal is a masterpiece of harmonising architecture and sculpture, and its constructive craftsmanship merits as much acknowledgement as its depicting art.

49. Western Façade, St. Peter Cathedral, Exeter (United Kingdom), transformed between 1270 and 1369. In situ.
50. Nave, seen from the East, St. Peter Cathedral, Exeter (United Kingdom), transformed between 1270 and 1369. In situ.
51. Interior, seen from the West, King's College Chapel, Cambridge (United Kingdom), 1246-1515. In situ.

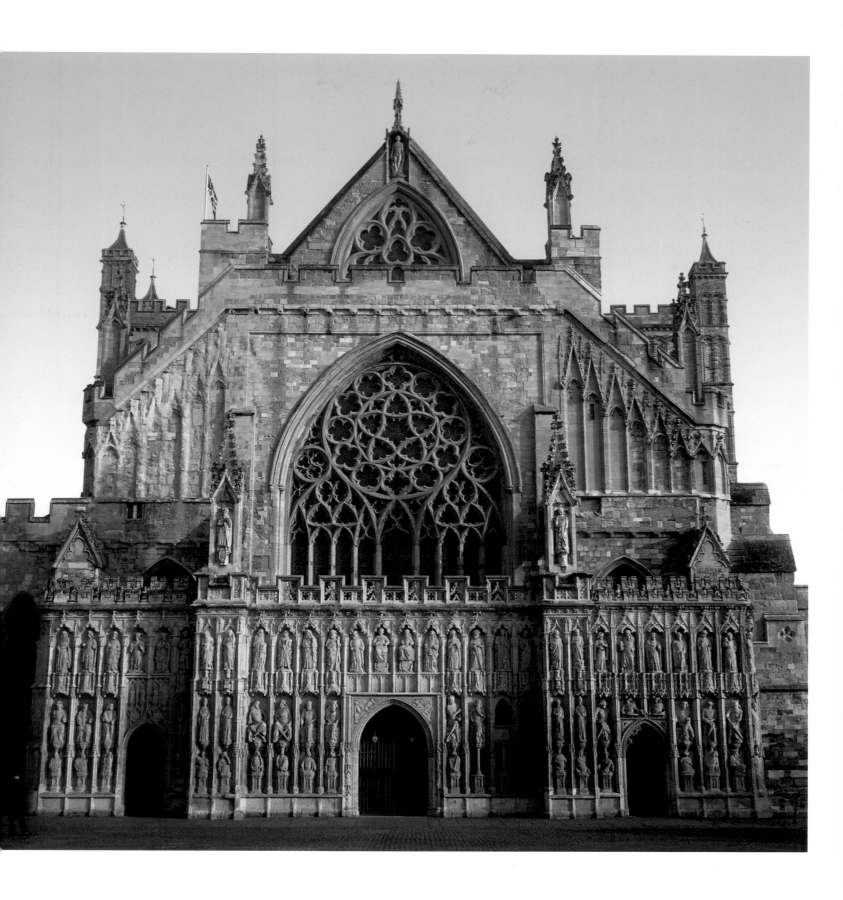

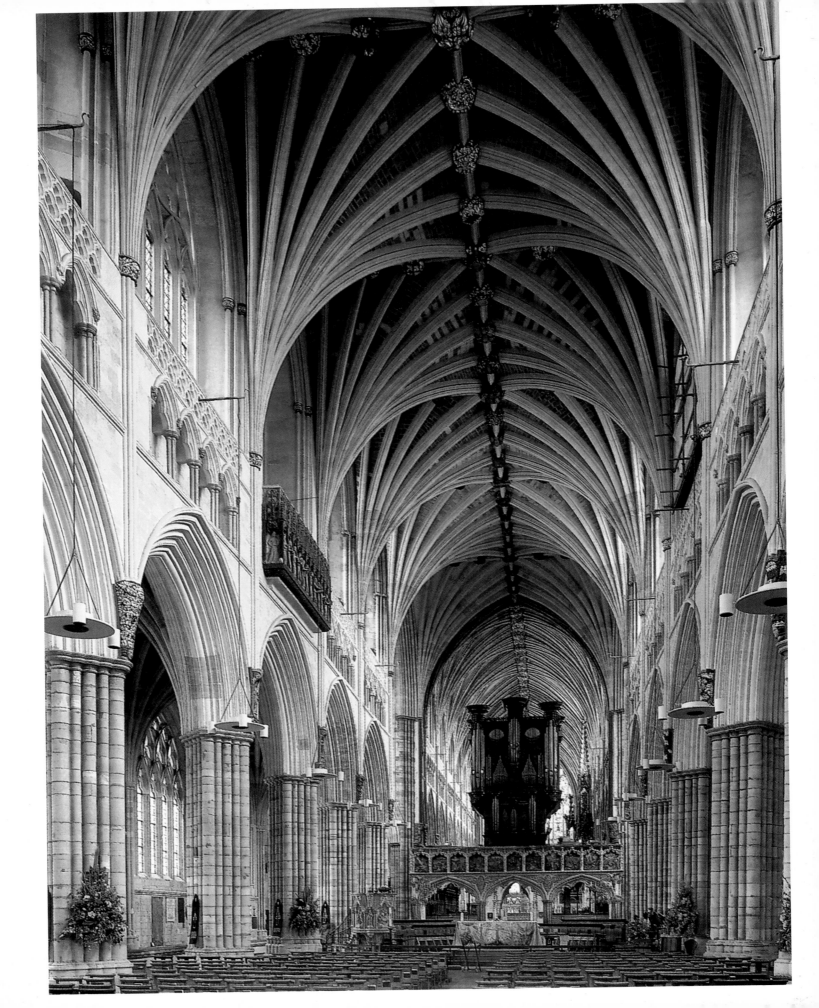

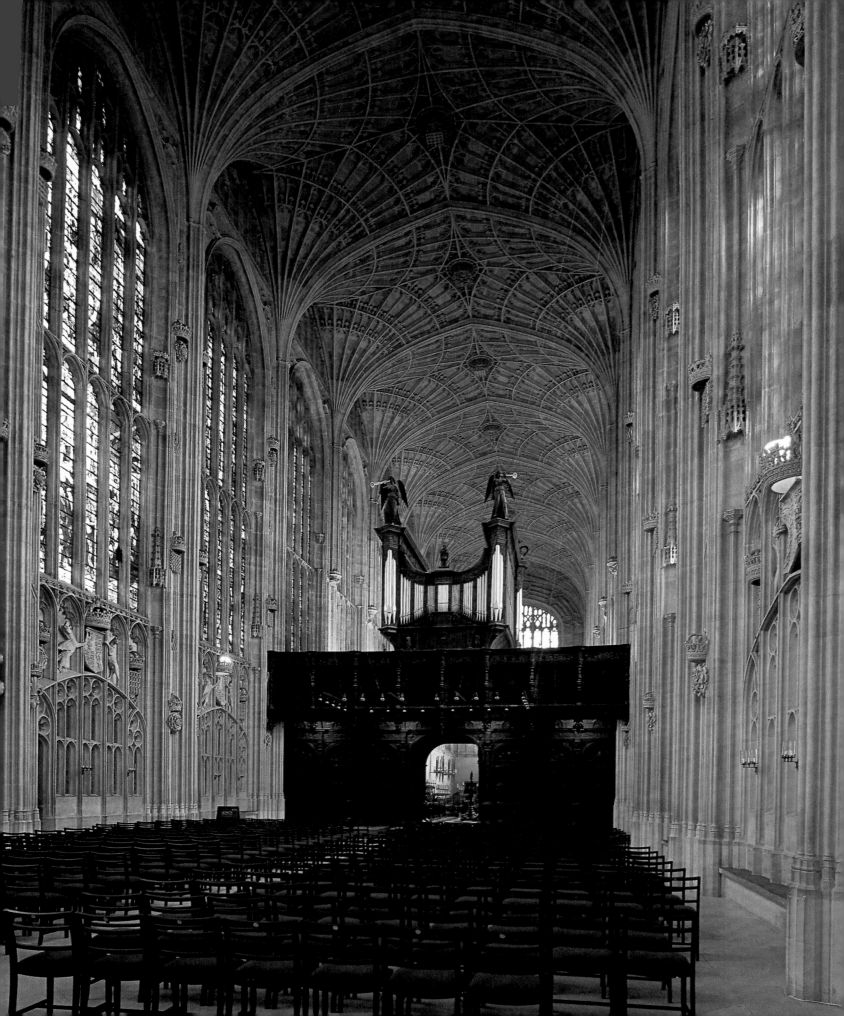

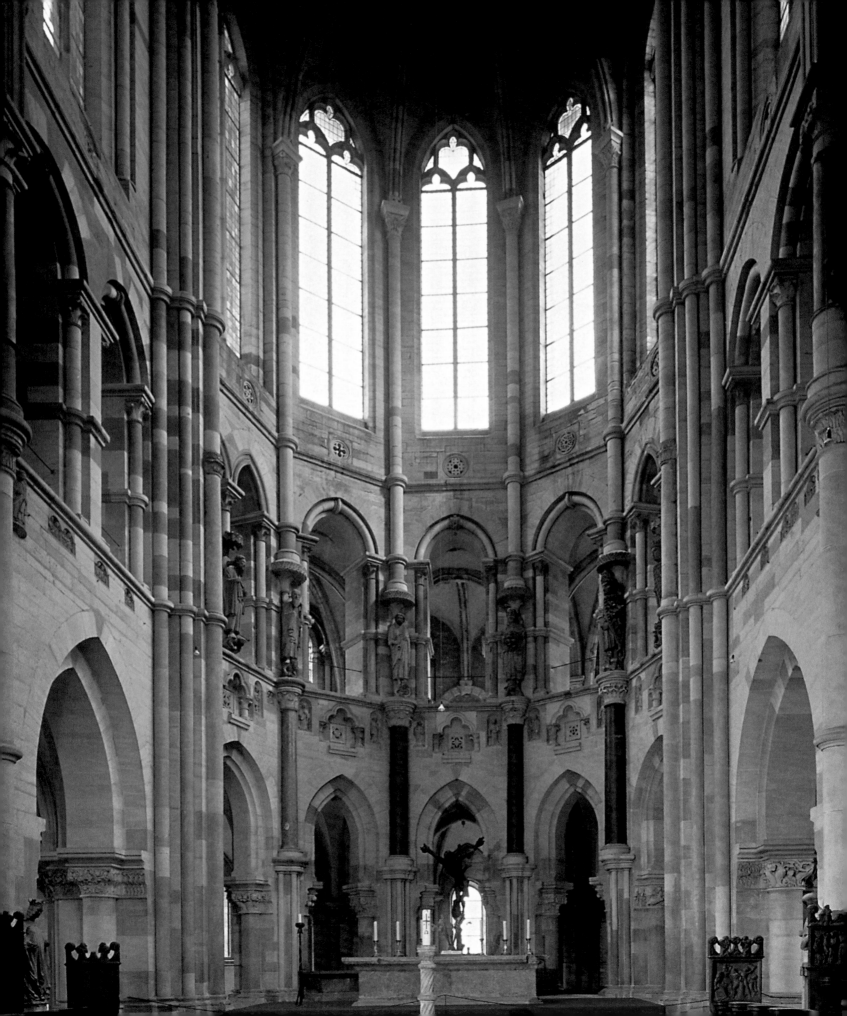

Hall churches were erected wherever there was a dependency on bricks. If there were not enough means for the richness of artistic décor, then at least the building should impress with its monumental size, its mighty rising walls. The *Frauenkirche* (Lady Church) in Munich (1468-1488) is the most imposing example. In the north and east of Germany, where brick building had been common for some time, the exterior lack of decoration would not do in the long term. The architects were able to at least imitate one of the main decorative motifs of the Gothic, the tracery, by combining the bricks with ornamental forms made from fired clay. In fact, the technique was perfected to such a degree that the high rising gable walls could be laced with windows and rose windows that were filled with tracery.

The rich Hanse towns with their enterprising populace preceded the cities inland with the construction of church and secular brick buildings. The structure of the *Marienkirchen* (Churches of Mary) in Lübeck and today's Gdańsk (Danzig) surpass all others in terms of extent and monumentality. In terms of artistic significance, however, a few major churches in Mark Brandenburg, where brick building had developed special characteristics, were their equal. The *Klosterkirche* (monastery church) of Chorin with its majestic appearance, and the *Katharinenkirche* (Church of St. Catherine) in the old bishop town Brandenburg are particularly worthy of mention. The splendid external decoration of the latter shows the brilliant accomplishments that resulted from the competition of brick building architecture with delicate forms of stone sculpting.

St. Stephen Cathedral in Vienna

St. Stephen Cathedral in Vienna (see p. 69), begun in 1339, shows predominantly German characteristics, not only in the design of the choir, but overall. Since its nave is only slightly higher than and almost as wide as the aisles, it resembles a hall church. This structural type had also appeared in southern Germany since the fourteenth century and due to its spaciousness also remained popular in the fifteenth century. A characteristic of St. Stephen's Cathedral is the arrangement of the towers, which were positioned not at the western façade, but along the two long sides where they replace a missing transept. Unfortunately, only the southern tower measuring 137m in height was completed by Master Wenzel in 1433. It ranks fourth in height among the cathedrals in German speaking countries. Still, it is a masterpiece of technology that shines with the originality of its design: from the very beginning it was intended to become a pyramid that rises immediately from the ground.

Gothic Secular Buildings – Town Halls

The artistic effects gained from using the rather intractable building substance of brick were also transposed to secular buildings, namely town halls. Above their façades towered tall gables that usually appeared in groups of three and fulfilled a merely decorative function (blind gables). Brick was also used for the fortification towers of city gates. The old towns of Mark Brandenburg, particularly Brandenburg itself, as well as Tangermünde (town hall) and Stendal (*Uenglinger Tor* – Uengling Gate) have a wealth of town

52. Choir, SS. Catherine and Maurice Cathedral, Madgeburg (Germany), started in 1209. In situ.

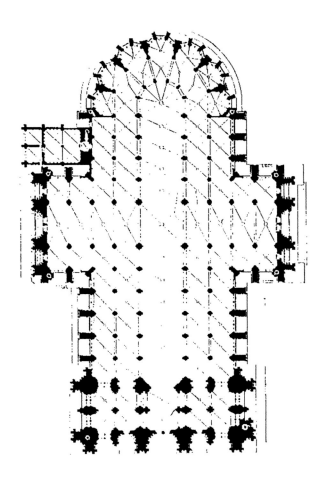

of their street-facing façades. In Germany and the Netherlands these stepped gables are an especially typical trait of Gothic private buildings, which was also later adopted by the Renaissance. Towards the end of the Gothic Middle Ages the common half-timbering method also sought artistic development, which would fully flourish only in the Renaissance, particularly in old Saxon towns such as Braunschweig, Halberstadt, Hannover, Hildesheim and others. Contrary to today's sober, unimaginative, and uniform rows of private homes, each of these gabled houses tried to differ from its neighbours in individual construction. The same was true for private stone buildings, for which the fortress-like character of the medieval house had stronger emphasis, but which also featured a great variety of creations. The most convincing examples for this are the best preserved private home of the German Gothic, the *Nassauer Haus* in Nuremberg, which is more akin to a fortress than a family home, and the *Steinerne Haus* (Stone House) in Frankfurt on Main.

halls and city gates to this day. Town halls are the main monuments of secular Gothic architecture because only a few private Gothic homes that can claim artistic value have survived. This is more so in areas that used brick building than those that built with stone.

The old Hanse town of Lüneburg, which held a long-lasting monopoly on salt and thus became very wealthy, contains the most interesting examples of private Gothic brick building. Others can be found in Pomeranian and Brandenburg areas. These houses all have tall, stepped gables towering above the narrow form

Artistically, the most significant town halls of northern German brick building are not only those of the Mark Brandenburg, but also the more extensive government buildings in Lübeck und Stralsund. With their majestic structures and magnificent ornamentation the citizens of the Hanse towns strove to publicly express their power, which was based on wealth, while remaining humbler with the construction of their private homes. During the fourteenth century this bourgeois pride had grown exponentially in many other German towns, too, until even the smallest community with a town charter had to have a monumental town hall as a landmark of their self-aggrandisement.

53. Plan of St. Peter and Mary Cathedral, Cologne (Germany).
54. St. Stephen Cathedral, Vienna (Austria), begun in 1137. In situ.

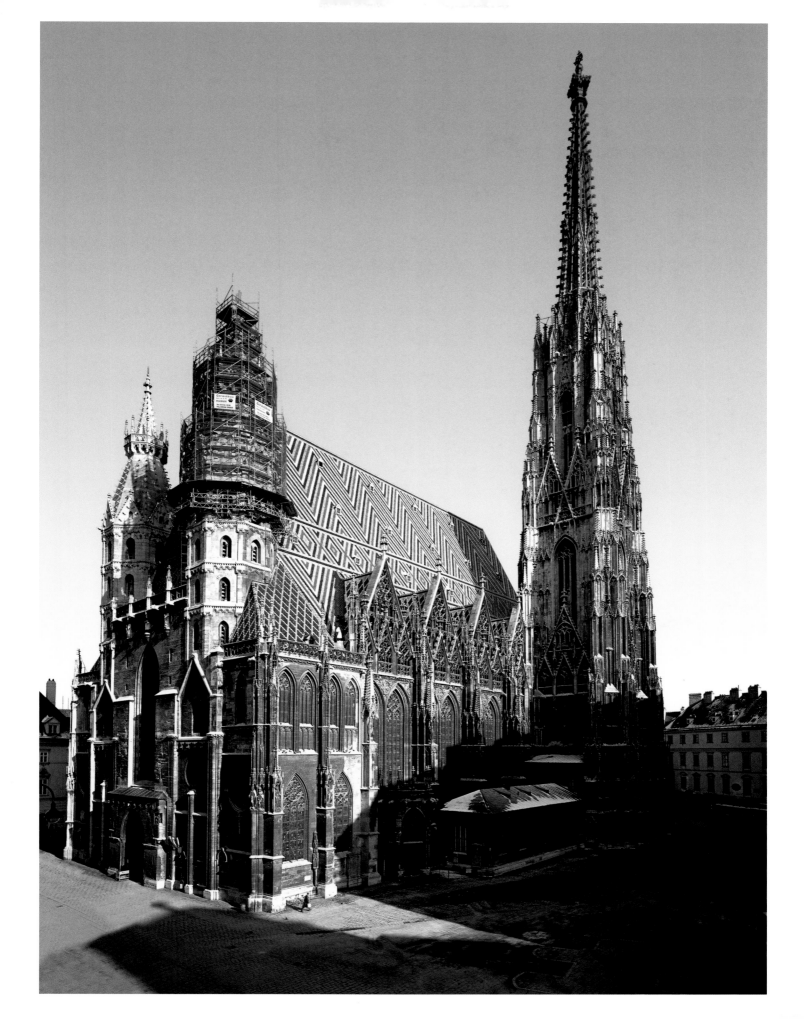

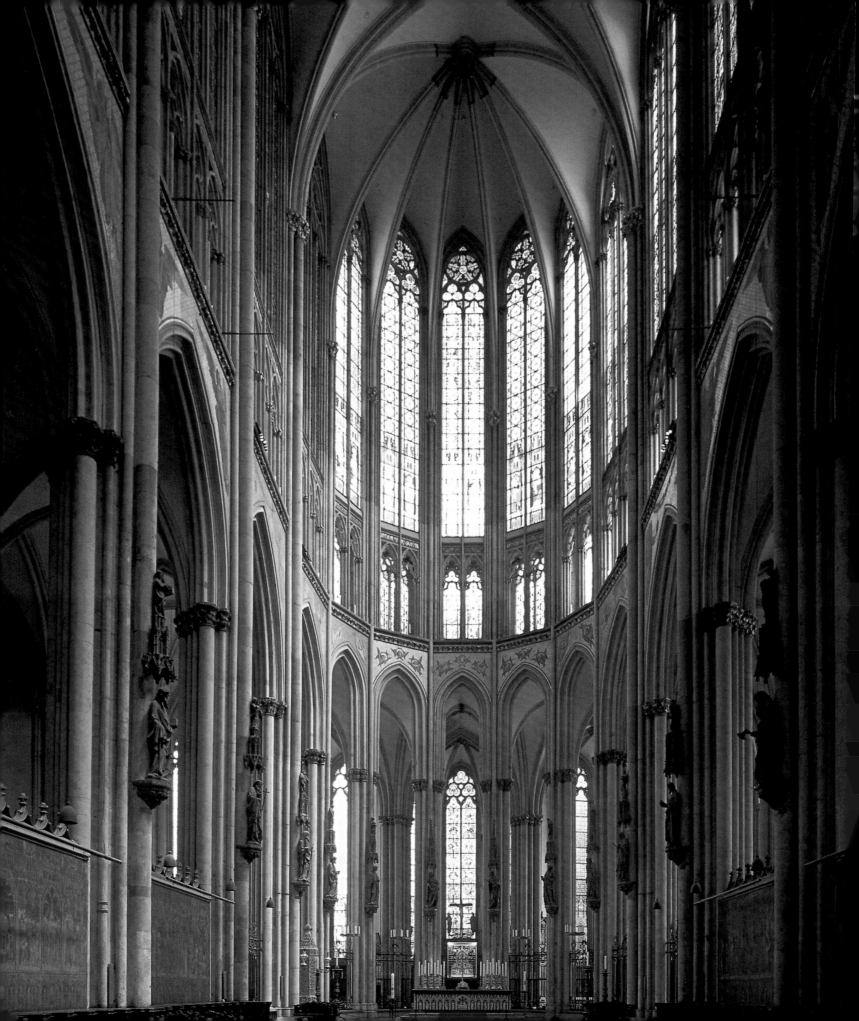

Although most of these town halls were remodelled according to a new style in the sixteenth century, or even entirely replaced by more splendid ones, there is no shortage of great, abundant testimonies to this flowering and strengthening of German townsfolk. The town hall in Münster, which is a much imitated, tall gable structure, and the town hall of Braunschweig, with its perpendicularly colliding wings that open in two pointed arch halls towards the market place, show in their rich and tasteful details the heights to which artistic Gothic secular architecture in Germany could rise towards the end of the fourteenth century.

Another field of secular architecture was city fortification. Gates and towers endured not only in terms of their main task of protection and defence, but also in terms of artistic ornamentation. Here also, the areas that use brick building techniques clearly stand out with their skilful combination of severe, monumental power with delicate structuring and fine decorative details. Outstanding monuments of this kind include the gates and towers of the old towns in Mark Brandenburg, and most of all the *Hostentor* (Holsten Gate) in Lübeck (1477), which grew into a virtual gate fortress; and the city gates in Neubrandenburg.

In other German speaking countries of the time, there is likewise no lack of gate buildings that adopted the artistic characteristics of their time. Examples are the *Svalentor* (Svalen Gate) in Basel, the *Eschenheimer Tor* (Eschenheim Gate) in Frankfurt on Main, and the *Altstädter Brückenturm* (Oldtown bridgetower) in Prague

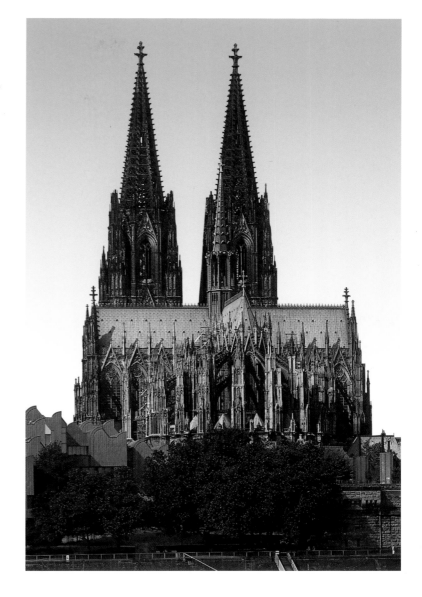

(Czech Republic). The latter is one of the city's last in a series of grand building projects, which Karl IV began with Castle Karlstein.

55. Choir, St. Peter and Mary Cathedral, Cologne (Germany), begun in 1248. In situ.
56. St. Peter and Mary Cathedral, Cologne (Germany), begun in 1248. In situ.
57. Western Façade, St. Lorenz Church, Nuremberg (Germany), 1353-1362 (central part), 1383 (towers). In situ.

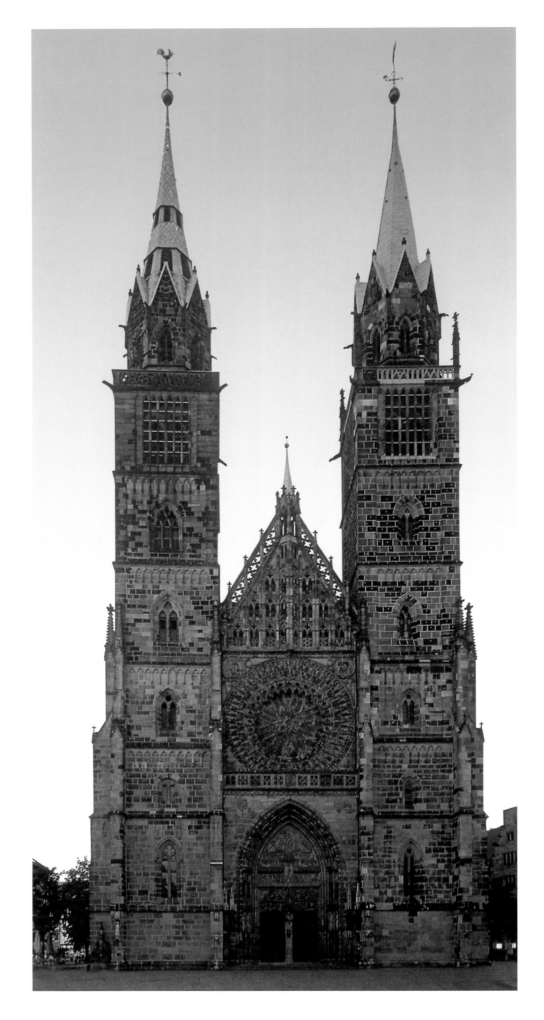

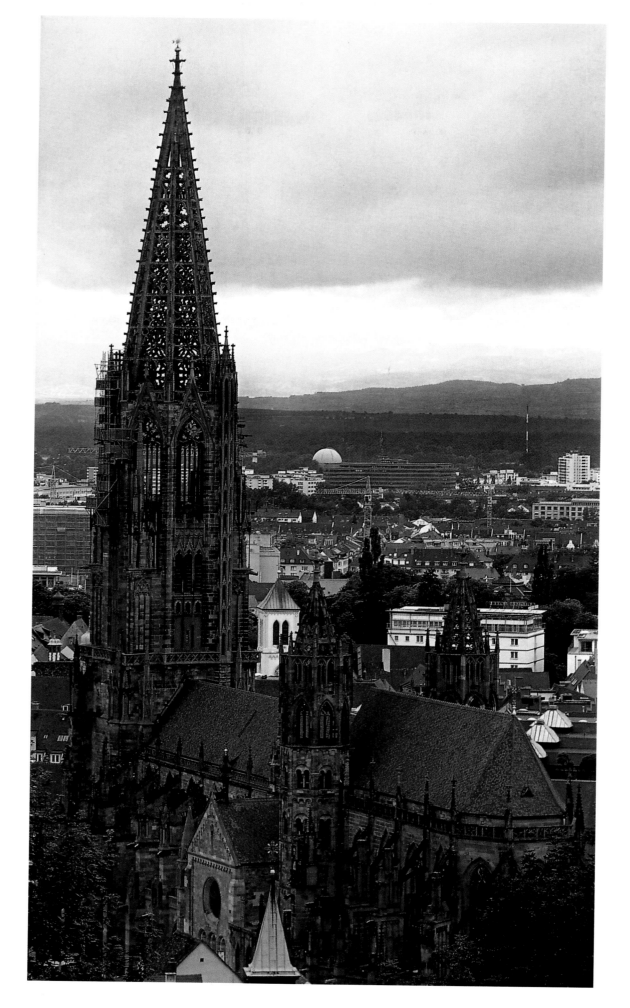

73

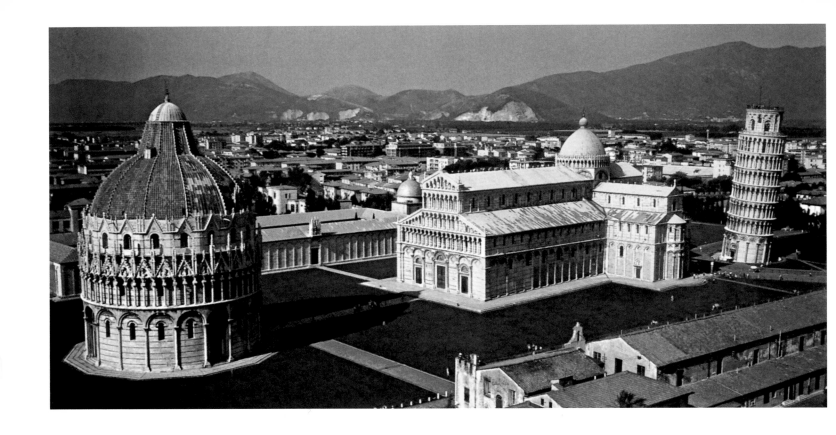

From the middle of the fourteenth century, the castles and princely palaces, which were homes to powerful ruling families, began to lose the merely functional and defensive character that they had inherited from the early middle ages. While their exterior did not deny its original purpose, the design of their interior, particularly the grand halls, greatly benefited from the spatial strength of the Gothic style. Master Arnold of Westphalia understood and applied this most skilfully and intelligently in the *Albrechtsburg* (Albrecht Castle), which he began to build in 1471.

However, in terms of magnificent spatial atmosphere, Master Arnold had been surpassed earlier by the master builders of the Teutonic Knights (also: Ordo Teutonicus, or German: *Deutscher Ritterorden*). Between 1309 and 1457 they created the most significant artistic work of secular architecture in the entire German middle ages: The *Marienburg* (Castle of Mary), which was then the seat of the Grand Masters. The order had been already founded during the third crusade (1189-1192). As it grew in importance, the older part, the *Hochschloss* (High Castle), was extended into a *Mittelschloss* (Middle Castle), which served as a home to the grand master and contained the large assembly hall of the knights, the famous *Remter* – an incomparable masterpiece of vaults and arches. Over subsequent centuries the castle fell into disrepair and had to be restored several times. Destruction was particularly hard-hitting at the end of World War II.

58. Freiburg Cathedral, Freiburg-im-Breisgau (Germany), begun in 1182. In situ.
59. Baptistery, Cathedral and Bell Tower, Pisa (Italy), baptistery begun in 1153, cathedral in 1063 and bell tower in 1173. In situ.
60. Tower of Pisa, Pisa (Italy), 1173-1370. In situ.

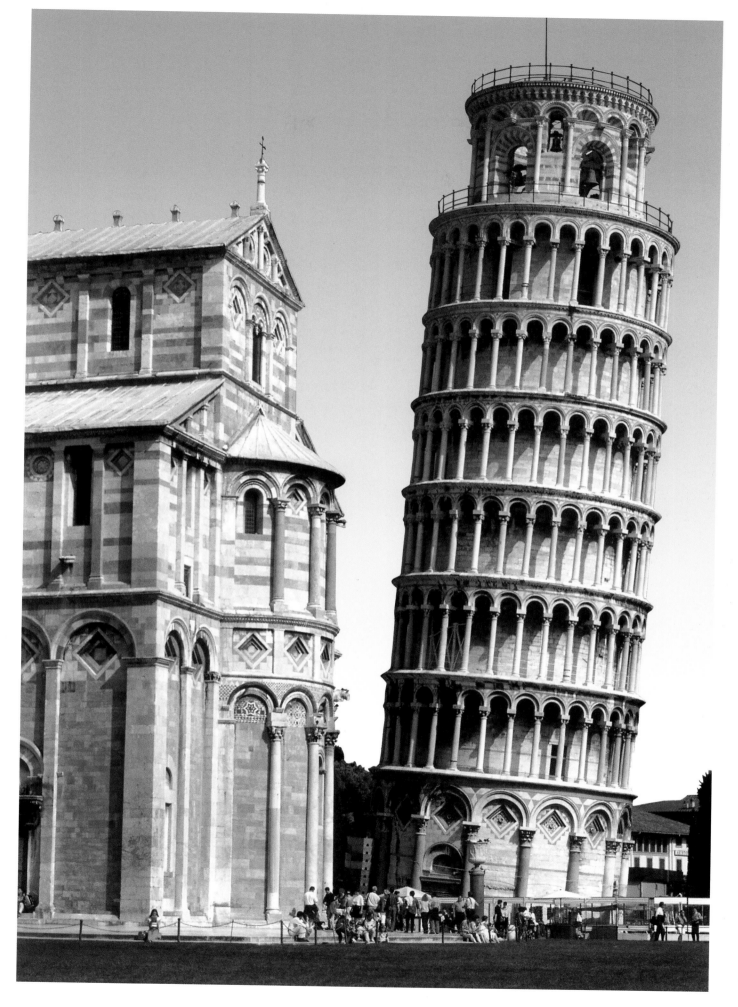

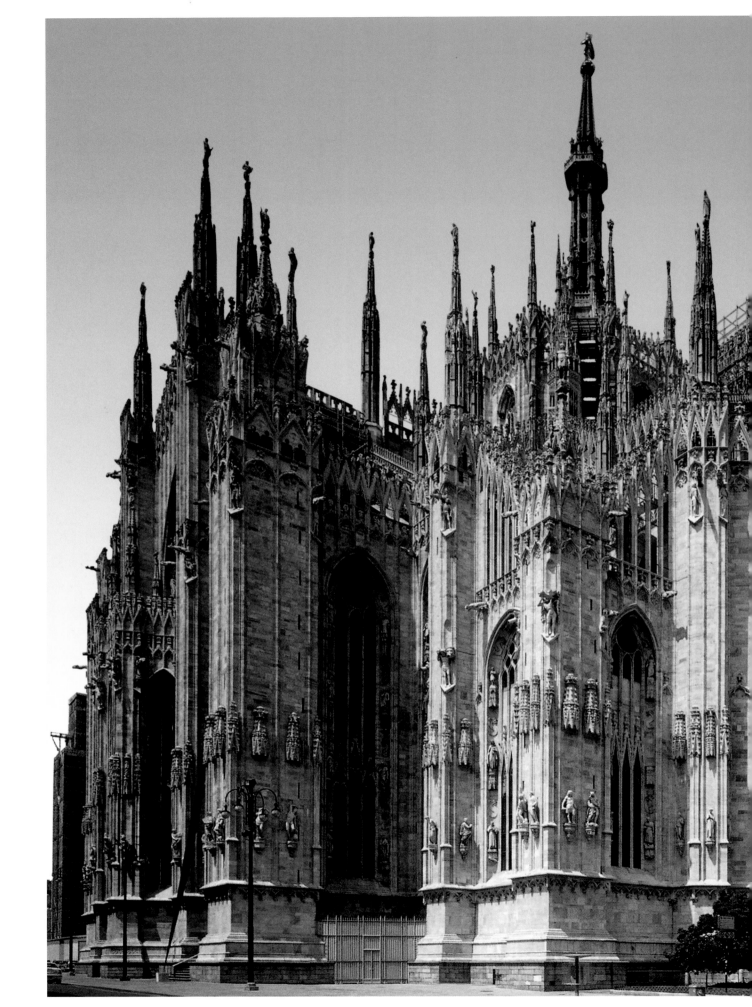

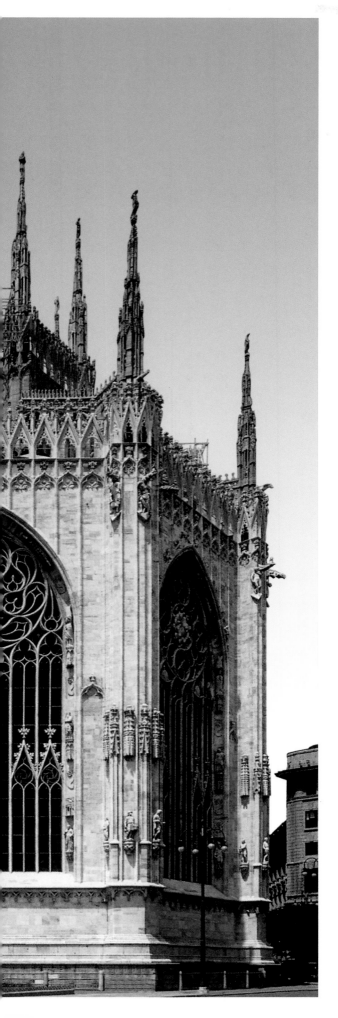

The Gothic in Italy

When the Gothic style came from Germany to Italy, it experienced a complete national transformation. That which had specifically marked the German Gothic – the extreme development of the joist system resulting in a ubiquitous tendency towards heights – was utterly ignored by the Italian master builders and simply not accepted; century-old building traditions were rooted too deeply for that. At first, the conditions of the Romanesque vault construction were mostly retained. That which was adopted from Gothic construction methods was actually little more than an external contribution to modernity. It is therefore hardly possible to speak of an Italian Gothic style as a closed system. The Mediterranean disposition with its natural feel for wide, medium height rooms and horizontal building mass structure remained unimpressed by the upward striving vaults; it altogether rejected the towers in which the German Gothic had found its aesthetic paragon. The Italians were all the more interested in all things decorative that the Gothic offered them. With childlike joy for the variety, delicacy and flexibility of these objects, they let their imagination run free. The new wealth of forms resulted in such splendid decorative creations as the façade of Siena Cathedral (see p. 79) and the somewhat simpler Orvieto Cathedral, which was modelled on the former.

The oldest Gothic building in Italy is the church of St. Francis in Assisi (1228-1253) (see p. 80-81), which holds the remains of the popular saint. The building features an upper church, the *Basilica Superiore*, and, a floor below, a lower church, the *Basilica Inferiore*. It is a double church that rises over a cross-shaped ground plan. The architect

61. Chevet, Santa Maria Nascente Cathedral, Milan (Italy), begun in 1386. In situ.

was Master Jakob, although French influences from Burgundy and Aquitania are palpable. This first Gothic work already illustrates how Italian notions were incorporated: there is a single nave of great width, large wall spaces holding frescos and a horizontal structure.

Inseparably connected to the church is the neighbouring monastery, Sacro Convento. The impulse to build this magnificent burial church came from Pope Gregory IX, who laid the foundation stone himself on 17 July, 1228. In 1300, the precious frescos were begun in the upper and lower church. They were renovated after being severely damaged in an earthquake. The church holds many art treasures, among them a masterpiece by Girolamo Romanino: the painting of the high altar from 1515. This proclivity for effusive amounts of pictorial décor comes strongly to the fore even in the most Gothic of Italian buildings, Milan Cathedral (see p. 76-77). Its interior design is closely related to the German cathedrals, yet the entire building is overgrown with a forest of statues.

The new method of construction was spread by the two newly founded orders of the Dominicans and Franciscans. They brought it to Venice, where the magnificent churches Santa Maria Gloriosa dei Frari (1250-1338) and San Giovanni e Paolo were built by the Dominicans and Franciscans respectively. They served as models for further churches on Venetian territory.

However, the new style had already gained a foothold in Florence. The abbey church of Arezzo, which was begun in 1277, and the delightful sacred building Santa Maria Novella, which was started in 1278, were already built in the new style. It was here, too, that the grandest house of God was to be erected, larger and more glorious than any other in Tuscany. In the year 1294, under the leadership of master builder Arnolfo di Cambio, the construction of the abbey church San Reparata began. The building became truly extraordinary. It resembles a three-aisle, ancient Christian basilica in Gothic form without vaults, featuring an open roof truss. The choir and the transept are connected in an octagonal crossing that carries a cupola. To three of its eight sides are niches in semi-octagonal form. Colourful marble ornamentation completes the decoration of the abbey. After di Cambio died, construction was continued by the greatest artist of the time, Giotto. He gave us the glorious, free-standing belfry which, architecturally, is of great restraint; his walls are interrupted only sporadically with windows and are richly decorated with colourful marble. Giotto died two years after he began his work, which is why the cupola was created by Brunelleschi from 1421 to 1434.

In Rome, the city of classical Antiquity, the Gothic could not really gain a foothold This is why only a single Gothic church, Santa Maria Sopra Minerva (begun in 1280) exists.

The end wall of Siena Cathedral is considered to be the most beautiful manifestation of Italian Gothic. In the second half of the thirteenth century, the city wanted to rebuild its old cathedral to demonstrate to the world its wealth and power, which it had acquired through trade in the second half of the thirteenth century. In 1284, Giovanni Pisano was commissioned to realise the end wall. He designed the plans and partially executed them, but construction was only completed in 1380, long after

62. **Giovanni Pisano**, Western Façade, Siena Cathedral, Siena (Italy), 1284-1299, finished after 1357. In situ.

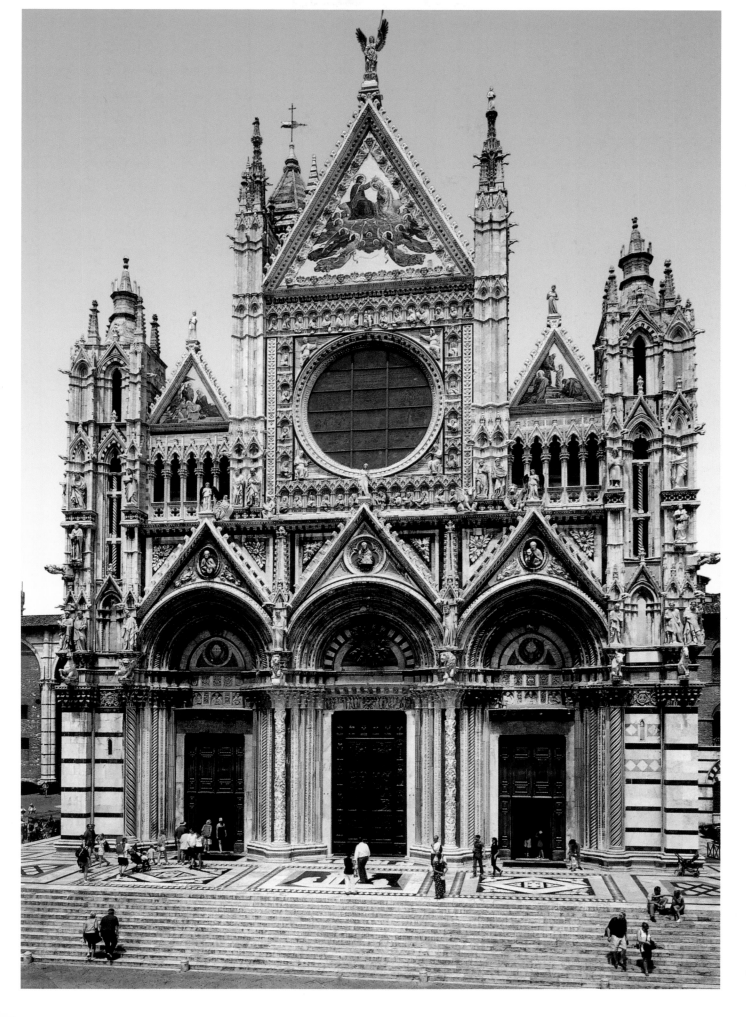

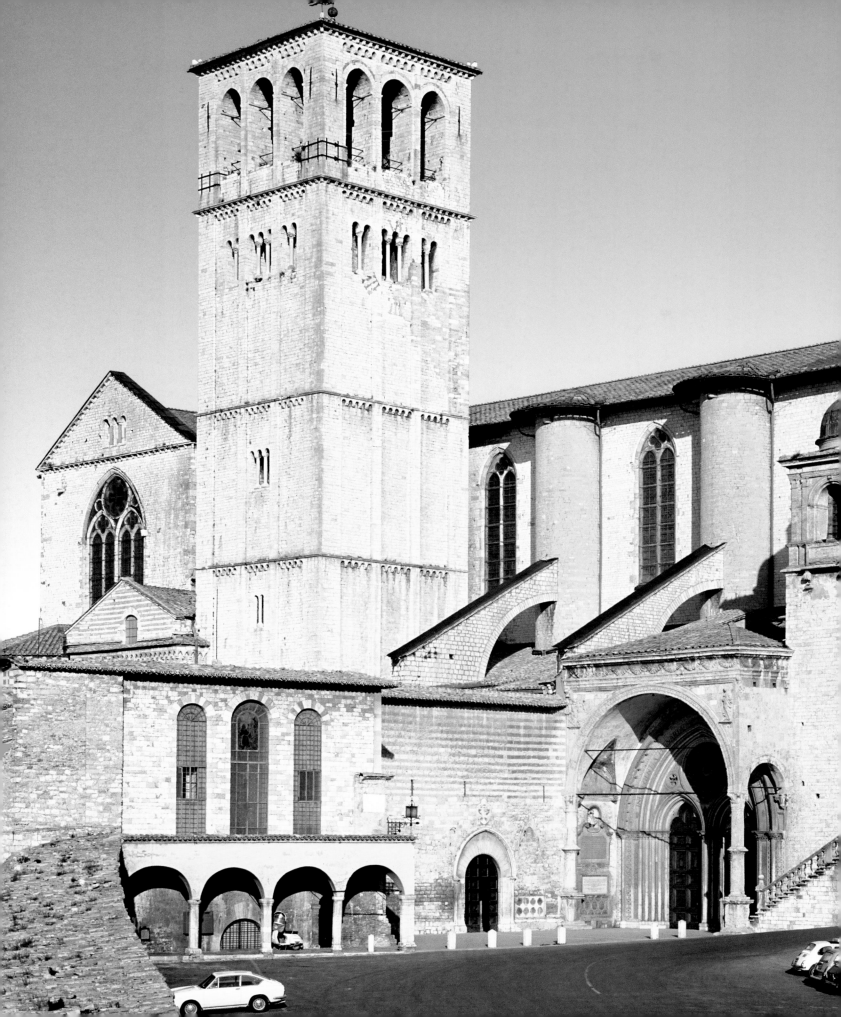

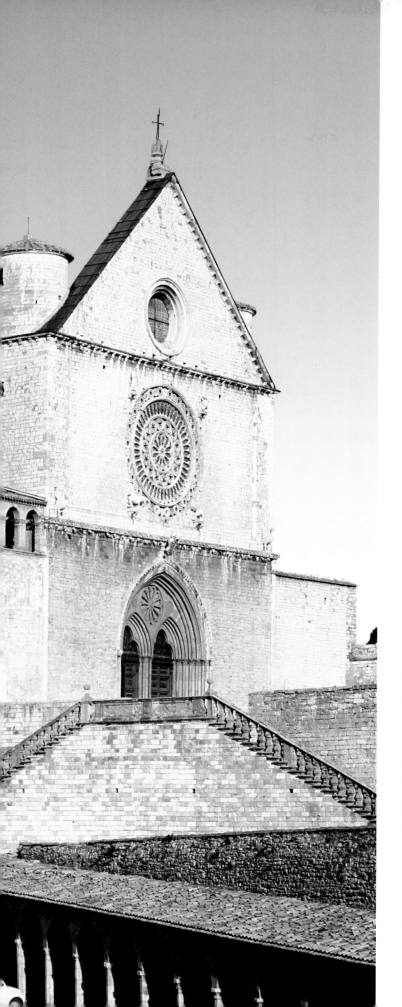

his death. For the exterior and interior of the cathedral layers of red, black and white marble were used, which created an impression of a striped building and emphasised the horizontal lines.

Orvieto Cathedral in Umbria deserves a mention. It was begun in 1310 by Lorenzo Maitani and its severe lines approach the northern Gothic architectural style. The decoration of the interior impresses with its glorious mosaic paintings.

Santa Maria Nascente Cathedral in Milan
In Lombardy, where the Gothic could not gain acceptance, the glorious Milan Cathedral was begun in 1386, a time when, elsewhere, this style was coming to a close (see p. 76-77).

Milan Cathedral, which is the fourth largest, five-aisled cathedral in the world, was most likely designed by German master builders. It was commissioned by Gian Galeazzo Visconti in 1386 as a monument to his great rule and power. In 1391, a famous German architect, Heinrich von Gmünd, was invited to Milan in Lombardy. He was probably the oldest of the master builder dynasty of Parler. The jealousy of his Italian colleagues soon had him leave Milan, but other German foremen would be recruited continually. Still, the Italians also had a certain influence on the design of the building, the completion of which would last to the start of the nineteenth century. Napoleon I eventually brought the undertaking to a close by finishing the façade with its approximately 4,000 statues according to an older, baroque design.

63. Basilica of St. Francis of Assisi, Assisi (Italy), 1228-1253. In situ.

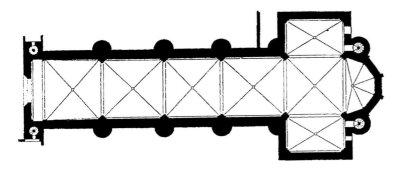

The Gothic Churches of Florence and Venice
The Dominican church Santa Maria Novella, the Franciscan church Santa Croce, and the cathedral Santa Maria del Fiore (see p. 83) are the Gothic churches in Florence of absolute Italian character. The seemingly restrained and severe church, Santa Croce, was created by Arnolfo di Cambio, who died in 1300. Di Cambio had also contributed to the first ground plan of the cathedral, which was later continued by artists such as Giotto and Filippo Brunelleschi, who is also known as Brunellesco. Giotto designed the glorious belfry, which, in true Italian tradition, is free-standing. It surpasses the beauty of the church itself with its structure and freedom of decoration. The cathedral's *pièce de résistance* is the cupola, which was created by Brunelleschi.

The Gothic in Venice developed a most peculiar character that stems from the population's predilection for the fantastic. Here, the sacral buildings, among which the Franciscan church Santa Maria dei Frari is the most striking example, are less important than the secular ones. The Doge's Palace (see p. 84), which was started at the beginning of the fourteenth and completed in the middle

of the fifteenth century, reveals a completely monumental feel without reducing the Venetian sense of décor. This seat of Venetian government features open halls that lead around both façades, something which became a real Venetian motif. It would reappear in fascinating, manifold variations in all private palaces of the fifteenth century, particularly those that face the Grand Canal. The greatest wealth, and at the same time the highest poverty, in Gothic ornamentation was manifested in the Palazzo Foscari (begun in 1453) and the famous Palazzo Ca'd'Oro (1421-1438), which was named after the original gold-plated façade. All of their floors are opened by airy arch formations.

Gothic Secular Buildings – Palazzi
The monumental secular buildings that were built throughout Italy during the dominance of the Gothic style reflect the military spirit of a belligerent time. This particularly holds true for the Florentine Palazzo Vecchio (1299-1314), which was the seat of the Signoria; and the Palazzo del Bargello (1255-1261), which was the palace of the chief of police. An example in Siena is the Palazzo Pubblico (begun in 1297) (see p. 85) which still has the appearance of a heavy, massive castle.

Milan's *Ospedale maggiore* (Great Hospital) is the most beautiful of Italy's brick built Gothic constructions. Its oldest parts were designed between 1456 and 1465 by the master builder, sculptor and architect Antonio Filarete, whose real name was Antonio di Pietro Avertino. Their decorative splendour competes with the Venetian buildings and even surpasses them in terms of artistic finesse. A characteristic of Gothic use in the Venetian

64. Plan of the upper church of St. Francis of Assisi Basilica, Assisi (Italy).
65. Santa Maria del Fiore Cathedral and Bell Tower, Florence (Italy), begun at the end of the 13th century. In situ.

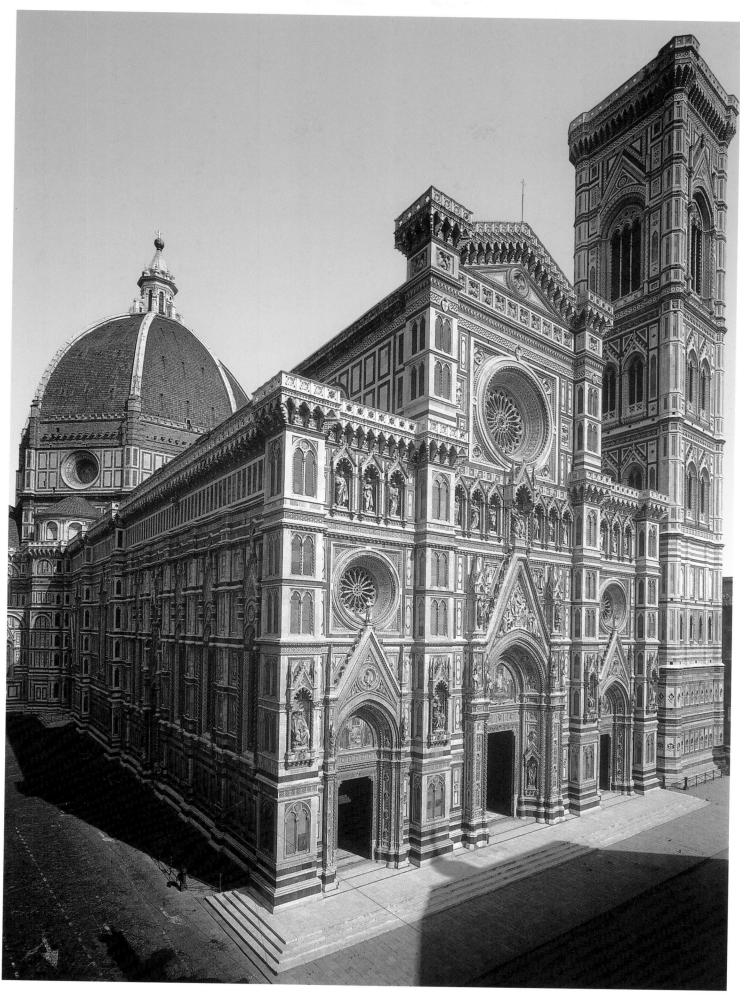

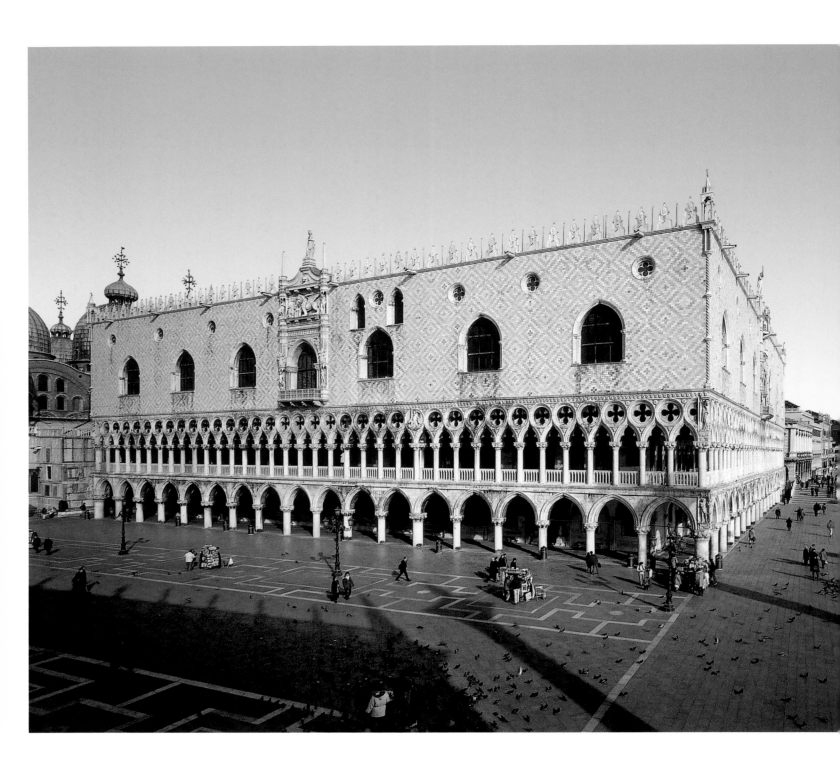

66. Doge's Palace, Venice (Italy), 1340-1365. In situ.
67. Piazza del Campo, Palazzo Pubblico and Torre del Mangia, Siena (Italy), Torre del Mangia: 1325-1348; Piazza del Campo begun after 1280 and
Palazzo Pubblico begun in 1297. In situ.

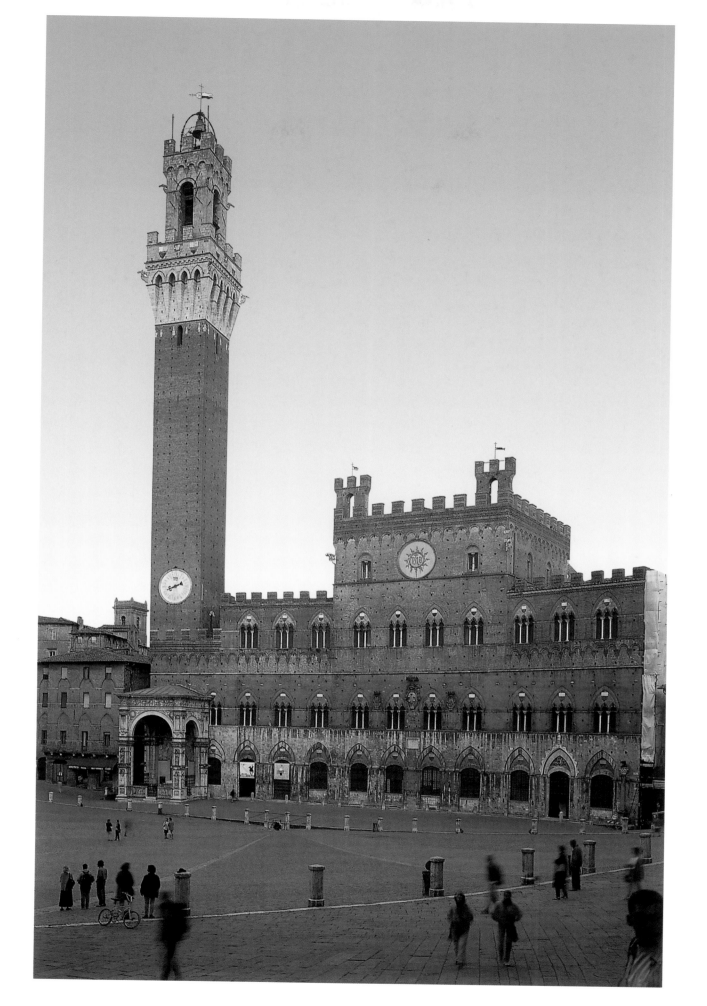

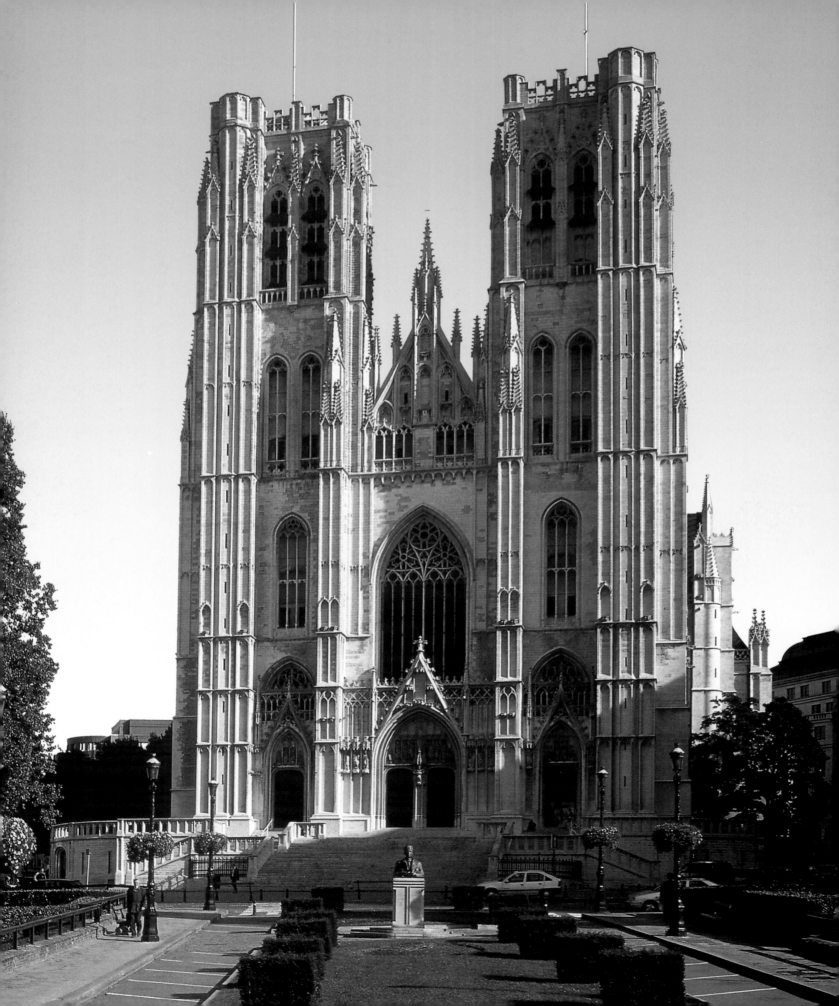

palaces are the pointed arches and the tracery that creates crossing half-circles or inflexed arches.

The Palazzo Ca'd'Oro and the Palazzo Foscari are astonishing examples of the use of such decoration in Italian Gothic secular architecture.

The Gothic in Belgium and the Netherlands

Ecclesiastic architecture in the Gothic style developed less independently in the Netherlands than it did in Germany. The southern part, which is today's Belgium, was entirely under French influence, while the northern part, today's Netherlands, followed German models. The reasons for this lie in the geographic situation as well as the heritage and history of the population.

The oldest Gothic church in Belgium is the SS. Michael and Gudula Cathedral in Brussels (see p. 86), which began construction in 1226. Despite its long construction period of almost 300 years, it was planned and executed entirely in the French spirit. During the later development of the Gothic in Belgium, French and German influences commingled.

From this mixture rose the main work of the Belgian Gothic and the largest church in Belgium, the Cathedral of Our Lady in Antwerp. Construction began in 1352, finished in 1521 and shares the same fate as Strasbourg Cathedral, having only one completed tower of the western façade. This individual and splendid tower shows in its deliberate deviation from the German pyramid-form that late Belgian Gothic attained certain independence.

Belgian secular architecture already achieved this independence at an earlier time.

The rich trading towns of Brabant and Flanders, where many of the world's most precious goods were stored, strove to reveal their wealth in great market halls and town halls. The extent and energy of their pursuit exceeded even that of their German neighbours. Each town insisted on its own symbol of power, its own *Beffroi* (see p. 89) (Belfry), which was a square tower that usually culminated in a slender, open spire. The town halls of Bruges, Brussels and Leuven and the Cloth Hall (1280-1304) in Ypres, which was heavily bombed in World War I, are monuments to their townsfolk's pride. Their dazzling, picturesque effect and the obvious wealth of their plastic décor bear witness to the love of splendour and the strongly developed artistic sense of those that built them. All these immense structures are made of stone, while in the Netherlands, where sober, practical sense held artistic interests in check, the main building substance was brick. Regardless of the intentional simplicity of their exterior, the Dutch churches have a strong monumental effect on their beholder, due to the spaciousness of their interiors. In their overall character they correspond closely with the German Gothic, the only difference being the complete bareness of the immense halls. This whitening of walls and the end of church building in Holland are the work of fanatical iconoclasts in the sixteenth century.

The Gothic in Scandinavia

Gothic architecture's character in Scandinavia developed similarly to that of the Netherlands, yet it never took on

68. Western Façade, SS. Michael and Gudula Cathedral, Brussels (Belgium), c. 1400-c. 1475. In situ.

69. Town Hall, Arras (France), 1450-c. 1572. In situ.
70. Belfry, Bruges (Belgium), constructed between the last third of the 13th century and 1486. In situ.

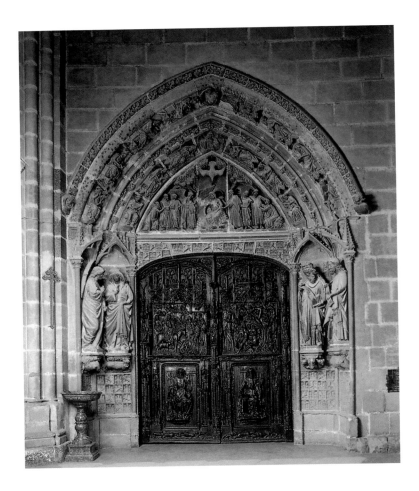

With the exception of Navarra, the Gothic took hold very slowly in Spain. Only in the thirteenth century did the first truly Gothic, or even high Gothic, buildings appear. Two fundamentally different uses of form collide: firstly, the decorative *estilo isabelino* (Isabella Style) with its rich decoration, which gave Spanish art of the time its own national character; secondly, the monumental, severe Gothic style. In the fourteenth and fifteenth centuries, foreign, mostly German or Flemish master builders, constructed churches and cathedrals in Castille. On the Balearic Islands hall churches appeared, which either had one nave or several aisles of equal height with either a groin vault or a wooden ceiling supported by diaphragm arches. Plain walls give the uniform church room a severe appearance without diminishing the harmonious effect that comes from its clarity and width.

Secular buildings followed the same principles. The trade halls in particular demonstrate extraordinary harmony and perfection of spatial proportions.

Spain's Gothic churches are clearly influenced by the French style. The greatest examples are Burgos Cathedral (1221-1765) (see p. 90), which was declared a world heritage site by UNESCO, the cathedral Santa Maria in Toledo (13th-15th century), and the cathedral Maria de la Sede in Seville. Only the spacious design of the interior and the larger, at times, almost excessive ornamentation, which often incorporates Moorish decorative forms, bespeak the lively spirit of the south. Eventually, the German form of the open pyramid spire would be

national traits. Norway, where the Trondheim Cathedral is the central Gothic work, was under English influence. In Sweden, on the other hand, it was French master builders who introduced the Gothic style, just as they had done in Germany. In 1287 they began with the construction of Uppsala Cathedral, which would be renovated at the end of the nineteenth century. However, this building did not significantly influence the course of later developments because the Swedes would eventually follow the brick-building style, as it was practised in nearby northern Germany.

71. Portal of the Cloister, south-side of the transept, Burgos Cathedral, Burgos (Spain), begun in 1221. In situ.

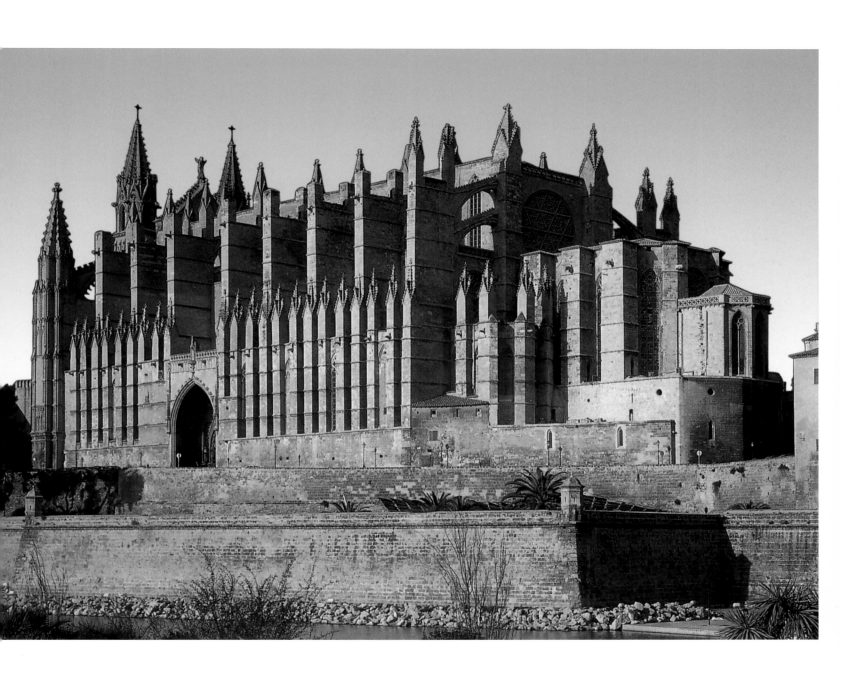

72. **Berenguer de Montagut**, St. Mary Cathedral, Palma de Mallorca (Spain), begun in 1229. In situ.

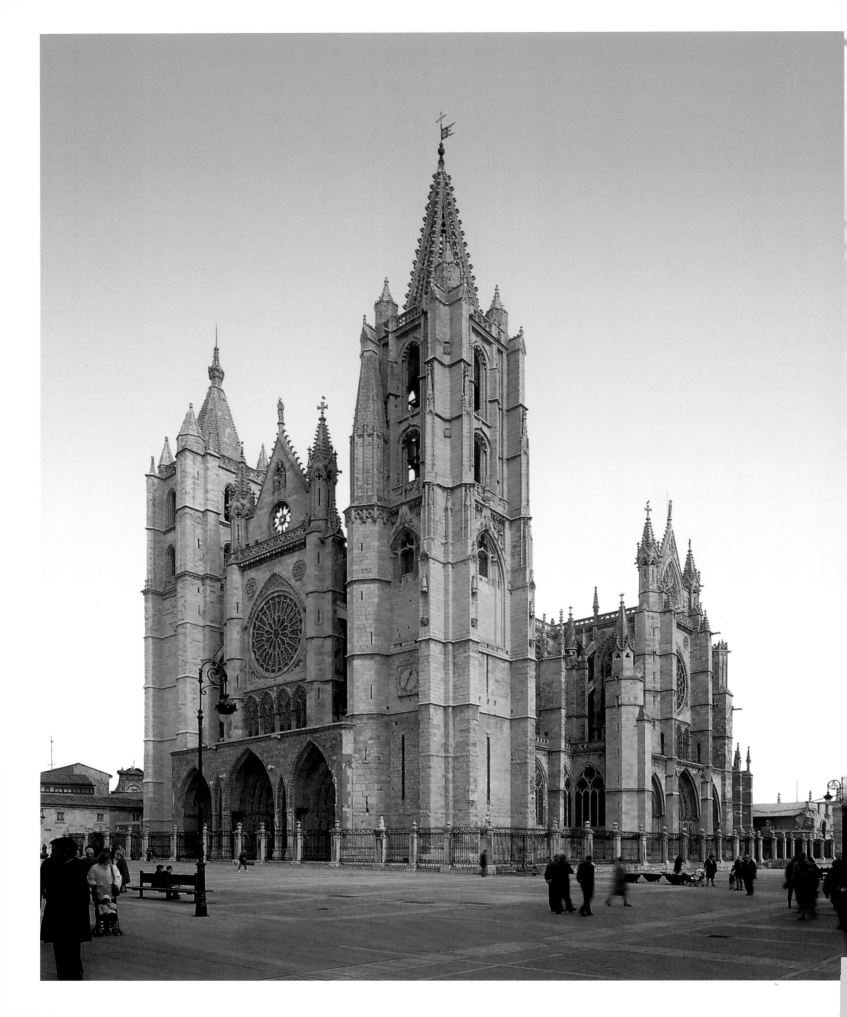

accepted in order to further increase the fantastic splendour of the Spanish cathedrals. Spain's most beautiful towers, those of Burgos Cathedral, were built by Master Johannes of Cologne. However, practically all ecclesiastic and secular buildings profess a strong oriental character, which goes back to the Mudejar style with its horseshoe arches and decorative brickwork. In Aragon a whole series of buildings feature this style; today they are all UNESCO world heritage sites.

The decorative *estilo isabelino* (Isabella Style) with deserves special mention, was built at the end of the twelfth century in the centre of Toledo's Jewish quarter and was most likely designed by a French master. Its most interesting feature is its chevet, which dates back to the twelfth century and demonstrates entirely new building methods. For the first time, a doubled semicircular ambulatory appears structured into alternating triangular and rectangular sections. The five aisles of almost equal height, which were built during the second phase of construction, are a further characteristic that rendered this church a national model and delineated it clearly from the spatial conceptions of the French Gothic.

Cuenca Cathedral, which was built in the first half of the thirteenth century, is one of Spanish Gothic's oldest works. Medieval cathedrals often had a more military appearance than a religious one and were frequently used for that purpose. This was also the case with Siguenza

Cathedral, particularly its façade. The cathedral's interior bears witness to its Romanesque origin and its Gothic completion. The builders of the cathedral found an original solution, which was also used later during the Renaissance: by reinforcing the supporting pillars and rearranging them horizontally, the impression of two consecutive buildings arose. A further example of Spanish Late Gothic in the *estilo isabelino* is Alcalà Cathedral. Its typical ambulatory served as a model for Toledo Cathedral.

The few Gothic monuments in Portugal bear similar features to the Spanish, but profess a greater splendour in ornamental design of the façades. The most magnificent is the Abbey of Batalba with the added mausoleum of Prince Manuel. It shows the most daring play of Mediterranean decorative forms and at the same time marks the collapse of the Gothic.

73. León Cathedral, León (Spain), begun in 1205. In situ.
74. Plan of León Cathedral, León (Spain).

Gothic Painting

The Gothic started in France, but influenced all of Europe, particularly Germany, Italy and the Netherlands. The complex filigree architectural style was echoed in the reliquaries of the times, which were ornately decorated by sculptors.

Whenever the Gothic is mentioned, the first thought naturally goes to the architecture of the period. Just as music, literature and philosophy were almost exclusively determined by spiritualisation and the longing for God, painting, too, features almost exclusively religious motifs. In the Romanesque period large wall spaces were filled with monumental frescos. The relatively narrow walls of Gothic architecture no longer afforded room for such extensive wall paintings. This is why Gothic paintings are often small.

The most important event in painting during this period was the emergence of panel painting, which soon developed into an independent art form that was free of architecture and featured its own rules. Painting was of secondary importance in the creation of altar shrines, where it was initially employed. Wooden sculpture assumed the main role of depiction in these altars. The countless figures looked more like paintings than plastic artworks. Painting in turn originally took a secondary role, but began to compete with sculpture by depicting figures in as plastic a way as possible, but without making use of the power inherent in colour.

Since money only came from princely courts or the clergy, most reredos were painted on wooden panels – hence the name "panel painting". This new style of painting asserted itself from the fourteenth century. The altarpieces were hinged in such a way that their wings could be opened and closed. Most often these "winged altarpieces" came in the form of diptychs with two panels, or triptychs with three. The polyptych, with several panels, was much rarer. The dimensions of these altarpieces varied from large and solid to small wooden, or ivory, house altars and travel altars.

75. **Giotto di Bondone**, *Madonna and Child Enthroned with Angels and Saints*, known as *Ognissanti Madonna*, c. 1310. Tempera on wood panel, 325 x 204 cm. Galleria degli Uffizi, Florence (Italy).

This construction was derived from reliquaries. Relics played a significant role in the mystical views of the time. Originally their receptacles had been simple boxes; the use of precious metals only came later. Eventually these simple boxes transformed into mini-cathedrals studded with plastic ornamentation and precious stones. In the Gothic, these shrines were crafted from wood and covered with paintings. The most beautiful example is *The Shrine of St. Ursula* (1489) (see p. 97) by Hans Memling. A winged altarpiece was only ever opened on feast days to show the faithful their precious contents. During weekdays it remained closed. The wings carry biblical imagery both outside and inside. The most famous retable is the *Ghent Altarpiece* (1432) (see p. 98-99) by Jan and Hubert Van Eyck.

Earlier descriptions of these paintings as "primitive" usually referred to the form of expression and the powers of imagination, but not to the quality of the images themselves, as in the case of the *Bartholomäusaltar (Altar of St. Bartholomew)*. Nevertheless, many other works are still somewhat clumsy and use loud colours mostly on a golden background, which gives them more art-historic than artistic value. The paintings often depict scenes from the Bible, such as Judgement Day, purgatory, or the realistically depicted martyrdom of saints. It seems as if such events had been common back then. In these times of feuds and quarrels, of robber barons and the inquisition with its persecution of heretics, the church tried to use terrifying visual depictions to instruct and deter; these negative depictions were juxtaposed with Heavenly glory.

The opposite of these terrifying depictions were graceful images of the Madonna by Hans Memling, Martin Schongauer or Rogier Van der Weyden. In later pictures of the Madonna, such as those from the Renaissance, less emphasis was placed on grace than on motherliness. This is why there is no difference in the quality of depiction, but a change in style. The paintings by Jan Van Eyck, Stephan Lochner or Rogier Van der Weyden are of such high artistic significance, it is astounding that such perfection was possible at the beginning of oil painting.

Secular motifs are hard to find in the paintings of those years; common living quarters hardly featured any paintings at all. Images of flowers, still lifes or landscapes were virtually unknown and portraits were only known as inclusions in religious paintings of donators, who gave them to the church. Therefore, it was mostly councillors and mayors, sometimes even with their wives, who were integrated into a group, or devoutly kneeling in a corner of the painting.

Gothic Painting in Germany

Master Bertram, sometimes also referred to as Bertram of Minden after his birth place, was one of the earliest Gothic painters in the fourteenth century. He created the *Grabow Altarpiece* (1383) (see p. 101), named after the place where it stands, St. Petri church in Hamburg. Little is known about his biography. He probably learned his art in Prague, lived in Hamburg after 1367, and also produced a *Passionsaltar (Passion Altar)* between 1390 and 1394.

Another of the early Gothic painters was a master from Hohenfurth in the fourteenth century. Nothing at all is known about his life. His famous picture, *Geburt Christi (Birth of Christ*, before 1350), is in the Národní Gallery in Prague. It is one in a series of nine panel paintings about

76. **Hans Memling,** *The Shrine of St. Ursula,* 1489. Oil on panel with gilding, 87 x 33 x 91 cm. Hospitaalmuseum, Bruges (Belgium).

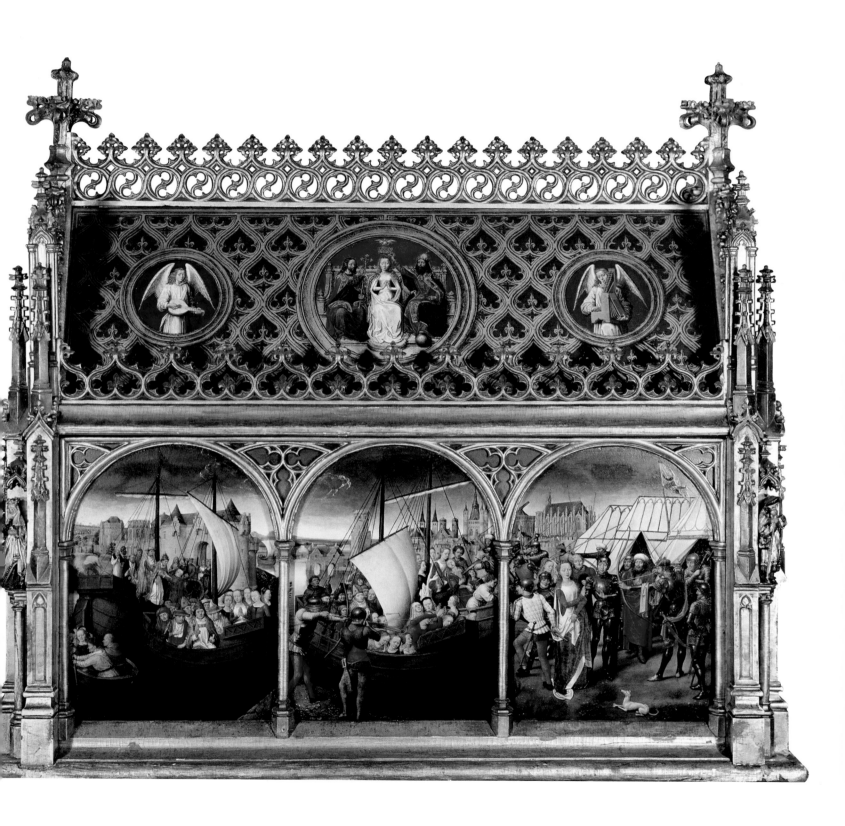

77. Hubert and **Jan Van Eyck,**
Triptych of the Adoration of the
Mystic Lamb, known as *The Ghent*
Altarpiece, 1432. Oil on wood
panel, 350 x 461 cm.
St. Bavo Cathedral,
Ghent (Belgium).

the life of Christ, which were originally intended for the Cistercian monastery *Vyssi Brod* in the Czech Lands.

Conrad von Soest, or, in the spelling of his day, Conrad van Sost, was probably born in Dortmund. Around 1420 he created the *Marienaltar* (*St. Mary's Altar*) in Dortmund (see p. 100), which fell into the hands of unwitting eighteenth-century craftsmen. In an effort to fit it into a 16m tall reredo, they simply cut it to size with saws and hammers. During World War II it was destroyed in a bomb attack. Another of Conrad von Soest's major works was the 1403 altar in the *Stadtkirche* (City Church) in Bad Wildungen.

The Master of the *Wittingau Altar* received his name from the altar he created around 1380-90 for the Augustine monastery church, St. Egidius, in today's Treboò, formerly Wittingau. The three panels depicting Christ's passion – Christ on the Mount of Olives, resurrection and burial – have survived.

Of Master Theodoricus, or Theoderic of Prague, only an approximate date of death is known: March, 1381. He was court painter under Emperor Charles IV who commissioned him with a cycle of panel paintings. Theodoricus also painted the portraits *Der schreibende Heilige Gregor* (*St. Gregory Writing*, c. 1370) and *Der ein Buch öffnende Heilige Hieronymus* (*St. Jerome Opening a Book*, also c. 1370).

Another major figure among the important painters of the Late Gothic is undoubtedly Martin Schongauer, who is also called Martin Schön, Bel Martino or Beau Martin. He received his schooling in the workshop of his father, Caspar Schongauer, a goldsmith from Augsburg. His exact date of birth is unknown; the first documented evidence for his biography is his student registration at Leipzig University, which he attended from 1466 to 1467. It is plausible to assume that for some time after his studies he travelled, probably as far as Beaune in Burgundy to look at the *Polyptych of the Last Judgement*

78. **Conrad von Soest**, *Dortmund Altarpiece: Death of the Virgin* (central panel), c. 1420. Oil on wood, 141 x 110 cm. Marienkirche, Dortmund (Germany).
79. **Master Bertram**, *Grabow Altarpiece*, 1383. Oil on wood, 277 x 726 cm. Kunsthalle, Hamburg (Germany).
80. **Robert Campin (Master of Flémalle)**, *The Virgin and Child before a Firescreen*, c. 1440. Oil with egg tempera on oak with walnut additions, 63.5 x 49 cm. The National Gallery, London (United Kingdom).
81. **Stefan Lochner**, *Madonna in the Rose Garden*, c. 1440. Oil on wood, 51 x 40 cm. Wallraf-Richartz-Museum, Cologne (Germany).

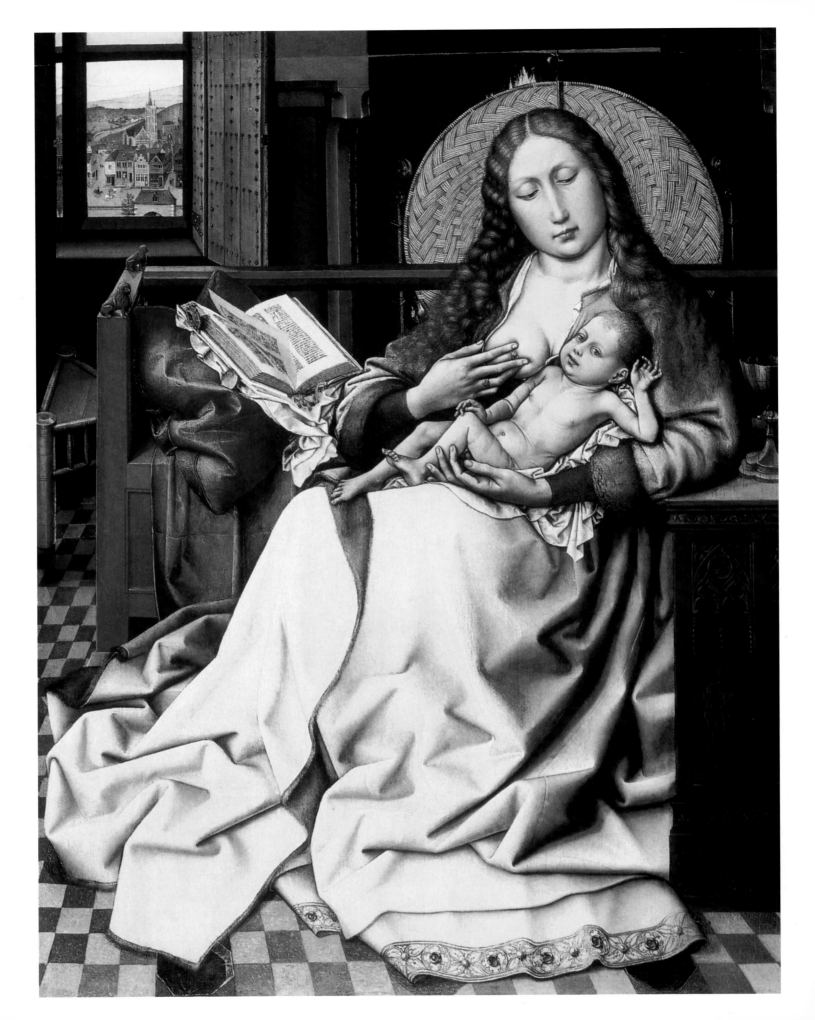

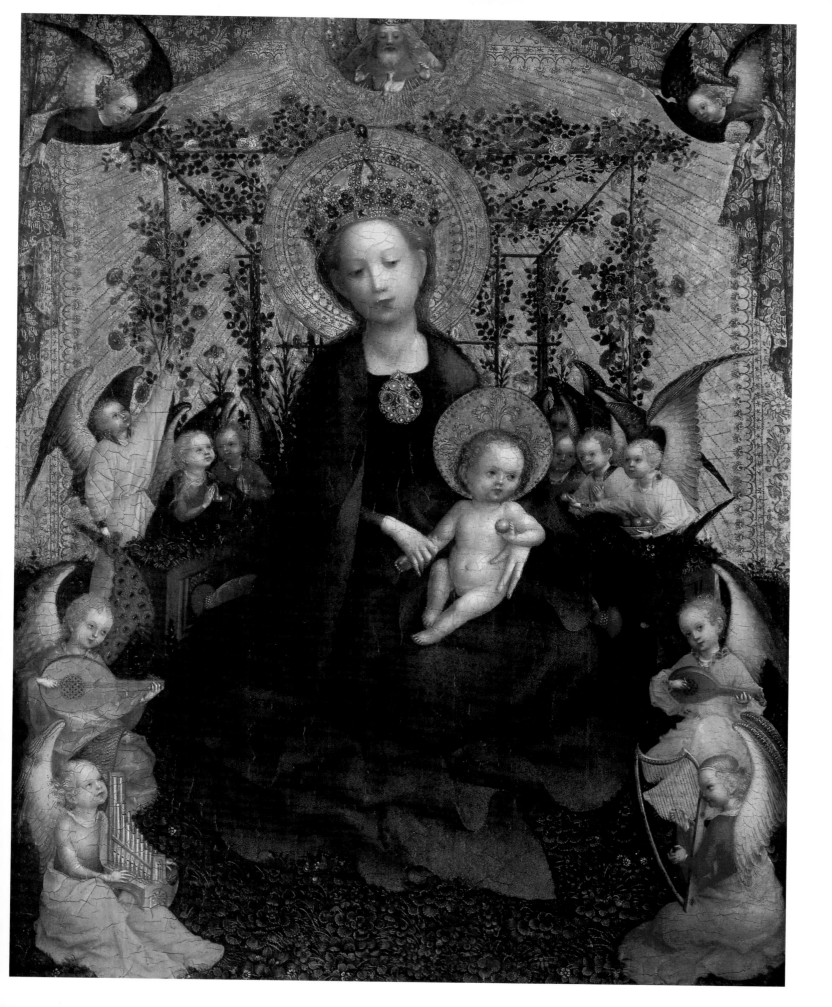

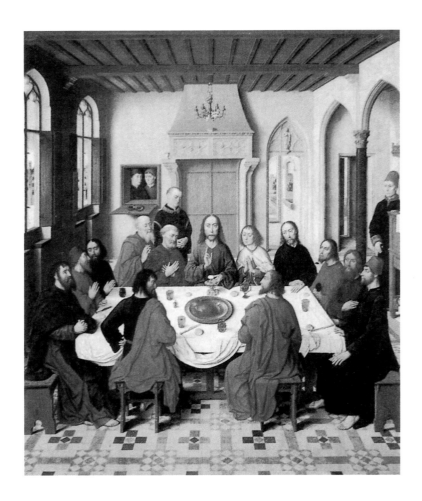

Equally important are his copper etchings such as his twelve leaves series on the *Passion Christi* (*Passion of Christ*, 1470-1480) or the copper etching *Die Anbetung der Heiligen Drei Könige* (*The Adoration of the Three Kings*) which was created before 1479; all of which influenced Albrecht Dürer.

The Cologne School

The beginnings of the new painting style in Cologne are closely connected to a certain Master Wilhelm (until 1378), who was in the services of Cologne's council. He painted works of all kinds and sizes: wall paintings, images for standards and pennants, and miniatures for written books. For the times, his accomplishments must have been extraordinary, since a contemporary historian, the chronicler of the city of Limburg on Lahn, mentioned the artist and his works with an enthusiasm not typical for a chronicler.

"There was none like him in all of Christendom," he said, and added, "He painted everyone, as though they were alive." And yet imitation of reality was not the aim of and reason for the Cologne school of painting; instead, its members tried to remove nature from the harshness of reality with poetic idealism. Of Master Wilhelm's own works only a few are preserved in the upper hall of the town hall. The heads of his Nine Worthies, which he painted as ideals worth emulating, are today housed in the museum of Cologne. However, many of the panel paintings which are preserved were created either by him or later students from the painting school that he founded.

by Rogier Van der Weyden (see p. 112-113). In any case, the latter's motif of the Judge appears on several of Schongauer's sketches. After 1471 he lived in Colmar again, where he opened a workshop. His paintings have a soft, almost lyrical tone, as can be seen in his *Maria im Rosenhag* (*Mary in the Rose Bower*, 1473), *Anbetung der Hirten* (*Adoration of the Shepherds*) and *Porträt einer jungen Frau* (*Portrait of a Young Woman*), both of which were painted between 1475 and 1480.

82. **Dirk Bouts,** *Altarpiece of the Holy Sacrament: The Last Supper,* 1464-c. 1467. Oil on panel, 180 x 150 cm, Sint-Pieterskerk, Louvain (Belgium).
83. **Dirk Bouts,** *Diptych of the Justice of the Emperor Otto III: The Ordeal by Fire,* between 1471 and 1475. Oil on wood, 343 x 201 cm. Musées Royaux des Beaux-Art de Belgique, Brussels (Belgium).

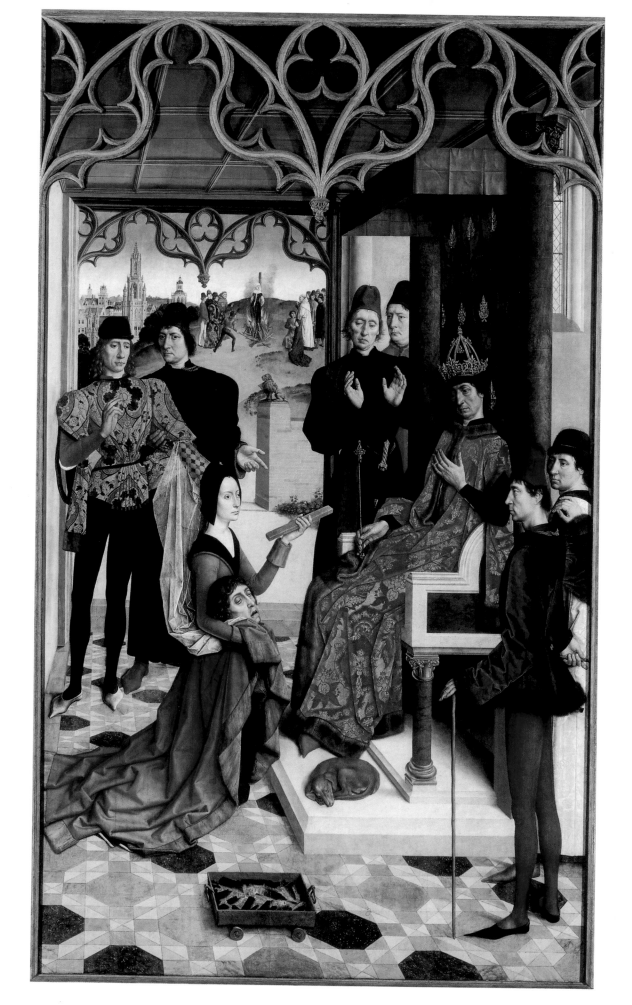

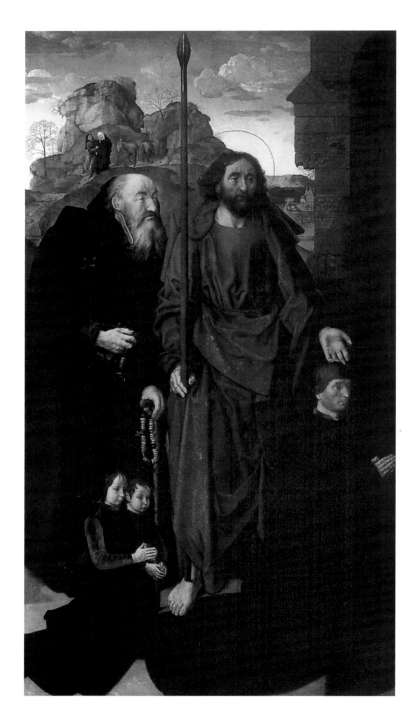
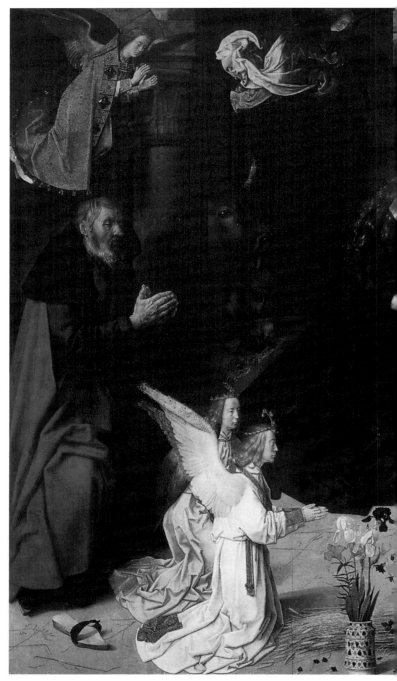

84. **Hugo Van der Goes**, *Portinari Triptych: Adoration of the Shepherds, Tommaso Portinari and his Wife, with their Patron Saints,*
between 1473-1478. Oil on wood, central panel 253 x 304 cm, left and right panels 253 x 141 cm each. Galleria degli Uffizi, Florence (Italy).

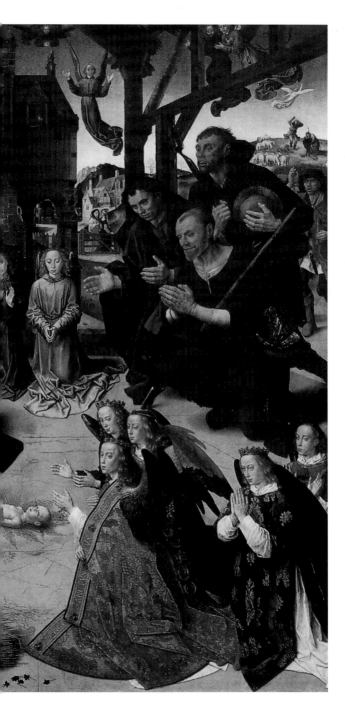

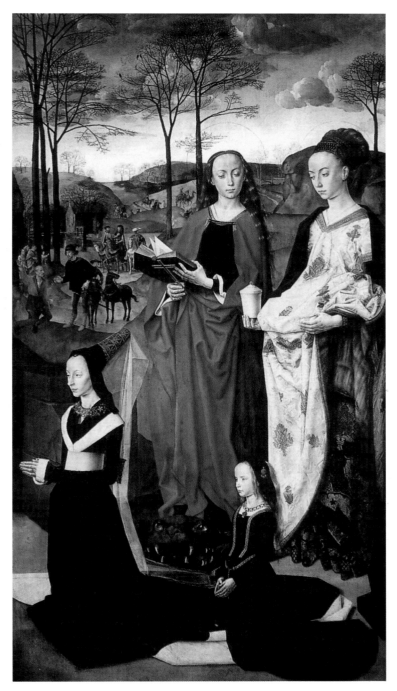

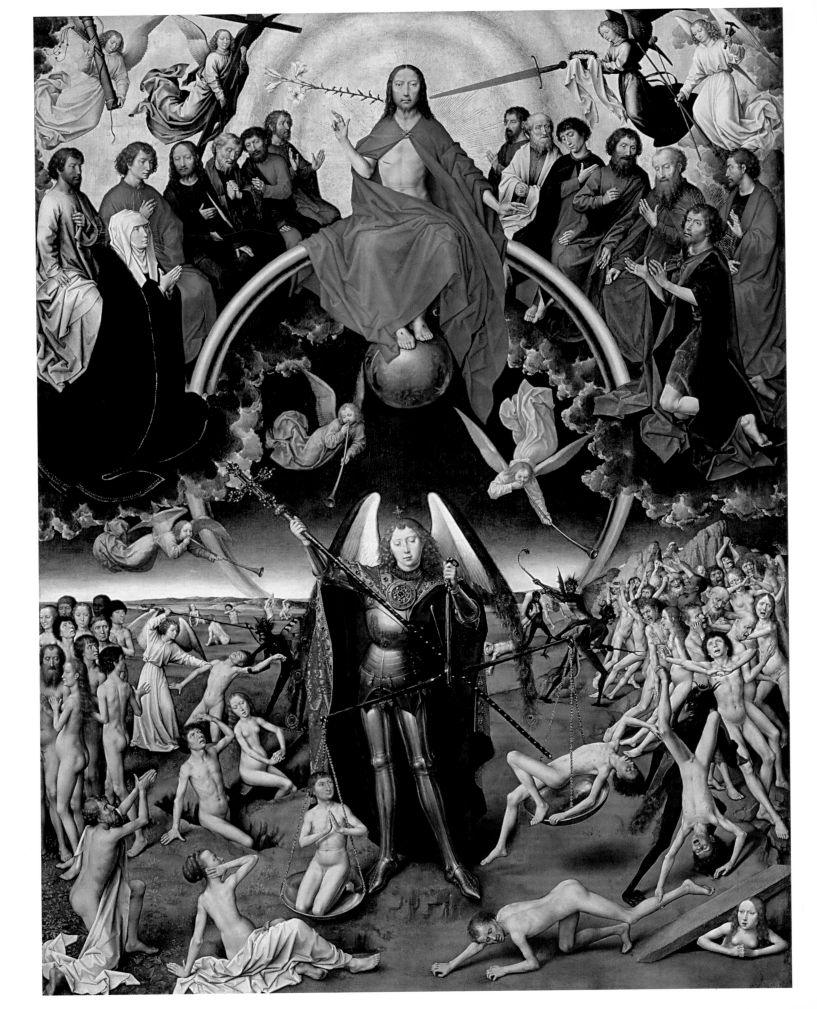

If he himself had no hand in these paintings, then his spirit certainly endures in them. With the exception of a large altarpiece from *Klarakirche* (St. Claire Church) in Cologne that depicts the life of Christ (now in Cologne Cathedral), they are all small devotional pictures which were painted as décor for the altars in the house chapels of Cologne patricians. Extensive carving work of architectural character would have been out of place in these tight spaces.

With this development, painting became more important and the artists were able to speak eloquently to the faithful. Painting's natural language was quickly understood in the depiction of Mary alone, who to medieval man had become more worthy of devotion than Christ Himself. The half romantic, half crudely sensual cult of the feminine had so closely merged with the adoration of Mary, that the divine and the profane could no longer be separated. The painters of Cologne made it their indefatigable goal to depict an ideal Mary that also corresponded with their personal ideal of womanhood. They eventually had the satisfaction of seeing the lovely gracefulness of their paintings imitated by later masters, but hardly ever surpassed. These works brought the spiritual movement that had begun with minnesong, courtly epics, and religious didactic poetry to a close. The 'spring' of minnesong found its painterly equivalent not in the miniatures of the older manuscripts, but in the images of the Cologne school of painting. Each flower, each blade of grass was rendered true to life by the Cologne masters, who added these painstakingly gathered treasures as if they were threads of a woven carpet, which they spread beneath the feet of the blessed Mother of God.

Because of this poetic urge, painting developed earlier than drawing, and intensity of feeling came before expression of character. The Madonna herself vanished into an impersonal figure that usually represented the popular ideal of beauty; the depiction of her naked child, however, increasingly demonstrated a lack of anatomical knowledge. These shortcomings were more than compensated for with painterly appeal. For the first time the contrast of light and shadow appears, and paint becomes lighter or darker, depending on how much or how little it was exposed to light. From this game of opposites arose the accomplishment of modelling, which hitherto had been a prerogative of sculpture.

85. **Hans Memling**, *Triptych of the Last Judgement* (central panel), c. 1467-1471. Oil on wood, 242 x 360 cm. Muzeum Narodowe w Gdańsku, Gdańsk (Poland).
86. **Conrad von Soest**, *The Wildunger Altarpiece*, c. 1403. Oil on panel, 158 x 267 cm. Bad Wildungen Church, Bad Wildungen (Germany).

Cologne's churches and museums hold most of the school's major works, which are separated into an old and a new school. The old school began with Master Wilhelm: he created a small, winged altar that features, in its centre, the *Madonna mit der Bohnenblüte* (*Madonna with Bean Flower*), with St. Catharine on the left wing and St. Barbara on the right. A similar *Madonna mit der Bohnenblüte* can be found in the *Germanische Museum* (Germanic Museum) in Nuremberg; another *Madonna mit dem Kind* (*Madonna with Child*), who is surrounded by female saints on a flowering meadow, is in the collection of Museum of Berlin; there is also the *Heilige Veronika* (*St. Veronica*) with the face-cloth of Christ in the *Alte Pinakothek* museum in Munich. All these images are as characteristic of Cologne's old school as they are of their environment.

The main exponent of the new school was Stephan Lochner who came from Meersburg at Lake Constance but moved to Cologne early in his career. Archival documents show that he worked frequently for Cologne council and seemed to have been wealthy. It is possible that he became one of the countless victims of the plague that ravaged Cologne in 1451. In 1435, he had painted *Judgement Day*, which features a multitude of figures. In 1440, he created his *Dreikönigsaltar* (*Altar of the Three Kings*), which was originally consecrated in 1462 for the chapel of the town hall, but which is now housed in Cologne Cathedral. The inside of the altar's left panel shows St. Ursula with her retinue; the central panel features the *Adoration of the Kings*; and the inside of its right panel contains St. Gereon with his companions, the martyrs of the Theban legion. In 1810, it was moved to *Agneskapelle* (St. Agnes Chapel) in the cathedral. By the fifteenth and sixteenth century the painting had become so famous that Albrecht Dürer when he stayed in Cologne on his journey to the Netherlands in 1529 sacrificed two silver pennies to have Master Stephan's panel opened. When the wings are closed, their exteriors show the Annunciation of Mary with the angel to the right and the blessed virgin to the left as she kneels on the prie-dieu of her chamber. Among Lochner's later works are *Geburt Christi* (*Birth of Christ*, 1445), *Darbringung im Tempel* (*Offering in the Temple*, 1447) *Madonna im Rosenhag* (*Madonna in the Rose Garden*, c. 1440).

When Cologne's bishop miraculously brought the relics of the Three Kings – the highest patron saints of the city – the noblest among the saints that were of particular importance to Cologne had been united. Master Stephan applied all his skills to the middle panel, which, in terms of glorious colours and subtlety in terms of painterly treatment, surpassed everything that painting of the time had to offer, including Italy. All details are executed with the same amount of love: the heads, which already show a variety of characterisation; the splendid clothes that were fashionable at the time; the weaponry; the precious gifts, which the Magi brought from the East; the carpet that angels hold behind the Madonna; as well as the flowers and plants that grow from the grass. These single impressions and the overall harmony of the piece – the poetic mood that irresistibly and powerfully communicates with the viewer – are all due to the use of colour. The golden background and the rich tracery of the row of arches that concludes the tops of the images are the only reminders of the role that architecture and sculpture had played in such altarpieces up until this point.

Cologne's older school of painting reached its peak in the *Kölner Dreikönigsaltar* (*Cologne Altar of the Three Kings*).

87. **Dirk Bouts,** *"Pearl of Brabant" Altarpiece: Adoration of the Magi* (central panel), c. 1470. Oil on wood, central panel 62.5 x 62.5 cm. Alte Pinakothek, Munich (Germany).

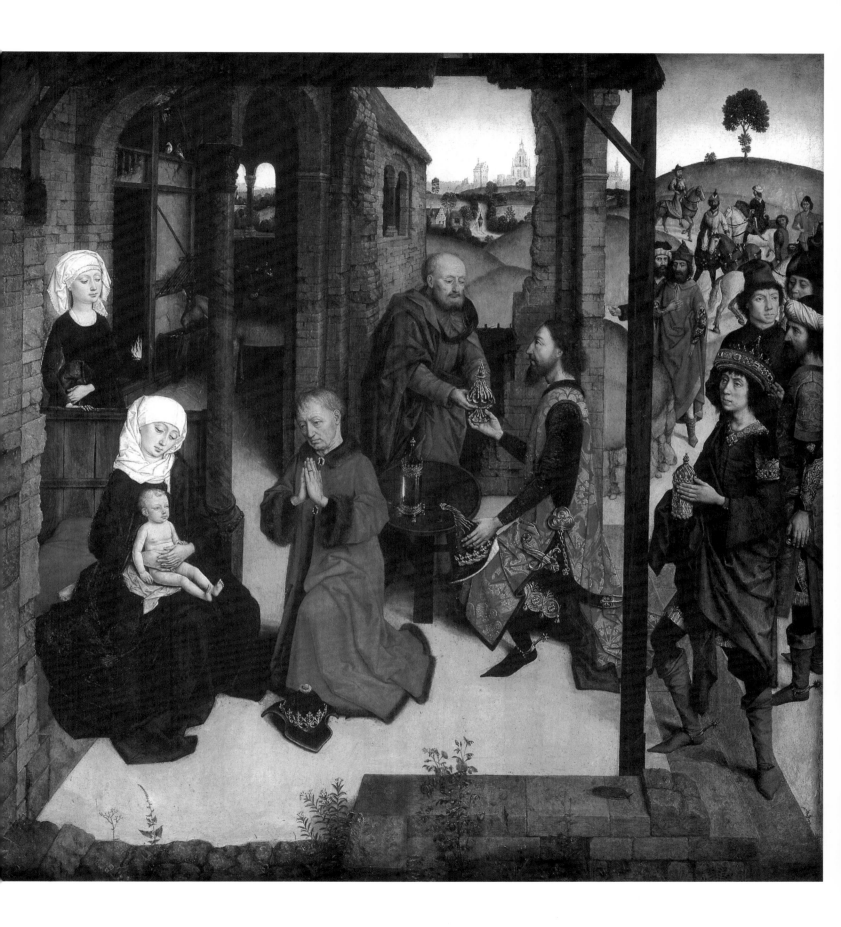

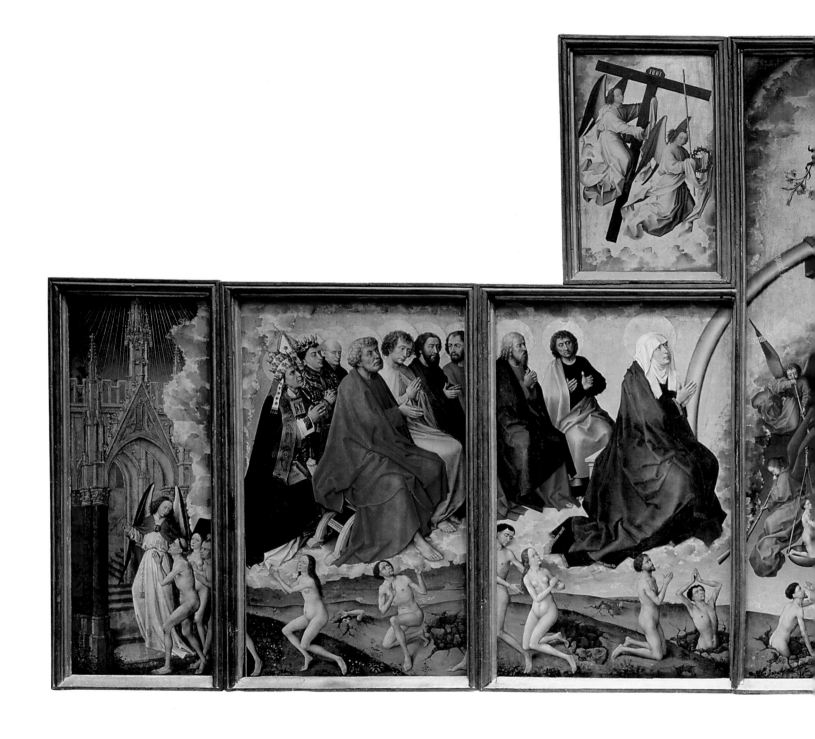

88. **Rogier Van der Weyden**, *Polyptych of the Last Judgement,* c. 1443-1450. Oil on wood, 135 x 560 cm. Hôtel-Dieu, Beaune (France).

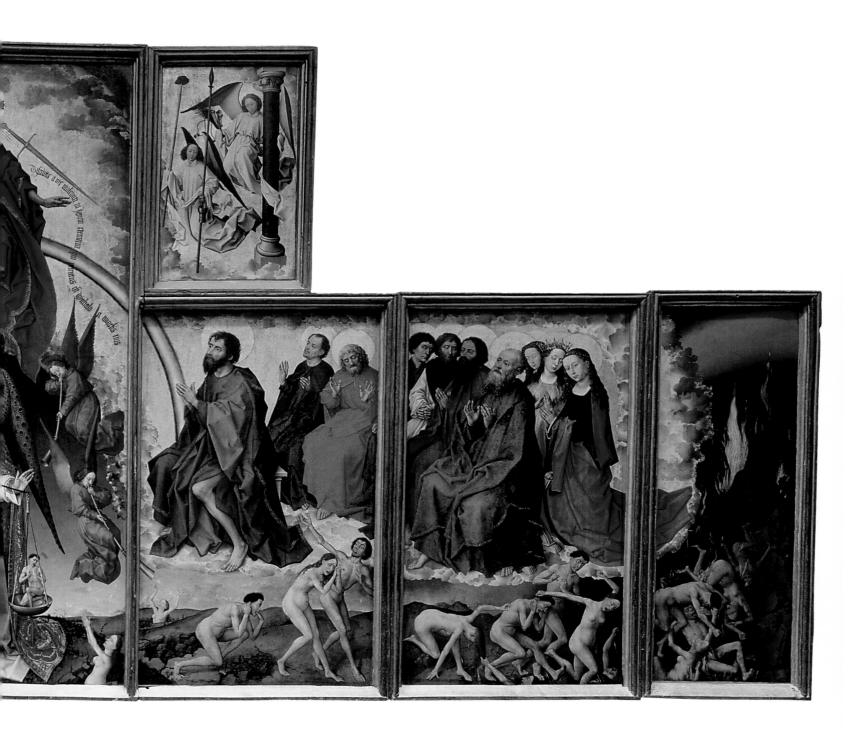

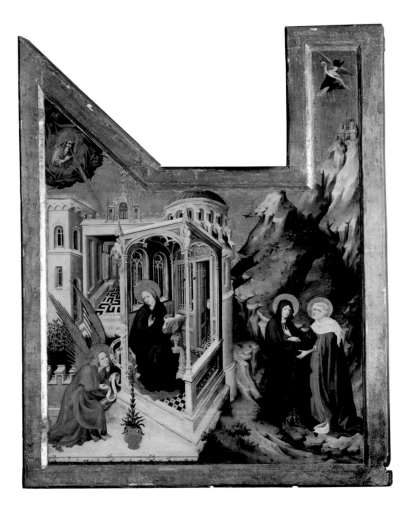

The Prague School

The Prague School, which was initiated by Emperor Charles IV, intended its images to be more plastic than painterly. Its pictures are still partially in their original locations: Mary's Chapel and the Chapel of the Cross in Castle Karlstein in Bohemia, and the Imperial Gallery in Vienna. Although painted in tempera on wood, these images were supposed to function as replacements for frescos and are therefore stylistically related to wall paintings. They show progress only in the striving for spiritual depth and strength of the characters. This is particularly visible in the Chapel of the Cross that features a long row of disciples, half-length portraits, church fathers, and male and female saints creating a continuous decoration on the chapel walls. This series of images is attributed to Theoderic of Prague, who was, along with Nicolaus Wurmser from Strasbourg, one of the main masters of the Prague school.

However, the Prague school did not contribute to the further development of painting as such. That happened in Cologne, which had attained high prestige with its spiritual power and secular wealth, and those areas of the lower Rhine that were ruled by the city.

It was not destined to reach beyond the depiction of a beautiful, peaceful human existence thus make the transition to the dramatic or even the passionate. Wherever the altar tried to express the latter in images of the Passion or of martyrs, it slid into unrefined caricature, which was in unpleasant contrast to the lovely depictions of Heavenly peace. Painting's further perfection and its complete absorption of nature were reserved for the Dutch School under the leadership of brothers, Jan and Hubert Van Eyck. Their work belongs to the following epochs.

Gothic Painting in Belgium and the Netherlands

The two Van Eycks are unquestionably among the first and most important painters of Flanders. Little is known about either, even their dates of birth are uncertain. Jan Van Eyck was supposedly born around 1390 close to Maastricht and Hubert around 1366. Jan is the more renowned of the two. He collaborated with Hubert on the *Ghent Altarpiece*, or *Triptych of the Adoration of the Mystic*

89. **Melchior Broederlam**, *The Dijon Altarpiece: Annunciation* and *Visitation* (left panel), 1393-1399. Tempera on panel, 167 x 125 cm. Musée des Beaux-Arts, Dijon (France).

Lamb (see p. 98-99), which was started in 1426 and completed in 1432. On the left outer wing the donor Jodokus Vyd is portrayed in prayer. The date for the beginning of the altarpiece may be determined by the death of Jan's employer, John III, Duke of Bavaria, also known as Pitiless John, which led to Jan Van Eyck entering the services of Philip III, Duke of Burgundy, also called Philip the Good. He was registered in the latter's household as "squire and painter" and also took the role of confidant. For his services he received a salary, two horses for personal use and a servant. He spent most of his life in Bruges.

Magnificent use of colour is the primary reason for the Van Eycks' fame. Artists from as far as Italy would come to study their works and learn how to create colours of such luminosity. Jan is actually considered the inventor of oil painting. Up until his time, artists painted with tempera (a mixture of water, egg, and colour pigments). Earlier attempts to use colours with oil had failed because the varnish blackened the colours. Admixing white varnish, a kind of turpentine, to oil and colour leads to a quicker drying of the paint, and thus retains the luminosity and avoids cracking. Apparently, the recipe's secret was not kept well enough because Antonello da Messina, who worked in Bruges, discovered and distributed it. The birth of oil painting introduced the enormous, subsequent development of painterly art. This is why Jan and Hubert are considered the founders of Dutch painting. Just as "the sudden flowering of the Aloe after centuries of sunny sleep", the art of oil painting now experienced a grandiose flourishing. Its development was mostly furthered in Italy, even though it originated in Flanders.

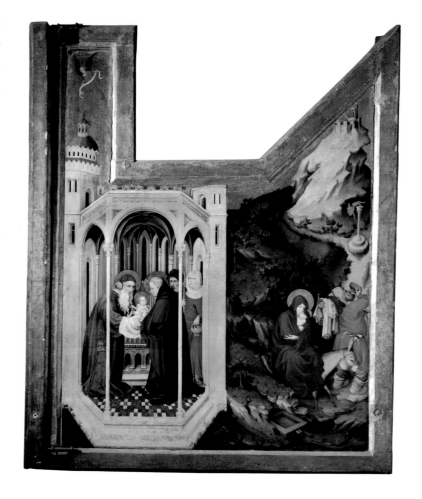

Hugo Van der Goes, who was active in the second half of the fifteenth century, can be added to the list of master painters who exclusively painted religious topics. His surname allows the speculation that he came from Goes on the island of Seeland. Other historians maintain that he came from Ghent. The place where he died is also uncertain: sources suggest Oudergem and the Rooderdale Monastery close to Brussels. What is certain is that he was one of the most important Dutch painters in the second

90. **Melchior Broederlam**, *The Dijon Altarpiece: Presentation in the Temple* and *Flight into Egypt* (right panel), 1393-1399. Tempera on panel, 167 x 125 cm. Musée des Beaux-Arts, Dijon (France).

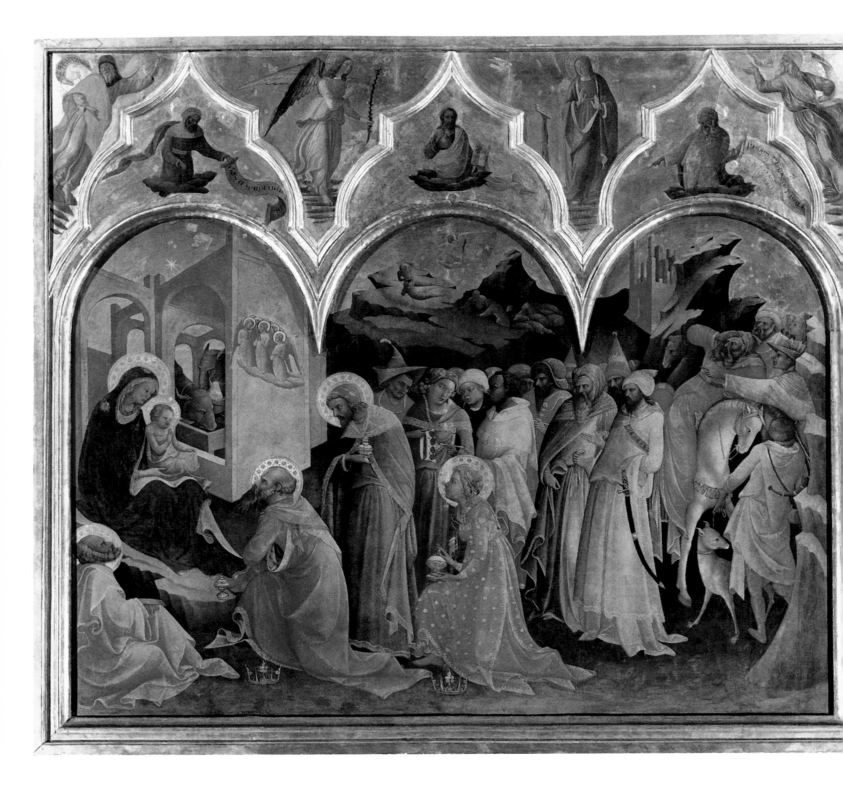

half of the fifteenth century. He created the *Portinari Triptych* (1476-1478) (see p. 106-107); the *Portrait of a Man* (around 1480); and the portrait of a donor, *Sir Edward Boncle Admires the Trinity* (around 1480).

As of 1436, Rogier Van der Weyden lived as the official painter of the city of Brussels. His influence was felt throughout Europe. One of his benefactors was Philip the Good, who was an avid art collector. Van der Weyden's tempera masterpiece *Pietà* (before 1443) is housed today in Madrid 's Museo del Prado. It precedes the completion of his polyptych *Last Judgement* (1448-1451). He was the only Flemish painter to continue the artistic conception of the Van Eycks and perhaps even surpassed it. Rogier Van der Weyden's influence spread beyond the borders of Flanders, mainly to Germany. His most famous pupil was Hans Memling. Van der Weyden was the last follower of Giotto's tradition and the last painter whose work was exclusively religious.

Very little is known about the biography of Jan Van Mimmelynghe, also known as Hans Memling. Supposedly he was of German origin, born in Seligenstadt, not far from Aschaffenburg. However, only his presence in Bruges after 1466 is documented. There he worked as a painter and shared with the Van Eycks the honour of being one of the leading artists of the so-called Bruges school. He refined its art by developing a wonderful sense of measure and grace, as well as the use of exceptionally beautiful colours. Many consider him the most important Dutch painter with the ability to exquisitely express local ideals. Among his most important works are *Adoration of the Magi* (1470), the *Triptych of the Last Judgement* (c. 1467-1471) (see p. 108) and the *Mystic Marriage of St. Catherine* (1475-1473).

Dieric (Dirk) Bouts painted symmetrical compositions with luminous colours. Examples are the *Pearl of Brabant* (around 1470) (see p . 111) and the *Altarpiece of the Holy Sacrament* (1464-c. 1467) with the depiction of the *Last Supper* (see p. 104). This important work by Bouts was commissioned by the Confraternity of the Holy Sacrament in Louvain. The painter had to swear that his depiction would follow the strict instructions of two theologians. This is the first time that the Last Supper was shown at the moment of the bread's blessing and not, as it was usually the case, at the moment of betrayal by one of the apostles. Bouts' *Diptych of the Justice of the Emperor Otto III* (c. 1460) (see p. 105) addresses an entirely different topic. This image depicts a court scene, something that was typical for the secular Gothic in the fifteenth century. The verticality of the figure and its shapelessness are particularly pronounced.

Gerard David is another of the many great Dutch Masters of those years. After Memling's death, he became the main master of the Bruges school. Next to nothing is known about his early life. He painted contemplative pictures that encourage prayer. The most important of these were created between 1500 and 1520. Among them are *Madonna and Child with the Milk Soup, The Mystic Marriage of St. Catherine, Baptism of Christ* with its donors and patron saints, and *The Annunciation.*

Gothic Painting in Italy

Contrary to German painting, Italian painting first showed its strength in frescos, while panel painting remained less important for a long time. Fresco had always been a typically Italian art-form and its

91. **Lorenzo Monaco,** *Adoration of the Magi,* 1421-1422. Tempera on panel, 115 x 177 cm. Galleria degli Uffizi, Florence (Italy).

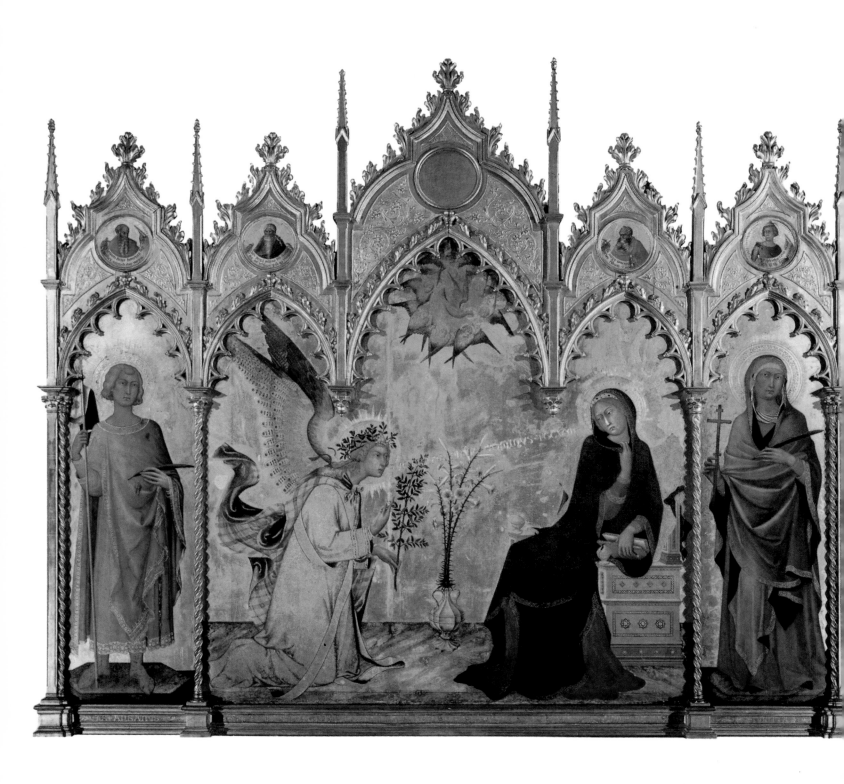

92. **Simone Martini** and **Lippo Memmi**, *Altar of the Annunciation,* 1333. Tempera on panel, 184 x 210 cm. Galleria degli Uffizi, Florence (Italy).
93. **Gentile da Fabriano**, *Adoration of the Magi*, 1423. Tempera on panel, 300 x 282 cm. Galleria degli Uffizi, Florence (Italy).

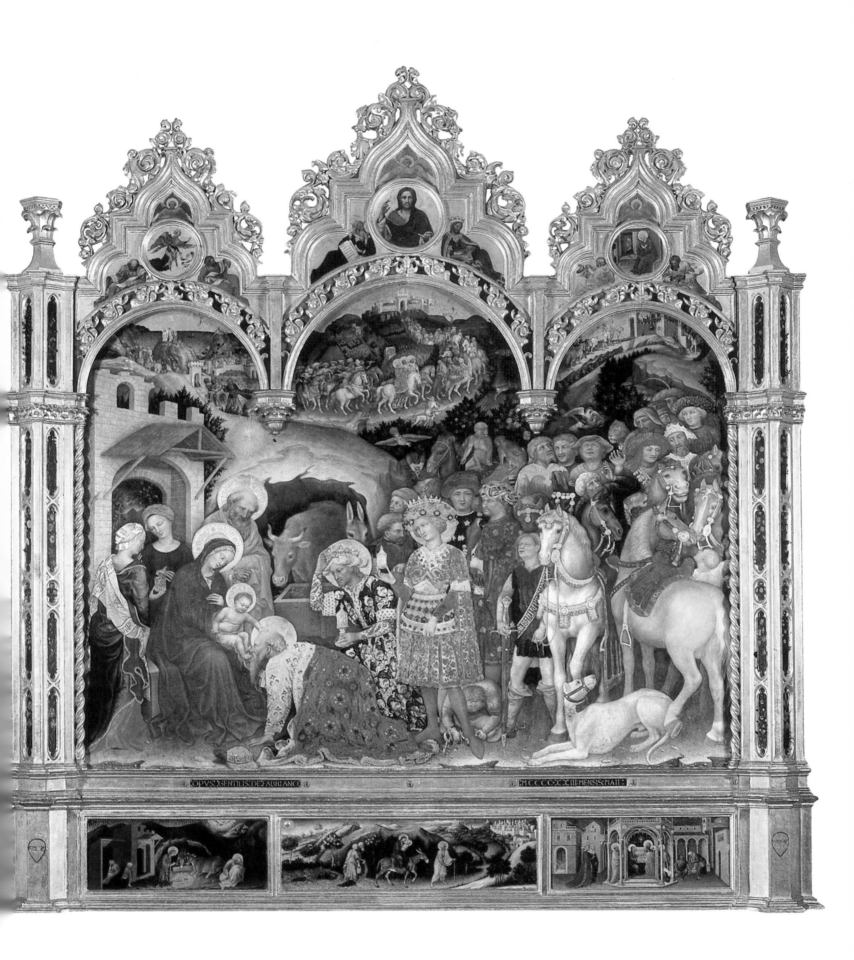

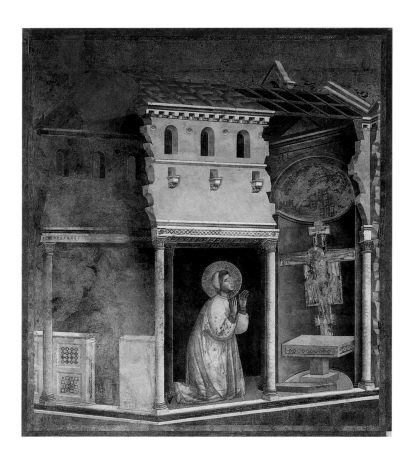

he was credited with the rejuvenation of Italian painting. Of the few works that can be attributed to him with certainty (one of the most important being *Madonna and Child Enthroned with Angels and Saints* (c. 1310) (see p. 94)), an assured greatness and majestic interpretation, as well as a striving for soulful grace, can be discerned. But he still had not freed himself from the Byzantine rules. Giotto receives all merit for returning Italian painting to reality, to the observation of life and facilitating its blossoming on entirely new ground.

Giotto, who mastered painting and architecture, worked in many Italian cities, from Naples to Padua. However, the main works that illustrate the development of his style – before his eventual greatness founded modern monumental painting – can only be found in Assisi, Florence and Padua. He first demonstrated his individual style when he painted the church raised in memory of St. Francis in Assisi. At first, Giotto probably still worked under Cimabue's instruction. As the most famous painter of the time, Cimabue had been commissioned to carry out extensive work with the help of minor artists. The Franciscans wanted vivid visualisations to enhance their sermons' influence over people. North of the Alps this role was reserved for sculpture, but south of them, where the eye demanded colour, painting would fulfil it. At first, the Franciscans considered motifs from the life of Francis; in the eyes of the enthusiastic faithful his sermons and his example of a new moral and religious ideal rendered him a benefactor to all mankind. Motifs from the miracles he performed in life and after his death were also considered. The intention was to exhibit a series of paintings concerning Old Testament stories, and the story of Christ, on the upper walls of the upper church's nave.

development continued uninterrupted after the introduction of the Gothic. The reason for this is due to the fact that wall spaces were not diminished by the new building system. Far into the thirteenth century Italian painting had remained under Byzantine influence and had finally sunk into mindless and soulless style.

Giotto's Painting

Giotto di Bondone was the first who freed himself from this domination. Born in Colle close to Florence, his first teacher was allegedly Cimabue, who, as a verse from Giotto's close friend Dante tells us, thought himself the greatest painter of his time. This is why, for a long time,

94. **Giotto di Bondone**, *Cycle of the Life of St. Francis: The Miracle of the Crucifix,* Upper Church of the Basilica of St. Francis of Assisi, Assisi (Italy), 1297-1299. Fresco, 270 x 230 cm. In situ.

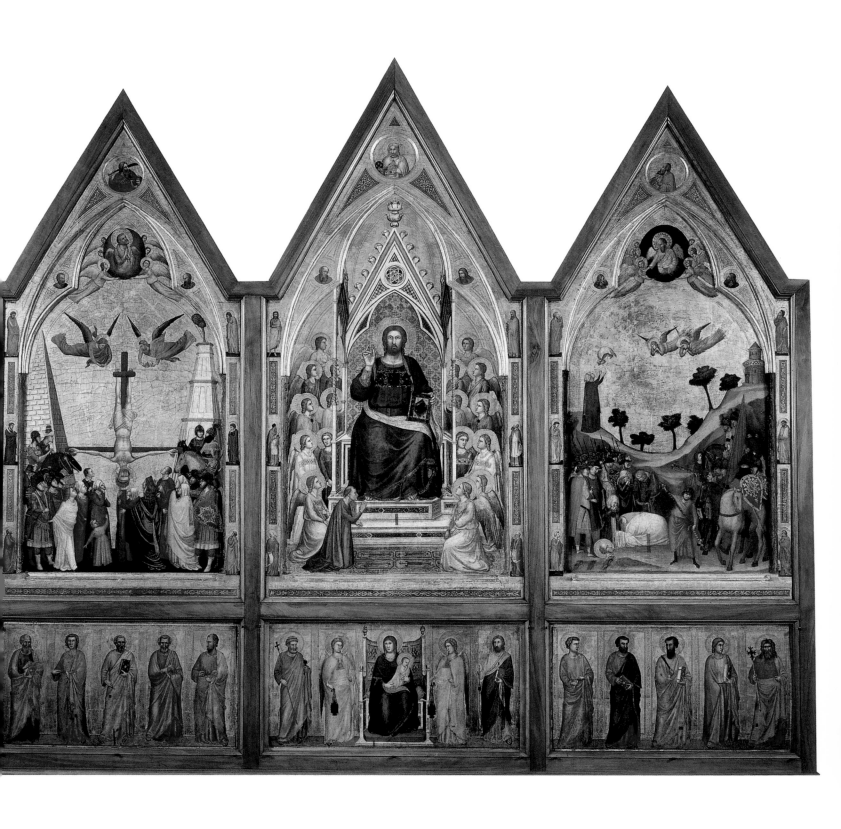

95. **Giotto di Bondone**, *Stefaneschi Polyptych* (recto), c. 1330. Tempera on panel, 220 x 245 cm. Pinacoteca Vaticana, Vatican (Vatican).

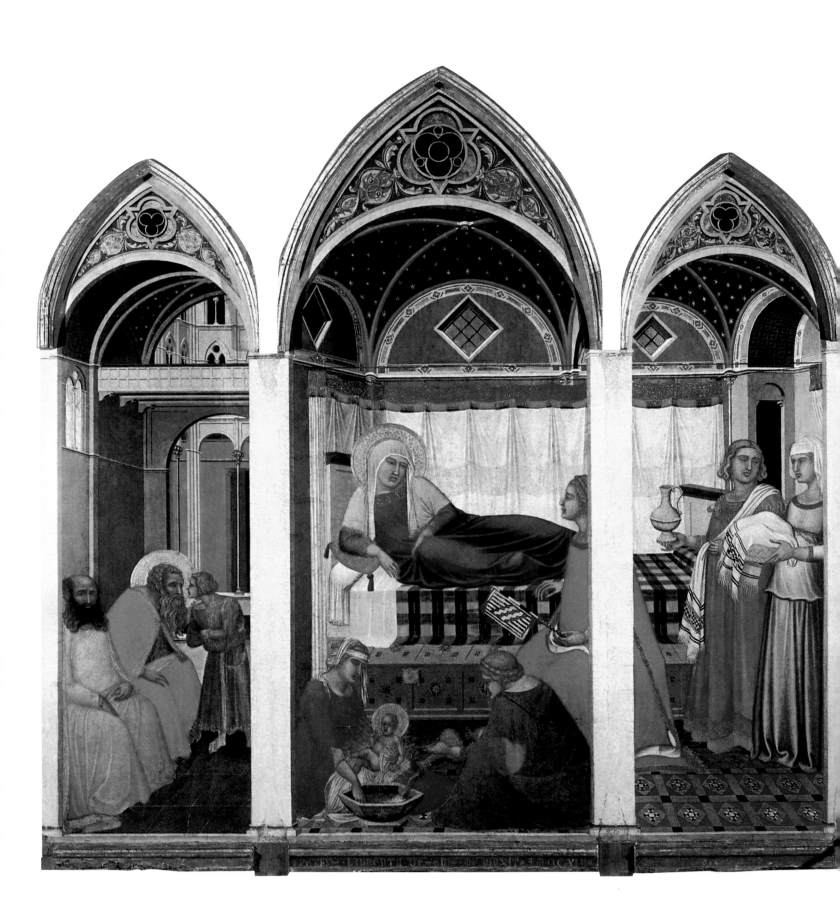

The room of the lower walls was filled with twenty-eight depictions from the life of St. Francis. Over the course of his work on them, Giotto arrived at a completely new interpretation of human depiction (see p. 120, 123). When telling historical events, Byzantine painters had already attained certain mastery, but theological dogma prevented the development of any artistic sense that would be able to master the number of figures and cut the essential from the unessential.

Giotto was the first to demonstrate this latter principle. When telling a story he depicted only the most crucial characters, which gave his work clarity. Superfluous clusters of figures were replaced by more effective structure and grouping. Thus the broad narrative transformed into a dramatic, vivid interpretation of events. One of Giotto's chief merits is the reintroduction of drama into the depicting arts, long after the demise of Antiquity. In the depiction of humans, he rid himself of all narrow-mindedness that had marked his artistic predecessors. This is visible in his treatment of their garments, which were depicted in the same grand style as they had been in Antiquity. However, he was not destined to achieve ultimate approximation to nature because he lacked a thorough knowledge of anatomy, perspective and other indispensable painting aids. Still, he achieved such a high degree of naturalism that his work became the artistic ideal of his contemporaries. Although they employed the same simplicity in their artistic means of depiction, they would not develop a stronger monumental effect.

The thirty-eight paintings from the life of Mary and Christ which decorate the two long walls of the Capella degli Scrovegni represent the apex of Giotto's work. The

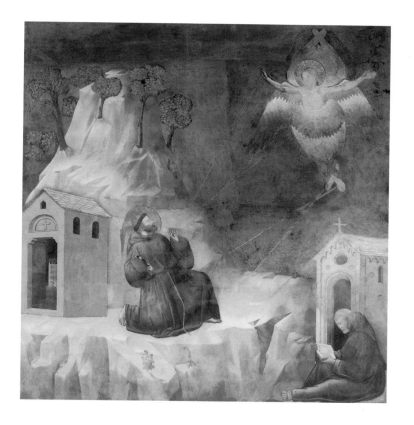

church had been built on the remnants of Padua's old amphitheatre and is therefore also called "Arena chapel" (see p. 126). At this point, Giotto's art had developed completely. Although at times nature and architecture contribute much, the human aspect is most important and depicted as something typical, even if at times there are first attempts at characterisation. Still, it is something lively that far surpasses the Byzantine schemata. From Giotto's new type of depiction individuality and ultimately nature itself could emerge.

Some time later Giotto returned to Assisi to work on the lower church. He illustrated the main events from Christ's life in three rows of images on the walls of the right

96. **Pietro Lorenzetti**, *Birth of the Virgin*, 1342. Tempera and gold on wood, 188 x 182 cm. Museo dell'Opera del Duomo, Siena (Italy).
97. **Giotto di Bondone**, *Cycle of the Life of St. Francis: Stigmatisation of St. Francis*, Upper Church of the Basilica of St. Francis of Assisi, Assisi (Italy), 1297-1300. Fresco, 270 x 230 cm. In situ.

transept. He also decorated the four areas of the vault with various figures: it shows St. Francis' transfiguration and allegorical depictions of the Franciscan order's three rules – poverty, celibacy and obedience. With his powerful depictions Giotto was able to make these allegories comprehensible and come to life, even if he required, at times, a confusing number of figures to achieve this. Giotto had great talent and an inclination to the expression of abstract notions. His allegories about vices and virtues, which he painted alongside images of the lives of Mary and Christ in the Arena Chapel of Padua, became models for the following times.

The fourth of Giotto's great preserved frescos is located in the Franciscan church Santa Croce in Florence. It consists of two rows of images which the artist painted between 1318 and 1328 in two chapels. The images in one chapel are again devoted to his favourite saint, Francis of Assisi. The other chapel features depictions of events from the lives of John the Baptist and John the Evangelist. These are the last and at the same time the most perfect of his works in which his great artistic skills matured completely.

Of his many works that he created during his years in Naples, almost nothing has survived, unfortunately. In 1332, Giotto was summoned to Florence. His fellow citizens entrusted him with the continuation of a project that was close to their hearts: the cathedral that had been begun by Arnolfo di Cambio. Giotto the architect is only known by the painted constructions that can be seen in his images. Nevertheless, he must have worked as an architect, because the townsfolk of Florence would not have commissioned him for such an important

construction otherwise. Alas, building could not have advanced significantly under his leadership because he died in January 1337. However, he did witness the foundation of the belfry that he designed; it was begun in 1334 and he saw it grow to the first row of the relief that appeared on all four walls. He also designed some of this relief, which in a lower row depicts human activities in craft, farming, stock breeding, art and science and, in an upper row, the seven main virtues, the seven manifestations of mercy, and others. These were depicted not as abstract allegories, but as realistic images taken from life. Supposedly, he even modelled some of these reliefs himself. They were executed in marble by Andrea Pisano, who, after Giotto's death, also continued construction of the tower.

Painting in Siena

Giotto's and Pisano's influence became so strong that the artists of Siena also succumbed to it. Duccio di Buoninsegna had founded a painting school there, which at first followed the Byzantine direction, but also strove for its own beauty and inner expression. It would remain true to these ideals later.

Its main figure was Simone Martini, whose art is best represented by his *Maestà* (1315) (see p. 125) in the town hall of Siena. The artists from Siena had a greater sense of beauty than those from Florence and the role of aesthetics should not be underestimated in this time of rising realism. The Florentines probably soon noticed the disadvantages of their one-sided naturalism and looked for a way to balance it. Surely the best that Italian painting had to offer during this time was the combination

98. **Simone Martini**, *Maestà*, 1315. Fresco, 763 x 970 cm. Palazzo Pubblico, Siena (Italy).

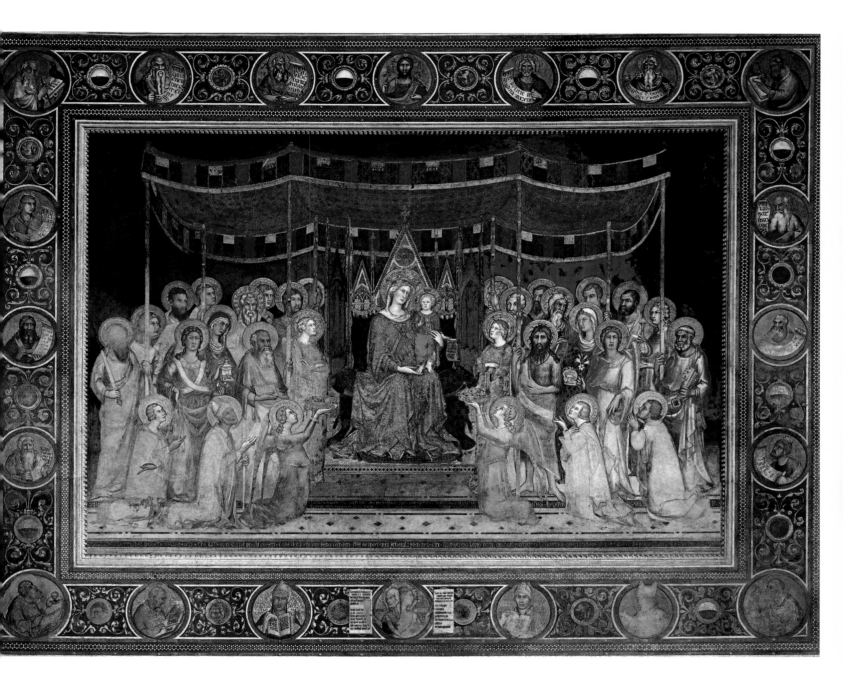

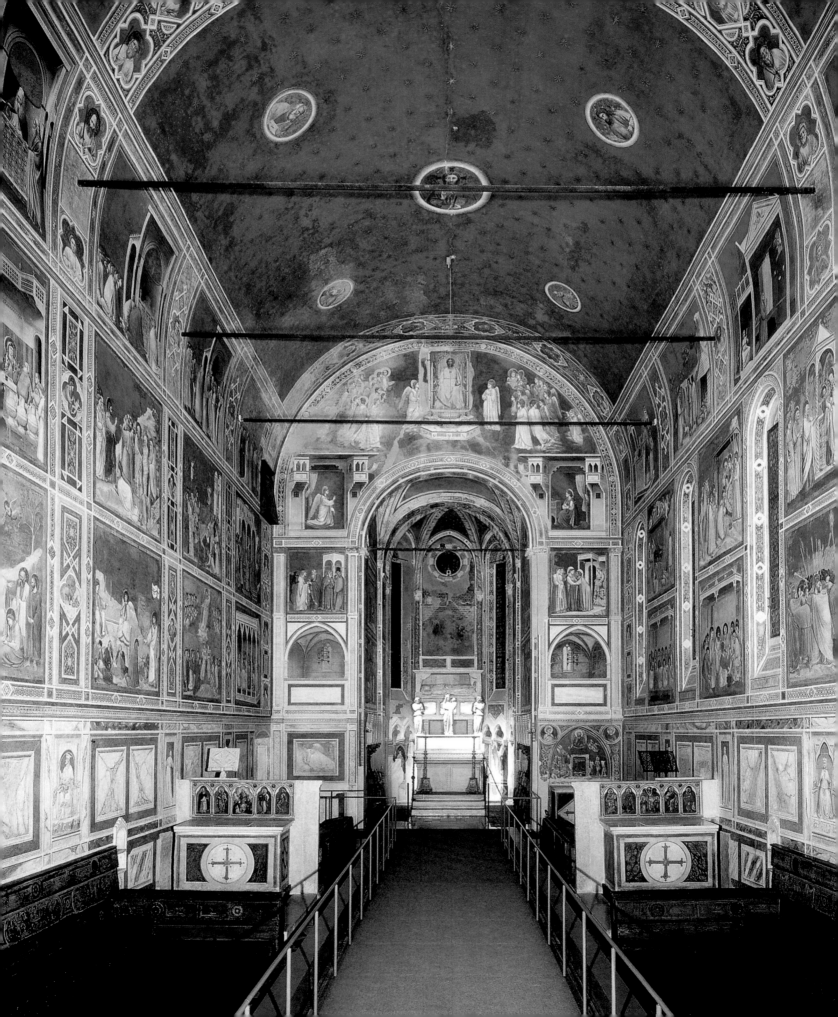

of strengths that originated in Florence and Siena. We first see this in the panel paintings and frescos by the brothers Pietro and Ambrogio Lorenzetti (see p. 122). The latter had decorated the peace hall in the Siena town hall with large symbolic compositions. The best preserved work shows the allegory *Good and Bad Government* (1338–1340) in Siena in a large number of genre paintings.

Painting in Pisa

In terms of spiritual significance, dramatic power of creation and passion in diverse expression, all of the abovementioned images are surpassed by the *Triumph of Death* that an unknown painter created on the inner south wall of the Camposanto in Pisa, a hall built by Giovanni Pisano that encloses the cemetery on three sides. This work is one of the most remarkable testimonies to Italian medieval painting, which demonstrates a brave imagination of no lesser artistic value than Dante's work. It shows the pathos of death with the joys of human existence and life's pleasures the way it would be praised in the poems of Giovanni Boccaccio. On the left of the painting is a noble hunting party with three kings at its head riding through a dark forest. They suddenly stop in front of three open coffins, which hold three partially decomposed corpses in royal attire. They obviously remind the living of the impermanence of earthly majesty and as a warning against pride and vanity. Death is already behind them, and no earthly greatness can stop its annihilation. In the form of a woman with bat wings and claws, which heighten the eerie scene, death swoops through the air with a scythe past a group of beggars and cripples, who in vain ask for death to release them from their misery. Piles of corpses, out of which angels and

devils extract souls, mark the path of Death who steers her flight towards a little forest, where a company of well dressed women and men are delighting in merry entertainment. Death has chosen her next victims: the young loving couple on the left side; above their heads hover the angels of death, which the artist modelled on ancient embossments on sarcophagi.

99. **Giotto di Bondone**, *Cycle of the Life of Joachim* (general view), Scrovegni Chapel (Arena Chapel), Padua (Italy), 1303-1305. Fresco. In situ.
100. **Giovanni da Milano**, *Scenes from the Life of the Virgin*, Rinuccini Chapel, Basilica of Santa Croce, Florence (Italy), 1365. Fresco. In situ.

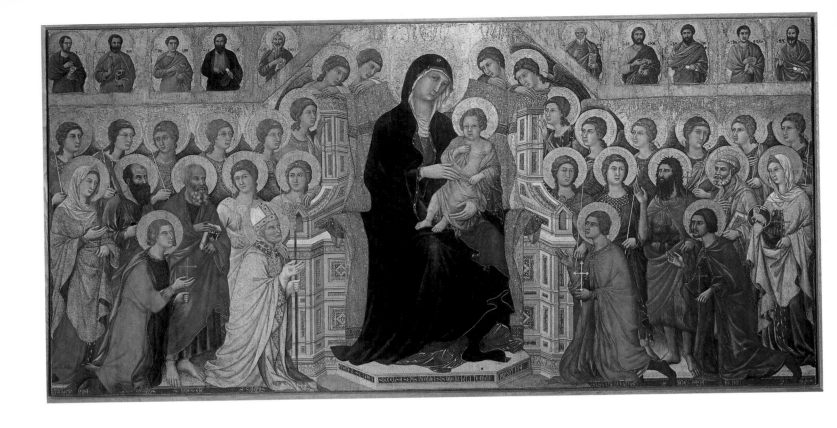

The artist comes from the circle of Pisa painters, among whom Francesco Traini, who worked between 1321 and 1363, was the most significant. Maybe he was the creator of the *Triumph of Death* and the *Last Judgement* that is beside it. Both images were the first to outline the greatest of all dramas. In the following two centuries its artistic design would be perfected until it found its ultimate perfection in the works of Michelangelo.

Painting in Padua

Giotto's example triggered a short but intense flourishing of monumental painting in Padua, where he had worked extensively. The interior decoration of San Antonio, the church of the city's patron saint, which is also abbreviated to *Il Santo*, kept the artists of the city busy. One particularly colourful personality, Altichiero of Zevio,

is worth mentioning. Starting in 1376, he painted the chapel of San Giacomo with depictions from the legend of St. Jacob and a Crucifixion (see p. 128-129). While at first he followed Giotto's example, he soon surpassed him by enlivening and deepening the physiognomic expression of his figures. He also strove for a richer coloration, removed perspective flaws, which often marked Giotto's work, and developed a richer aesthetic sense. All this progress culminated to great effect in a second row of Altichiero's frescos in the chapel of San Giorgio, on which he probably collaborated with the Veronese painter, Jacopo Avanzi. In this chapel, which is located on the square in front of *Il Santo*, the two artists told, in twenty-eight large paintings, the story of Christ's youth, the crucifixion, the coronation of Mary and the main events from the legends of St. George, St. Lucia and St. Catherine. The individualisation of the many hundreds of figures in particular shows great variety

101. **Altichiero da Zevio**, *Crucifixion*, San Giacomo Chapel, Basilica of St. Anthony, Padua (Italy), 1376-1379. Fresco, 840 x 280 cm. In situ.
102. **Duccio di Buoninsegna**, *Maestà*, 1308-1311. Tempera on panel, 211 x 426 cm. Museo dell'Opera Metropolitana, Siena (Italy).
103. **Andrea Orcagna**, *Tabernacle of the Virgin*, Orsanmichele, Florence (Italy), 1348-1359. Marble, lapis-lazuli and incrustations. In situ.

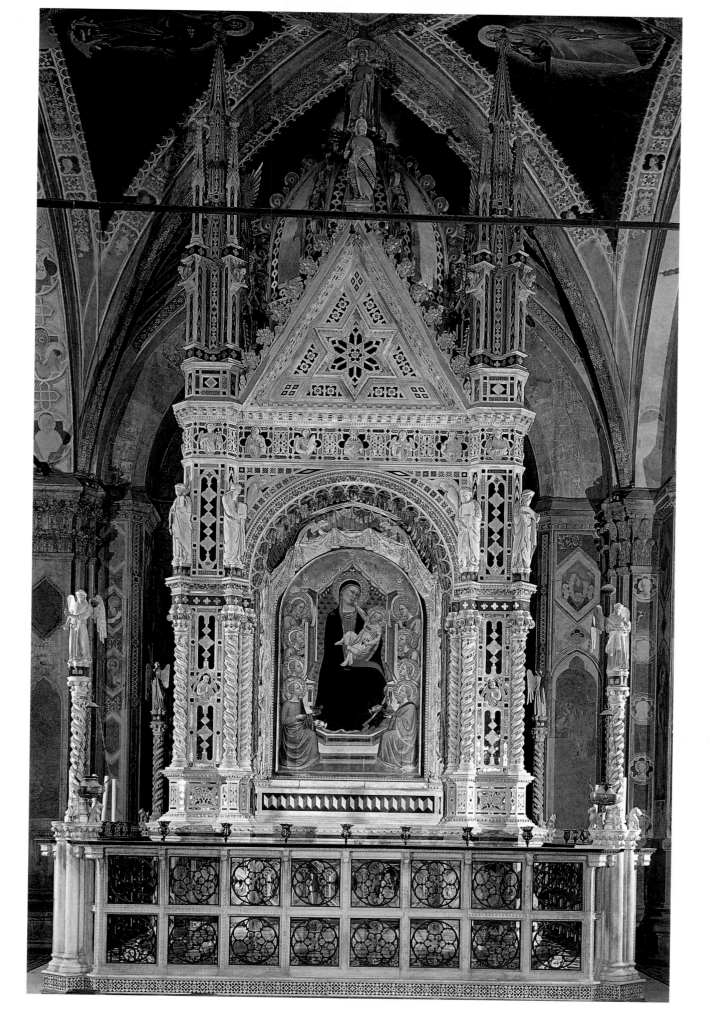

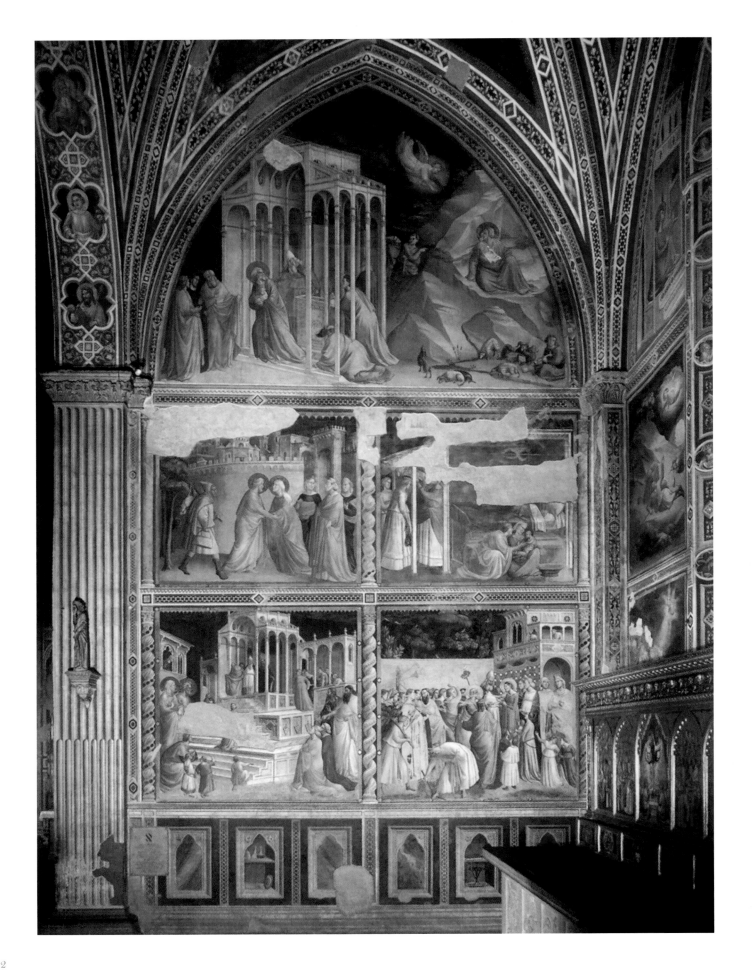

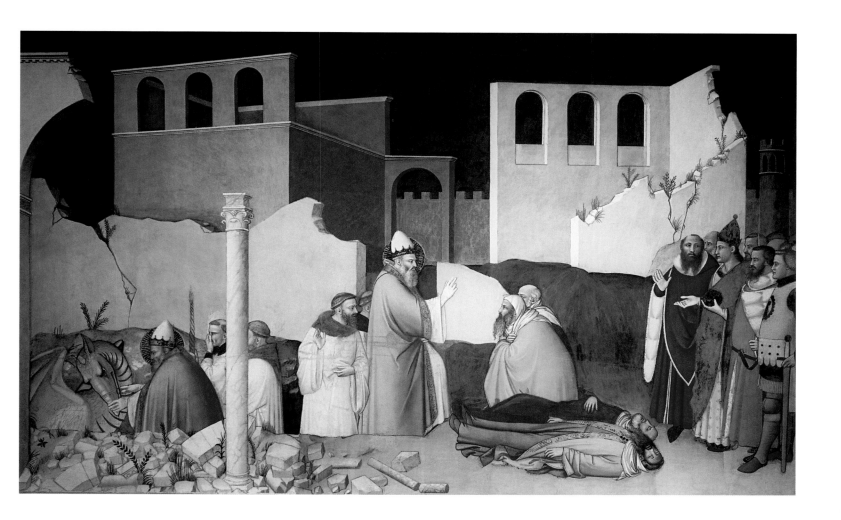

Painting in Florence

In Florence, Andrea di Cione, better known as Orcagna, was the most significant painter and Giotto's most independent successor. He also strove for an expression of ideal beauty that would surpass Giotto's. In the chapel of the Strozzi, Santa Maria Novella, which Orcagna painted with his brother Nardo, the depictions of the Last Judgement on the altar wall with its images of paradise, Christ and Mary enthroned, as well as of the countless blessed, are among those that illustrate the "highest limit of aesthetics and of beauty", of which the Florentine school was capable at the time. The only plastic work of

Orcagna's that has survived is the 1359 marble church tabernacle in the grain hall of Orsanmichele (see p. 131). It is a large altar construction with a cupola and a miracle-working image of Mary, as well as a multitude of statuettes and embossments. It is the last and richest developmental stage of the Italian Gothic before its predictable decline.

Also among Giotto's pupils was probably the unknown painter who created the much admired frescos in the Spanish Chapel in the transept of Santa Maria Novella. In these works, the art of the Franciscans, which

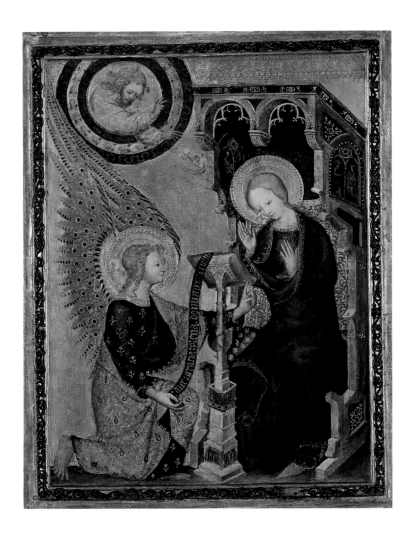

even shy away from tastelessness, and presents his order brothers literally as black and white dogs – domini canes. The altar wall of the spacious chapel shows the life of Christ from carrying the cross to the ascension. This is done in such a way that the crucifixion with its countless figures is central. The painting on the eastern wall is almost overloaded with characters and relationships. The lower part shows the earthly church, represented by the Pope, but also by emperors, nobility and clergy with their respective entourage. They all are loyally protected by the aforementioned "dogs of God". On the lower right the clergy are depicted giving their sermons, as well as converting heathens. Above this an unconcerned humanity pursues enjoyments, while the upper part of the painting depicts the peace of the church and reception of the blessed into Heavens populated by saints and prophets.

The image on the western wall illustrates the triumph of Thomas Aquinas. He is enthroned on the same level as enormous pews and surrounded by prophets and evangelists. Angels hover about him and overcome heathens lie at his feet. Beneath him in the Gothic choir stalls sit female figures, which can be interpreted as the churchly virtues, the arts and the sciences. At their feet, in the lower part of the image, the painter shows the worldly representatives of these heavenly apparitions, all of whom were most likely known to the artist's contemporaries.

This fresco of the western wall is not without art-historic significance because its structure and arrangements of groups contain the core of the monumental compositions, which Raphael will perfect in his *School of Athens*.

originated in Assisi, meets that of the Dominicans. If the allegorical images of the former's lower church are inspired by poetry, then the frescos of the Spanish Chapel are dominated by a dogmatic, almost scholastic spirit, which strongly represents the reputation of the Dominican order. But while Giotto depicts the life and virtues of his saint in a commonly intelligible manner, the creator of these images tries to integrate spirit, symbols and science so as to portray the significance of St. Thomas Aquinas as brightly as possible. He does not

106. **French Master**, *Annunciation*, c. 1375. Tempera and oil with gold on wood, 30.8 x 22.5 cm. Cleveland Museum of Art, Cleveland (United States).

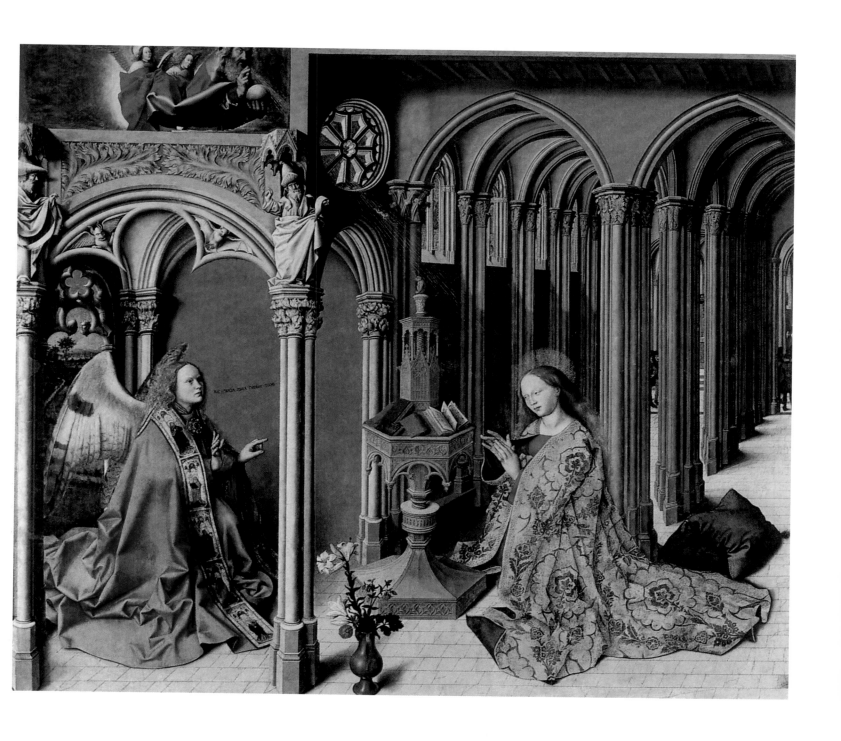

107. Master of the Annunciation of Aix, *Annunciation* (central panel of a triptych), St. Mary Magdalene Church, Aix-en-Provence (France), c. 1443-1445. Oil on wood, 155 x 176 cm. In situ.

Gothic Painting in Spain

Mostly the kingdom of Aragon, but also Catalonia, developed an intense activity in these areas of art. From the altarpieces, which were mostly painted against a golden background, and the up to 15m high triptychs, to the paintings that were often influenced by Italian, French or Flemish artists, these artworks lay the foundation for Spanish painting.

Sculpture also developed in this era and became evermore delicate and elaborate. The posture of sculptures gradually lost its stiffness and led to natural expression.

Illuminated Books

Illuminated books were created for the nobility, higher clergy and aspiring bourgeois financiers and merchants. They were true gems that competed with the finest jewellery in virtuosity and price. Widespread illiteracy and the high cost of these unique manuscripts limited the painters' audience. However, the elitism inherent in miniatures did not lead to an ossified technique. To the contrary, once book production became mainly the business of city craftsmen, new innovations in painting technology were made more frequently; they would influence all painting of its time. The acquisition of a new artistic language – the design of space, the rendering of mass, movement and volume – began in the workshops of the miniaturists. The illustrative function of miniatures demanded narrative: the painter not only had to depict the spatial, but also the temporal. Miniature played an important role in the emergence of genres, primarily landscapes and portraits. One painter after another introduced something new to the drawing, the colouring and the decorative motifs by including increasingly intense observations of daily life.

Like the objects of the craft industry, the illustrated book is one of the most mobile art forms. Merchants brought illuminated books back from their journeys along with other goods. Princesses, who were married abroad,

108. *Bible: Blanche of Castille and King Louis IX of France and Author Dictating to a Scribe*, 1226-1234. Ink, tempera and gold leaf on vellum paper, 38 x 26.6 cm. The Pierpont Morgan Library, New York (United States).

had works by some of the finest illustrators in their dowries. Sons, who received new estates, took inherited books with them. Books were also trophies of war.

Thus, illuminated manuscripts travelled across Europe as precursors of new ideas, tastes and styles. There is no doubt that their spread explains the influence of Parisian art on many countries from the second half of the fourteenth to the beginning of the fifteenth century. Miniature had a direct exchange not only with panel painting, but also sculpture. In the design of the plastic décor in Romanesque and Gothic cathedrals, illuminated books often served as inspiring source material for themes, shapes, and iconography. They informed weavers, architects, enamel painters, ivory carvers and masters of glass painting. Until the middle of the fifteenth century and the works of painter Jean Fouquet, the masters of French miniature were in turn inspired by the excellent sculpture of the High Gothic.

In the thirteenth century miniature is strongly influenced by glass painting and in the fourteenth century by Italian frescos. In the fifteenth century it incorporated the decisive discoveries of the Dutch painters, the Italian architects and sculptors, as well as the painters of the Quattrocento. In this complex and fruitful interaction of genres, schools and arts miniature played an important role.

As a "secondary art", that is as interpretation of a literary work, miniatures are invaluable documents that show how people of that time saw and understood literature; what emotions the ancient works triggered in them; how people adapted these works to their own times;

and how they correlated with high culture's next developmental stage. Nevertheless, illumination has to be seen as an independent art that has to be included as an important element in mankind's cultural heritage. Illustration of manuscripts is an exceptionally important stage in the history of book design. The manuscript ornamentation system became ever more complicated and

109. *Missal of St. Louis: Christ in a Mandorla Surrounded by Emblems of the Evangelists*, c. 1225-1256. Basilica of St. Francis of Assisi, Assisi (Italy).

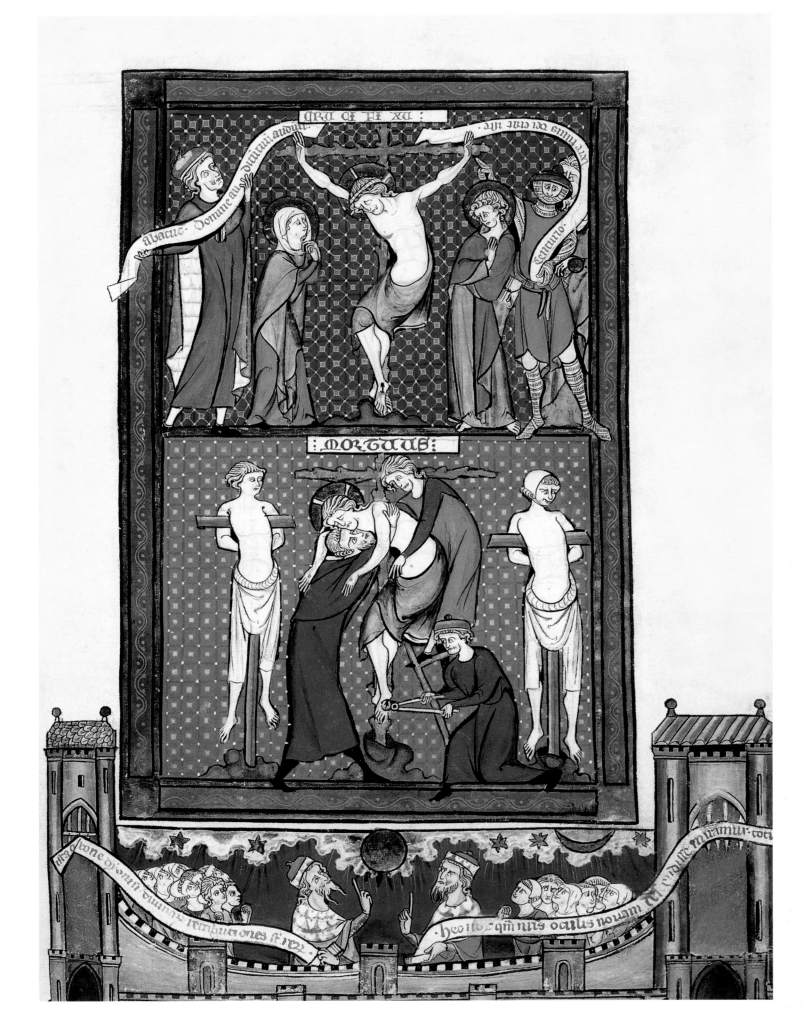

varied; it reached its peak in the fourteenth and fifteenth centuries. The initials are of diverse size, content and character; the rubrics in the text are painted with gold and colours; there are horizontal ornamentations within lines and borders featuring rich plant details; depictions of real and fantastic beings, humans, and various mythical creatures; filigree ornamentations spill into the margins; extensive compositions run onto the lower page and self-contained illustrations appear within miniatures. If a manuscript was to be illuminated, the writer left ample space for the initials, fields, medallions and half or whole page illustrations. Sometimes hints were left on the margins of these empty spaces informing the painter which plots, or "histories", should be depicted.

Then work began for the painters. When the centre of production for these manuscripts moved from the monasteries to the secular workshops in cities, specialisations occurred. The main master led the entire process, provided the sketches, and executed the most important pieces himself. One of his assistants copied the drawing in ink, pencil or silver pen according to the drafts and instructions of his master; another assistant painted gold where required; a third applied the colours.

This degree of specialisation increased the productivity of the workshop and guaranteed high quality. However, the honour of inventing a new technique, offering a new interpretation of a plot, or discovering a new artistic method was reserved for the master himself.

The work of these writers and miniaturists was hard. The old manuals taught that gold had to be polished delicately at first and then ever stronger until sweat would finally pour in streams. Sometimes colour was applied in seven layers, which often had to dry for several days before the previous layer had dried.

Byzantium inherited the ancient tradition of artistic book design directly and continued it. Western Europe, on the other hand, discovered the illumination of codices only in the sixth century. The first manuscripts with illuminated text appeared in Italy and in the territories of today's France. Here, from the end of the fifth to the middle of the eighth century, an artistic culture developed, which was named after its ruling dynasty: Merovingian. The few existing manuscripts from the middle of the seventh to the second half of the eighth century show that the graphic style predominated in Merovingian illuminations, which reflected the influence of late Roman art, the art of Lombardy and Northern Italy (depictions of figures and architectural motifs), and of the orient, mainly Coptic Egypt (colour and ornamentation). The leading centres for the production of manuscripts were the monasteries at Fleury and Tours (Loire Valley), Luxeuil (Burgundy), and Corbie (Picardie). Books were the most important instrument of monastic culture. Therefore the manuscript designs were characterised not only by the religious worldview, but also by the traditions of the orders.

The most striking and original development of miniature art occurred in the British Isles after the conversion to Christianity. The illustrators from these islands used and developed their own local ornamentation traditions as it had existed in decorative craft. The monasteries of Ireland and Anglo-Saxon Northumbria became strong centres of the art. Their scriptoria produced the first masterpieces of Western European illumination.

110. *The Missal of Reims (Missale Remenense): Crucifixion* (top) and *Deposition* (bottom), 1285-1297. Parchment, 23.3 x 16.2 cm.

In France and Great Britain this era peaked in the eleventh and twelfth centuries. By the beginning of the thirteenth it had already transformed into the Gothic. In Germany, on the other hand, the eleventh century was still closely connected to the Ottonian circle. In the thirteenth century Germany produced masterpieces of Romanesque art. Romanesque book art is almost exclusively monastic.

The history of French miniatures as a phenomenon of national culture begins in the tenth century with the dynasty of Hugo Capet, which would last until 1328. Until then, there were only singular, nevertheless important sources of book manufacturing on the territories of today's France (Reims and Tours). But since the thirteenth century the flourishing French illumination ranked first in Western Europe and strongly influenced the art of other national schools.

The thirteenth century represents not only a transition from the Romanesque style to the Gothic, but it is also a time of fundamental change in illumination and its principles of design. The epoch of monastic book production neared its end because the secular workshops in the cities assumed an increasingly crucial position. In France, Paris became a cultural centre. The reasons for this can be found in the activities of Paris University, named after its founder, Robert de Sorbon. It had become the leading Western European teaching and research facility of the time. Another reason lies in the successful unification policy of the French kings, whose courts, for a long time, would commission sumptuous manuscripts. It is here that typical French traits began to emerge, such as high technical perfection, clear calligraphic drawing, a well thought-out system of décor, and harmonious coloration, which built on gold and the triad of red, white and blue.

As early as 1292, the Paris tax office lists seventeen masters of illumination along with painters, architects, sculptors, glass painters, goldsmiths, carvers and tapestry weavers. These masters of miniature were not only familiar with the achievements of other Parisian artists, but also with the latest innovations that merchants and travelling artists had brought from other countries. This artistic information was creatively employed and then returned to the neighbouring countries in an enriched form defined by Parisian taste. Because of Paris' centralising role, French miniature painting became a unified phenomenon in the thirteenth and fourteenth centuries.

The hegemony of liturgical literature was undermined by social and cultural changes, as well as a new readership and clientele. More and more secular works appeared, such as treatises, chivalric romances and historical writings, which brought worldly, lifelike plots to miniature art. As French court culture developed, notions of courtesy, refinement and finesse also increased. The legendary figure of Roland, who died in battle near Roncesvalles in 778, was replaced by the equally legendary lovers Tristan and Isolde. The Virgin Mary became the main object of religious adoration. Poetry and significant cycles of miniatures were devoted to miracles associated with her. For the first time, plots were told in multiple images.

The development of Gothic miniature began with stern, constructive, and relatively simple first manuscripts featuring precise sketches and large coloured areas; by the

111. *Windmill Psalter : Psalm 1 (Beatus Vir)*, c. 1270-1280. Ink, pigments and gold on vellum paper, 32.3 x 22.2 cm. The Pierpont Morgan Library, New York (United States).

in consilio impiorum: & in via pec
catorum non stetit: & in cathedra pe
stilentie non sedit.
Sed in lege domini voluntas eius:
& in lege eius meditabitur die ac nocte.
Et erit tanquam lignum qd plan
tatum est secus decursus aquarum:

execution approximates the works of the first famous Parisian painter, Master Honoré, whose individual traits are known due to comparisons of archival documents with preserved manuscripts from the end of the thirteenth century. Around this time French miniature had already achieved the unity of elegance and balance, which became an important hallmark of the national school. At the beginning of the fourteenth-century this unity also determined the style of lesser works.

When Early Gothic became High Gothic, a principal change took place in the margins of the manuscripts: the ornaments moved closer to the edge, and the initials grew shoots, which spread to the margin and in the space between columns. They increasingly became plant ornaments, which ultimately occupied all free space as frames and borders. The droll creatures and acrobats that appeared inside the initials during the Romanesque period moved to the margins. They were replaced with plot-related depictions. These small figures, so-called drolleries, balance on branches. They are integrated into the ornaments with berries, vines, leaves and flowers. Drolleries enact independent scenes on the page. The question of where these entertaining elements and decorative nature studies originated remains open. Some see the attempts of the Italians as the source of these "menageries" and "botanic gardens"; others consider the drolleries of English miniatures to be the origin; yet others believe that the Dutch interest in reality is responsible, or that the drolleries are the depiction of German dreams.

Obviously, however, drolleries owe their success to Paris, from where this new technology spread throughout Europe. Undoubtedly, they are related to the traditional fairs with

end of the thirteenth century works with delicate lines and graceful figuration were produced. The ensemble of all textual and illustrative elements grew ever more complicated. The new, Gothic unity of the "well illustrated missal" was compared succinctly by John Ruskin to the "wonderful Gothic cathedral with its many glass windows". Such an ensemble is represented by the *Missal of Rheims* (see p. 138), a creation from the transitional period of Early to High Gothic. The level of

112. **Walther von der Vogelweide,** *Manuscript of Heidelberg ("Minnessang"): Minnesänger,* 1315-1340. University Library, Heidelberg (Germany).

their juggling acts, acrobatics and animal tricks, as well as to the naturalistic elements of medieval theatre. Brunetto Latini's *Li livres du trésor* (precious books) are among the first French codices where entire juggling performances are shown on branches that reach far into the page.

At the beginning of the fourteenth-century French miniatures became increasingly refined. The drawing lines became lighter and more tentative; the proportions of the human body were lengthened; there is something musical about the rhythms of the garment folds and drapery. The intensely lush coloration of early Gothic miniatures is replaced with a delicate interaction of pale tones and lightly shaded drawings. This is the ascent of the grisaille.

In the first half of the fourteenth-century, there was an artist who summarised the achievements of the Parisian school and developed a new, forward-looking quality. This artist was Master Jean Pucelle, who, according to Erwin Panofsky, was "equally as important to the development of painting in the north as Giotto and Duccio were to Italy". Pucelle perfected elegant silhouettes, rapid drawing, and the grisaille-technique, which first allowed the rendering of volume. He turned the first timid attempts to overcome the abstract backgrounds into architectural compositions that demonstrated spatial depth.

Pucelle also designed his margins to be freer than his predecessors'. He further developed the main scene, added realistic details and proved his narrative talents. The characters' movements are livelier; the compositions become freer and richer. That the intimate art of

fourteenth-century illumination could do justice to the demands of its time was, to a large extent, thanks to Pucelle's contribution. Illumination was less exposed to the dramatic events of the fourteenth century than architecture and monumental art and it continued despite the Hundred Years War, economic decline and the plague. Pucelle's traditions remained influential and fruitful until the end of the century. His most faithful follower was Le Noir at the court of Charles V (see p. 147).

113. **Walther von der Vogelweide**, *Manuscript of Heidelberg ("Minnessang"): Minnesänger, Heinrich Frauenlob Directs his Orchestra,* 1315-1340. University Library, Heidelberg (Germany).

Or iar el pius denfer pure
La mors del usurier 7 de la pour
fame. Capitlm .X.

Tuit li miracle nře dame
Sont si piteuz 7 douz p mame
Nest nul q̃ bie les recitast
Qui tout liciaus nen apitast

Closest to French miniaturist art, or more specifically to its southern variant, was Spanish miniature. In the second half of the century an independent cultural milieu arose in the Mediterranean regions of Southern France and some areas of Italy and Catalonia. The centre of this culture was Avignon. The richly illustrated codex *Love Breviary*, which was copied in the Catalan city of Lerida, stylistically resembles the illumination of Provence. This art differs from the Parisian school in a hotter coloration, hard drawing and Arabic influences.

By the fourteenth century Italian miniature had already disintegrated into several centres and regional schools. Illumination was particularly active in the city of Bologna where the workshops of copiers surrounded the famous university. The great Italian painting of the Trecento strongly influenced all Italian painting. Around the middle of the century, the illuminators paid special attention to the teachings of painter and architect Giotto di Bondone.

The influence of frescos can be felt in the monumental style and coloration of the initial in the canon of the Persian philosopher, Avicenna; and in the illustration of the novel about the Trojan War. This series of miniatures is exceptional in size and detail. It takes up the lower part of the page and is one of the best examples of continuous narrative depiction, which goes back as far as ancient friezes or old scrolls. In the Middle Ages this method was adopted and transformed (e.g. in the famous Bayeux Tapestry).

Italian miniature in particular developed it intensively (Naples, Bologna, Lombardy), mainly in illustrations of chivalric romances. According to scholars, this Codex's spirit of Innovation, its attention to the illustrated texts,

as well as the enrichment of miniatures with lifelike topics, all act as evidence of the transition to the new epoch of humanism. Another example for the development of humanist culture in Italy is one of the early copies of Petrarch's works.

The illuminated book, *Schachzabelbuch* (Chessboard Book), is a fourteenth-century German illumination that was created by the Swiss Benedictine monk Konrad von Ammenhausen. The rare iconography and genre details

114. **Gautier de Coinci**, *Life and Miracles of the Virgin (La Vie et les miracles de Notre-Dame): Account of Damnation of a Money-lender and Salvation of a Beggar Woman to whom the Holy Virgin and Virgins Appear,* late 13th century. Parchment, 27.5 x 19 cm.
115. *Life of St. Denis: The Entry of St. Denis in Paris,* c. 1317. 24 x 16 cm. Bibliothèque nationale de France, Paris (France).

Prague – the national style professed succinct modifications, such as characteristic facial types, square figures, which were unknown in France, as well as a different coloration.

The features of the international style that flourished in many European centres also deserve mention. The highest accomplishments of this style of illumination at the turn of the fifteenth century were predestined by the development of the abovementioned courtly arts in France. The tradition of enlightened patronage and bibliophily arose at the French court especially. Both originate with the French King John II (John the Good) and were continued by the wise King Karl V, whose library held approximately 900 volumes on a wide variety of topics.

The tradition was further developed under Philipp II, Duke of Burgundy and Jean de Valois, Duke of Berry. This remarkable period in the history of French miniature art is often connected to the name of de Valois, since under his leadership Paris became the "ruler" of artistic taste. The advantages offered by the court and aristocracy brought many artists and masters from other countries to the French capital. Since the middle of the fourteenth century there was a particularly strong influx of masters from the Netherlands. They brought with them a taste for colour, light, space and an interest in the real. The combination of these tendencies with Pucelle's traditions brought forth one of the most interesting phenomena in the history of art: the so-called Franco-Flemish miniature. The traditional framework of the Parisian school had become too narrow by the fourteenth

make the miniatures of this book highly interesting – except for some peculiarities of national style. Depending on the place of production – Rhineland, Saxony, Swabia, or a school that followed the capital of the empire of that time,

116. **Giovanni de' Grassi,** *Brevarium ambrosianum* called *Il Beroldo*, c. 1390. Biblioteca Trivulziana, Milan (Italy).

117. **Jean Le Noir,** *Les Petites Heures de Jean de Berry: Birth of John the Baptist and the Baptism of Jesus,* 14th century. 22.5 x 13.6 cm. Musée Condé, Chantilly (France).

118. **Guyart des Moulins,** *Historic Bible (La Bible Historiale): The Trinity Enthroned (Opening Page),* third quarter of the 14th century. Parchment, 45.5 x 31.5 cm.

119. **Guyart des Moulins,** *Historic Bible (La Bible Historiale): New Testament (Frontispiece),* third quarter of the 14th century. Parchment, 45.5 x 31.5 cm.

e uentic matris mer uccauur me dñs
nomine meo. ct poliut os meũ liaut
gladuim acutum lubtegumento
manus lue protexit me poliut me

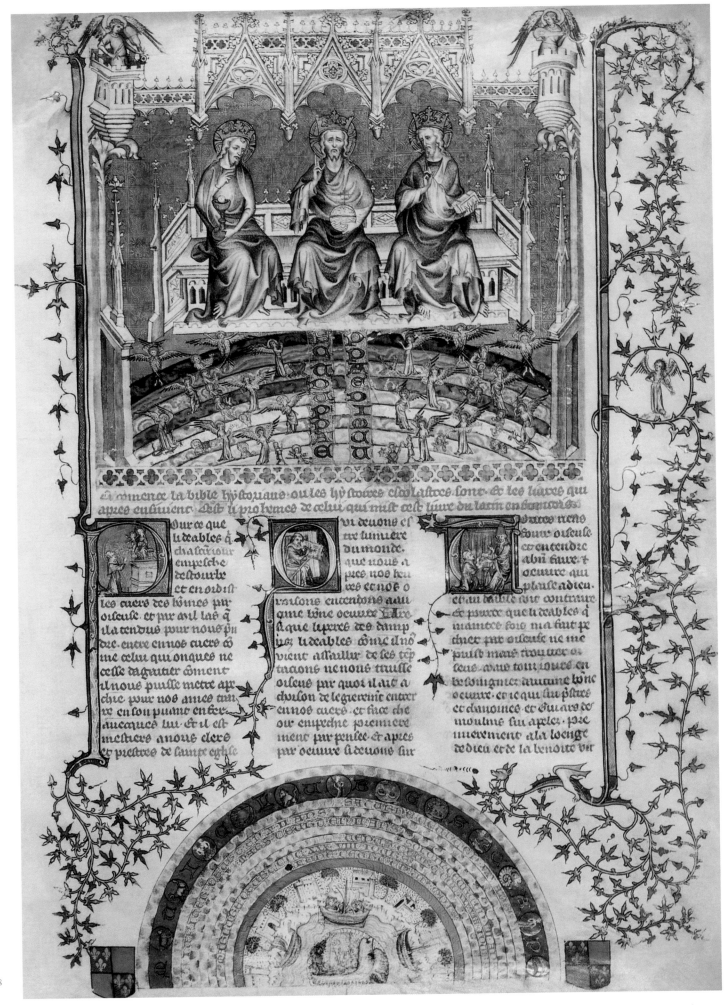

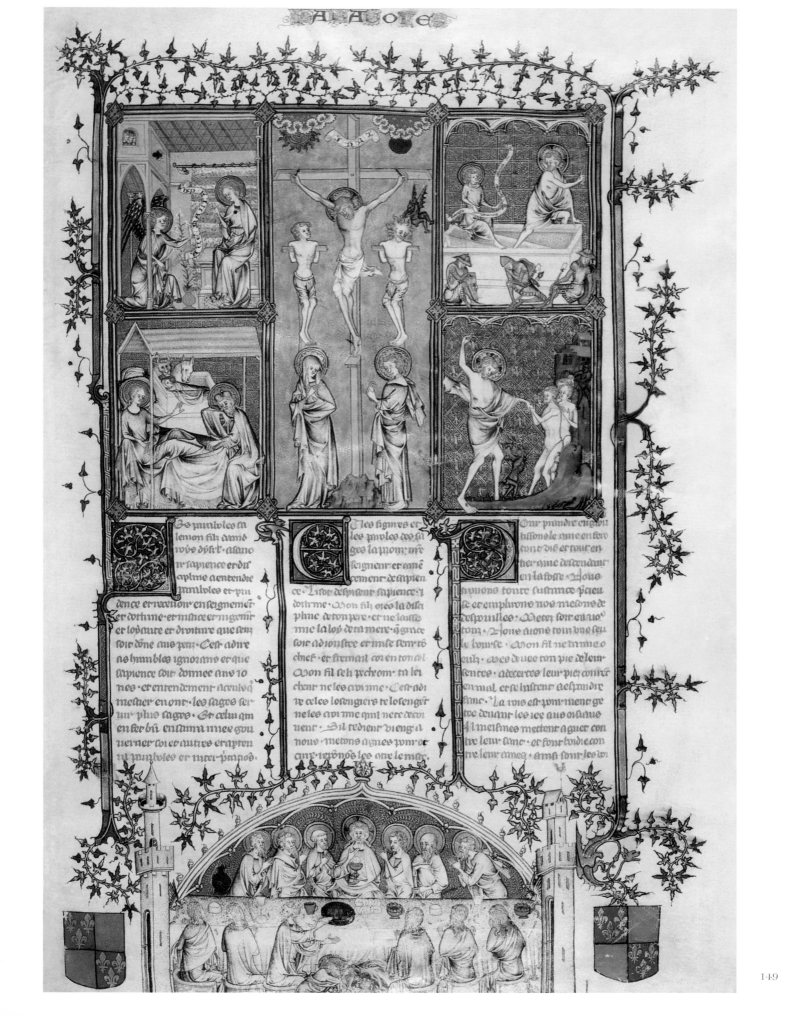

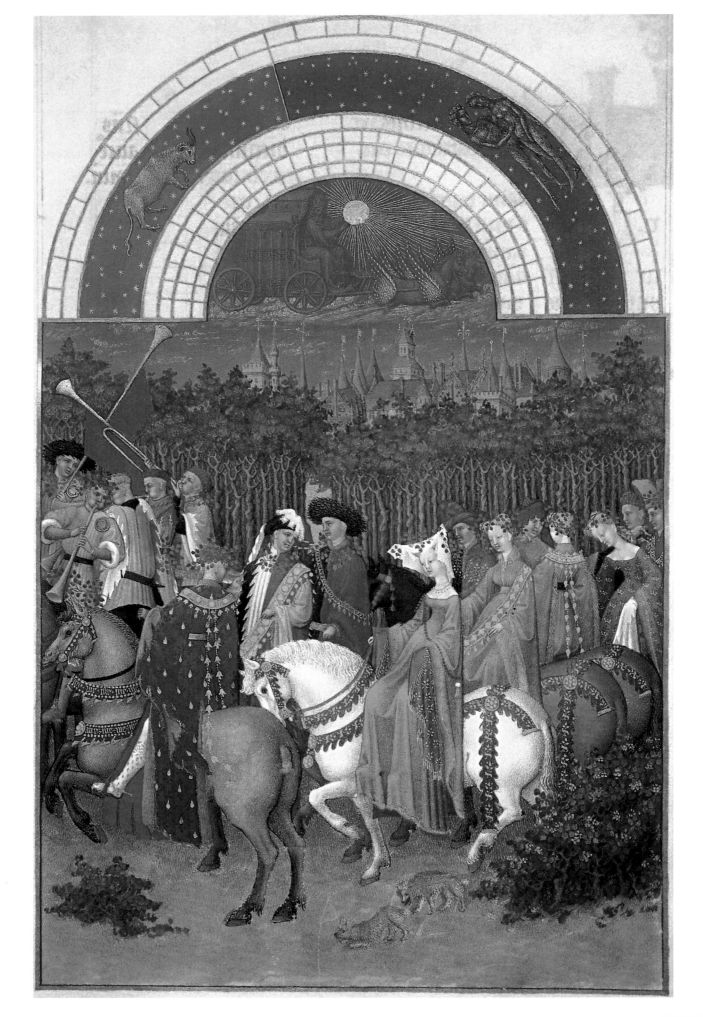

century. The figures had become too wide and complex and Pucelle's "doll houses" no longer sufficed for the imagination of Berry's masters.

Another step was needed to bring about the first attempts of portraiture and landscape painting. After the end of the fourteenth century panel painting developed alongside miniature art.

Italy was on the cusp of the quattrocentist revolution. The Netherlands neared the change heralded by the brothers Hubert and Jan Van Eyck. The revolution in illumination was triggered by the artists of the Berry-circle, such as Jacquemart de Hesdin who created the marshal's book of hours; Bouicaut, who designed the books of hours for the Dukes of Rohan; and particularly the Dutch brothers Paul, Hermann and Jan Limbourg, about whom next to nothing is known. Their works are accompanied by the illustrations of prayer books for laypeople, didactic and historical works, and courtly and chivalric romances, which exemplified the elegant fairy-tale world of courteous society (see p. 150, 151).

In the fourteenth century an entire system was created for the illustration of romances: the small miniatures, which are squarely framed, are placed within the two or three columns of the text. The illustrations were usually combined with initials or placed adjacently; they are frequently accompanied by an ornamental fragment on the margin. An example of an erstwhile exquisite, later common margin décor is the illumination of a book of hours that represents the Parisian variant of Franco-Flemish art. These miniatures show the rich and complex coloration of the era of Charles VI.

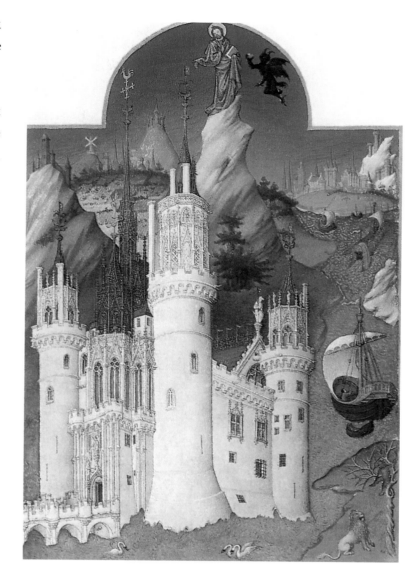

After the devastating defeat of Agincourt by the English on 25 October, 1415, the country faced its most difficult stage in the Hundred Years War. The effects this war had on French art were profound. The kingdom split up and the resulting regions sometimes even fought each other. Conquered and destroyed by the English, Paris lost its central role. The development of painting continued

120. **The Limbourg Brothers**, *Les Très Riches Heures du duc de Berry: The Month of May*, c. 1412-1416. 22.5 x 13.6 cm. Musée Condé, Chantilly (France).
121. **The Limbourg Brothers**, *Les Très Riches Heures du duc de Berry: The Temptation of Christ*, c. 1412-1416. Musée Condé, Chantilly (France).

the Prague court of King Wenceslas IV. Lombardy miniatures united aristocratic exquisiteness with an acute attentiveness and an objectivity that bordered on naturalism. These traits bespeak the culture's late Gothic character. Master Giovanni dei Grassi and Michelino da Besozzo, both of whom worked for the passionate bibliophile, the archbishop of Milan, Duke of Lombardy Giangaleazzo Visconti, achieved highest perfection in the décor and illumination of luxurious manuscripts.

Filippo Maria Visconti and Francesco Sforza inherited the taste for beautiful books along with the Duchy of Milan. Belbello da Pavia continued the tradition with his works from 1430 to 1473 and Bonifazio Bembo from 1447 to 1477. A remarkable example of Lombardy illumination is the *Semideus*, which was part of the Duke's library. In this work Michelino da Besozzo's precious coloration is united with Belbello da Pacia's microscopically subtle, expressive manner.

The exciting illustrations of the battle scenes are reminiscent of Bembo's favoured tinted watercolour drawings, which were typical for Lombardy miniatures. At the time when Milan and Pavia still produced manuscripts similar to the *Semideus*, Renaissance culture had already triumphed in other areas of Italy, mainly Florence. Illumination did not experience the same upswing as architecture, sculpture and painting. Still, one should not forget that the humanist book was as much an "instrument" of Renaissance culture as the monastic manuscripts had been "instruments" of medieval culture.

In the middle and second half of the fifteenth century French illumination was far-reaching. Today, efforts are made to ascribe the preserved illuminated manuscripts to

elsewhere. The artists fled from the ruined capital to the South of the country, to Burgundy, the shores of the Loire, or even abroad. The second half of the fifteenth century, which was the most fruitful time for Italian and Dutch masters, was the most unproductive period in French art, including illuminations. The miniatures of these years had no creative verve, and merely used existing techniques.

From the middle of the fourteenth to the beginning of the fifteenth century, Lombardy was the Italian centre of illumination closest to France. At the court of Duke Visconti in Milan courtly arts flourished and the same style, called "soft" by some scholars, was practised as it was in Paris, the five-aisled cathedrals in Bourges and Dijon, or at

122. **Jean Dalbon**, Decoration of the Pope's Room, Palace of the Popes, Avignon (France), 1336-1337. Tempera painting. In situ.

123. Decoration of the Stag Room, Palace of the Popes, Avignon (France), 1343. Fresco. In situ.

124. *The Nativity*, detail of the *Story of the Youth of Christ,* ambulatory, Basilica of St. Denis, Saint-Denis (France), 1140-1145. Stained-glass window. In situ.

specific masters and local schools. Thus emerged Master François, Master Juvénal des Ursins (the illustrations of the *Roman de Fauvel* also belong to this circle), Charles of France's master (who is credited with the illumination of Martin de Braga's treatises and those of Marcus Tullius Cicero). In the services of the influential family Rolin in Autun was an artist who professed ample individual manner (*Book of Hours* of the Rolin-Lévis). The productive school of Rouen (Chronicle of Jean de Courcy) tends towards a somewhat dry graphic style. The range of topics of the illuminated works was expanded by the work of the Italian philosopher and theologian, Thomas Aquinas, as well as novellas based on biographical episodes (*The Fifteen Joys of Marriage*). The latter manuscript is also an example of miniatures on paper.

The tinted quill drawings in the *Tournament* and in *Regnault and Jeanneton* are not complete illustrations, but sketches. Scientific treatises became even more popular and included herbals and works on medicine. The iconography of illustrations for such encyclopaedic manuscripts, which harkened back to the works of ancient and Arabic scholars, had already been developed in the Romanesque era. The Italians had contributed to it especially. The way this iconography was retained and developed is vividly demonstrated in the miniatures of two herbals by Platearius, which were produced fifty years apart.

In close connection to and lively interaction with French miniature art, illumination also developed in the "buffer state" of Burgundy, the culture of which was as complicated as its political fate. The great Masters of the northern Renaissance, who focused on panel painting,

came from the progressive citizenship of the Duchy's Dutch provinces. The court of Burgundy belonged to the brightly coloured demise of chivalry. In its past, even Paris had not known such sumptuous feasts, stylish garments or refined etiquette. Here the idea of the crusades was born; tournaments were carried out, and the Order of the Golden Fleece was founded. Poets, painters, sculptors, architects, historians and translators were in the court's services. Particularly during the reign of the last Dukes, Philipp the Good and his son Charles the Brave, who fell at Nancy, this courtly culture reached its peak. The ducal library owes its extraordinary wealth to the patronage of Philipp, who is also referred to as the "Great Duke of the West". Its collection was completed by both the acquisition of manuscripts and the commissioning of new works.

125. *Abbey Suger of Saint-Denis at the Feet of Mary,* detail of a glass window of the Basilica of St. Denis, Saint-Denis (France), 1140-1145. Stained-glass window. In situ.

The Duke had several workshops working for him, which is why they were more connected with courtly than with city culture. Although Burgundy's illumination could not ignore the discoveries of works by its great contemporaries, such as Jan Van Eyck, Rogier Van der Weyden, Hans Memling or Hugo Van der Goes, it remained closely attached to the aristocratic traditions of the French illumination from the beginning of the century. Confirmation of this claim can be found in a manuscript made for Philipp the Good, the treatise of Guido Parati, which opens with a miniature showing an excellent "group portrait" of Philipp and his entourage.

In Bruges many books were produced, the artists of which not only worked for their lord, Louis de Bruges, but also for respected citizens, noblemen from the Duke's circles, and even for foreign authorities, such as the King of England. One of these Flemish workshops produced the monumental folio, *Chronology of the World*. Rare in its form and binding, this work is a good example of Flemish miniature, as is the *Ovid* that was ordered by a relative of Louis Gruthuyse.

The illumination of Brabant is introduced by a few leaves from a humble prayer book. This is an example that illustrates how, in those times, various manuscripts were combined within one binding. After the Duchy of Burgundy disintegrated, which, historically speaking, was inevitable because of Louis XI's unification policy, its miniature art split, too. Those artists who identified with the French style joined the process of building a unified national art, while the masters of the northern cities, who had ended up under the rule of Hapsburg, now completely integrated their work with Dutch art. The works of Jean Fouquet and Simon Marmion were the apex of French miniature in the fifteenth century, just before its demise. Despite its formal and technical accomplishments, ornamentation of the manuscripts became increasingly clichéd. All creativity was directed at the illustrations, which gained their own meaning independent of the overall book. The influence of panel painting was inevitable and the opulently ornamented manuscript turned into a work of art, rather than literature. Half a century after Fouquet, the last illuminators copied panel paintings, often including the frames.

Another reason for the decline of the miniature was its replacement with printed books, which appeared on the market around the same time that Fouquet created his masterpieces. Fouquet's successors, who worked under the conditions of faster and cheaper book production, no longer equalled the creative energy of the master from Tours. They still used his tricks and motifs, but flattened and trivialised his discoveries without grasping their nature.

Gothic Frescos

Medieval Gothic painting was liberated from architecture earlier than it was from sculpture, which ultimately found refuge in wood carving. It was the drive for self-preservation that caused this liberation because the basic law of Gothic architecture gradually brought about the end of fresco. As the closely grouped pillars were increasingly removed, there was no more room for wall paintings. At first, fresco paintings fought for survival, but only a few of these last attempts are preserved. In Germany, the best example of late medieval wall painting is *Christ Enthroned* in the apse of the Church of Braunweiler. The last refuge of the fresco was castles and town halls where this kind of painting also eventually

126. *Story of the Youth and Passion of Christ* and *Jesse Tree,* glass window, Notre-Dame Cathedral, Chartres (France), 1150-1155. Stained-glass window. In situ.

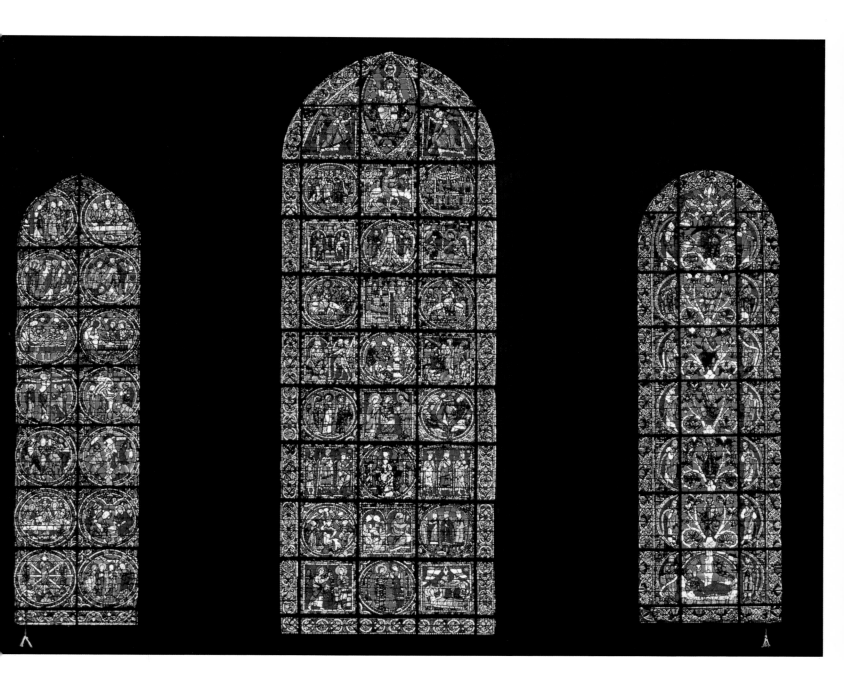

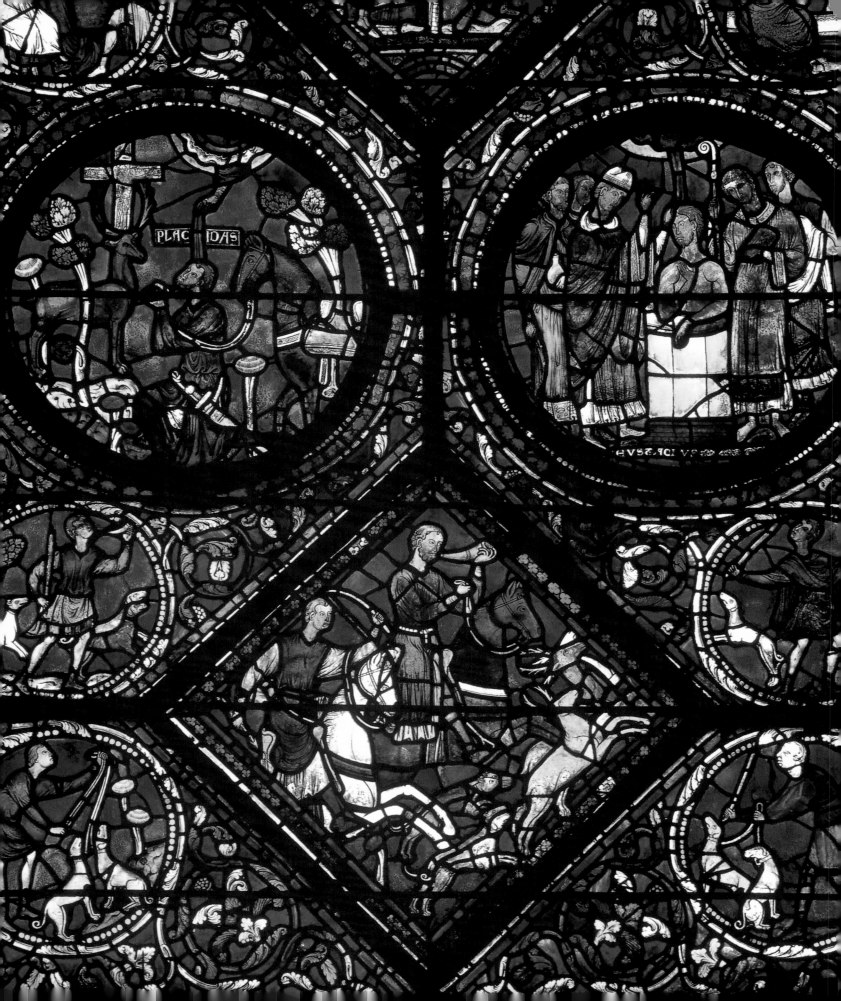

ceased. How significant the development of frescos was until that time becomes obvious in the wall painting at Castle Runkelstein near Bolzano, Italy. With its scenes from the legend of Tristan and Isolde, and of courtly life in the fourteenth century with its games and dances, it may have been the most beautiful fresco in Europe. The fact that the topics are taken from a masterwork of chivalric heroic poetry is due to the close interaction of frescos and illumination; the latter often inspired wall painting in the Gothic middle-ages.

Gothic Glass Painting

The role that frescos once fulfilled was gradually taken over by glass painting, which flourished in the fourteenth and fifteenth centuries. The windows of the aisles and particularly those in the choir offered a large creative space. Glass painting also willingly succumbed to architecture's domination, which it complemented with much imagination. Instead of the monumental single figures of the Romanesque style, an abundance of characters appeared that were framed by the surrounding architecture into a well structured organism. Both disciplines are correlated, and as content stimulates thought, these colourful, transparent glass plates, held by woven lead stripes to form a drawing, stimulate the senses.

Despite the use of fragile material, a relatively large number of windows escaped the storms of time. France has Reims, Beauvais, Chartres (see p. 157, 158) and Strasbourg Cathedrals and particularly the Sainte-Chapelle in Paris (see p. 25). Germany has Cologne, Freiburg and Regensburg Cathedrals, all of which have many relatively intact glass windows. They have preserved classic patterns of technology, which helps to revive the art of old glass makers and glass painters.

Unfortunately, the fresh impression that medieval people had of this art's narrative aspect is lost to our time of information overload.

When the church walls had been removed and northern painting looked for a new sphere of activity, it joined its lot with sculpting. The common goal was the decoration of altars, and they collaborated for a long time; sculpture created the architectural frame for painting. Entire buildings were erected on the altars and decorated with carved imagery. At first, painting played a larger part in covering and gold-plating these frames than in painting the free wooden surfaces left in the architectural framework. For a long time, the carving represented the most distinguished aspect of the altar or altarpiece, which was so valuable and artificial that they would only be shown to common people on high church holidays. On all other days, however, the wings were closed and the art was shielded from the spectators by two closed side panels. Only these two wings were decorated with figurative painting on the outside and inside which proves that painting was of a lower significance than sculpture during the reign of the Gothic. In many areas of Germany, north and south, sculpture would maintain its leading role well into the sixteenth century.

Only after the fifteenth century does painting manage to conquer the middle panel, too. It could freely flourish, become independent of sculpture and architecture, and develop into panel painting proper. The first steps in this direction had already been made by the painters in Cologne and the Lower Rhine at the end of the fourteenth century.

127. *St. Eustache Hunts a Stag,* detail from the *Life of St. Eustache,* Notre-Dame Cathedral, Chartres (France), c. 1200-1210. Stained-glass window. In situ.

Gothic Sculpture

During the era of the high Middle Ages, which in art is called Gothic (from about 1150 to 1450), the face of society changed. The church was still very powerful, but trade and industry brought increasing power and wealth to the cities. The townspeople's gain in cultural and political self-confidence was commensurate with the feudal lords' loss of power. This development had its effect on art. The Romanesque style had been almost exclusively shaped and financed by monasteries. Now, citizens commissioned works, too. Sculpture, therefore, was no longer a purely sacred art, but also served secular purposes. Nevertheless, the great Gothic cathedrals clearly demonstrate a striving for the divine and an orientation towards the hereafter. Architecture shakes off the fetters of Antiquity and looks for new solutions. The result has very little left in common with the massive, uncomplicated Romanesque style.

The development of the pointed arch, the cross vault, the joist system, and the immense windows, which are often sectioned by tracery, are proof of the striving towards Heaven, towards the supernatural. The walls literally dissolve; the feeling of Romanesque heaviness is absent. Art, like philosophy, reflects the two juxtaposing views of the world: on the one hand there is the exact depiction of nature, and on the other its beautifying idealisation. The merging of these two opposites is visible in the so-called "international Gothic" (or "soft style" in Germany), which arose around 1350. Beautiful Madonnas are characteristic of this style; their shapes are not determined by their bodies, but by the beautifully flowing lines of their garments. The overall impression of these sculptures is the classic *contrapposto* stance that is modelled on an S-shape.

At that time, the church took the leadership of the crusades to re-conquer the Holy Land. Despite, or perhaps even because of the crusades, Islamic notions and ideas found their way into medieval iconography.

128. **Andrea Pisano**, South Portal Door, San Giovanni Baptistery, Florence (Italy), 1330-1336. Gilded bronze. In situ.

It is impossible to separate the development of Gothic sculpture from the rise of new forms in architecture. The plastic programmes in the Gothic cathedrals exploded: there was an enormous variety of creative motifs and possibilities. The middle pillar supporting the tympanum, the side walls of the portal and the alcoves were all filled with angels, saints, prophets and other figures. The side walls are included in the plastic design and entry areas are created featuring up to three, or even five portals, and a great number of life-size statues. Some of early Gothic statues, such as the jamb statues at Chartres Cathedral (see p. 36), embodied their significant role in the church:

they are stiff and linear, yet in comparison to their Romanesque predecessors they are much softer, realistic and emotional; one could almost say "more human". Often, they also seem cerebral. The figure of Christ above the portal of Chartres, for example, expresses great goodness and mercy, and His body is no longer stiff, but suffused with motion.

The statues of medieval Gothic courtly culture are even more removed from the rigid Romanesque style. The figures are extremely elongated; the strictly vertical folds emphasise the dominant vertical movement. The ponderation interrupts the straight form, gives it an elegant, lithe S-form and gives a dynamic impression. The French Late Gothic in particular is defined by courtly elegance. The plastic design of living, seemingly moving figures (due to the S-Line) is often very attractive, even though these figures may be less expressive as narrative elements.

Whatever independence sculpture had gained by the end of the Romanesque epoch, it lost again as Gothic building style progressed. Only recently liberated, sculpture became a servant to architecture, and had to submit to all its guidelines without consideration for the natural shape of the human body, yet it was supposed to breathe life into the stone, an ability which sculpture managed to retain during the Early Gothic. Gradually, however, the expression of the inner spirit froze into a conventional smile, even on faces that should express seriousness, or into a grimace that merely suggested life. In particular, the statues that adorned the portal walls had to succumb to architecture's bent and curved lines. They resembled figures leaning to the left and the

129. **Andrea Pisano** and **Giotto di Bondone**, *Tubal-Cain, the Blacksmith*, 1334-1337. Marble. Museo dell'Opera del Duomo, Florence (Italy).
130. **Nicola Pisano**, *Pulpit*, Duomo, Siena (Italy), 1266-1268. Marble, h: 460 cm. In situ.

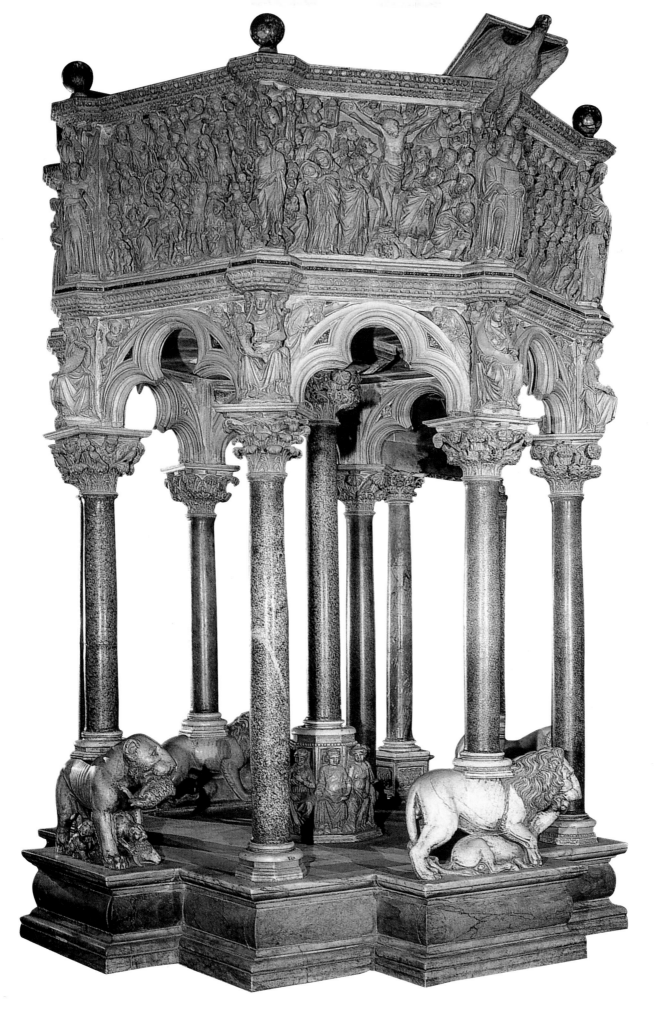

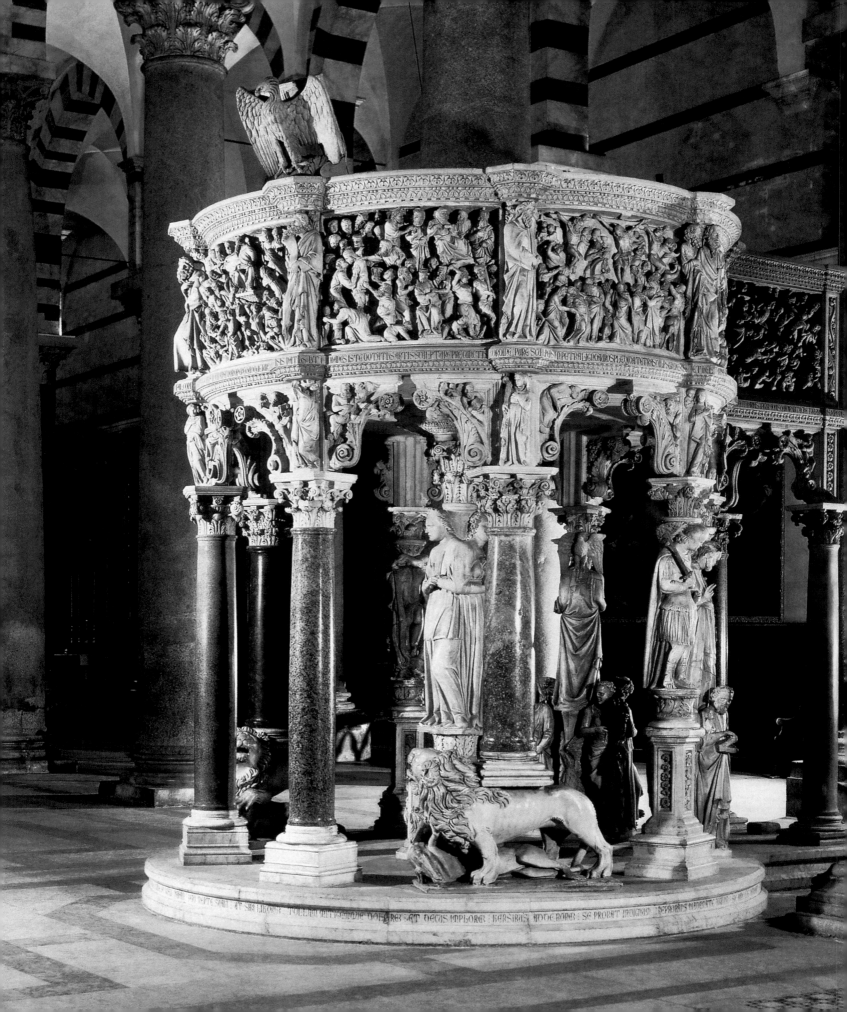

right, like flower stems swaying in the wind. For a long time this unnatural posture influenced not only sculpture, but also painting. Even an innovator like Albrecht Dürer was under its influence when he began his career. Naturally, the fashion of the time may have also contributed to this shape.

Despite the affectation of forms, which Gothic sculpture adopted at the end of the Middle Ages, there was always a competition with nature. Painting had to help and was widely applied to sculptures made from various materials such as wood, stone and stucco. Sculpture was intended to replace nature, and to achieve this goal all possibilities were explored. To the modern aesthetic sense, cultivated by nineteenth century colourless sculpture, the results often seem barbaric and exaggerated. Medieval naturalism considered the most beautiful to be as worthy of detailed depiction as the most horrible. This essentially proved its artistic validity. The method of depiction was of the greatest importance; the representational aspect remained secondary. Art only moves forward when great, all-encompassing thoughts define and shake the times (which is rare), or when the artists delve deeper into the creative secrets of nature. Gothic architecture always strove towards spiritualisation in all forms of expression. The very size of the rooms gave rise to spiritual reflection. At the same time, reality is observed more astutely and the sculptures became more expressive and realistic. The faces expressed sincerity and grace. They had souls. The symbolic depiction became allegoric depiction. There can be no doubt that some of the Gothic sculptors relied on models from

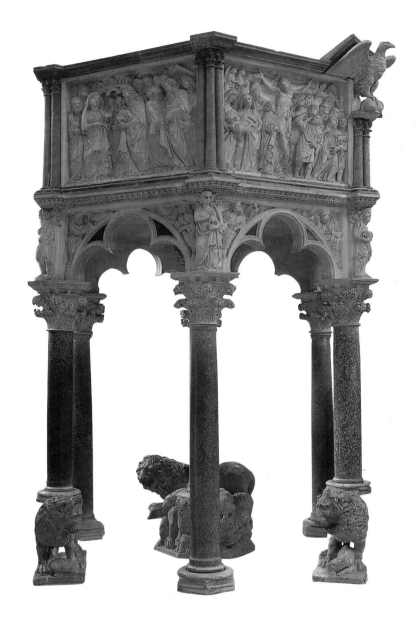

Antiquity. This can be clearly seen, for example, in the *Annunciation* in Reims Cathedral (see p. 42-43), and, even more strongly, in the works of the Italian Nicola Pisano.

131. **Giovanni Pisano**, *Pulpit*, Pisa Cathedral, Pisa (Italy), 1302-1311. Multicoloured marble, h: 455 cm. In situ.
132. **Nicola Pisano**, *Pulpit*, Baptistery, Pisa (Italy), 1260. Marble, h: 465 cm. In situ.
133. **Arnolfo di Cambio**, *Sickman at the Fountain*, sculpture fragment. Marble. Galleria Nazionale dell'Umbria, Perugia (Italy).

The plastic design of the Florentine Cathedral was most likely executed by Giotto himself from his own sketches: in its simple, characteristic truthfulness to nature it demonstrates a style informed by a fine aesthetic sense. Andrea Pisano had adopted the painterly qualities of Giotto's art even before he came to Florence to design an oak door for the baptistery (see p. 160). In 1330 he finished the models for the door and completed the brass-cast in 1336. Each wing of the door, which today is located on the building's south side, contains fourteen small, sculptural relief depictions framed by Gothic quatrefoils. Twenty of them tell the story of John the Baptist in Giotto's typically simple, concise style. Only employing a minimum of figures, the plot is so vividly told that the viewer feels like a part of the tale. These reliefs, and those on the belfry, are the basis for the greatness of Florentine fifteenth-century sculpture.

Andrea Pisano was a pupil of Giovanni Pisano, whose father, Nicola Pisano, stood at the helm of Middle Italy's new sculptural developments. In Tuscany the first stirrings of the ancient Italian spirit re-emerged; the first attempts to break the domination of the Byzantine style were made. Nicola Pisano was the first to completely overcome it by returning to national models: remains of Etruscan and Late Roman sculpture, which surrounded him in Pisa; Roman sarcophagi and vases; Etruscan ash urns. Their figurative depictions offered Pisano many motifs for his masterpiece, the six reliefs about Christ's life that he created for the pulpit's balustrade in Pisa's baptistery (see p. 165). In terms of architectural structure this pulpit is influenced by the Gothic. Only the balustrade's reliefs and the lions carrying the pillars are of Italian origin. They may well be reminders of ancient art.

Nicola Pisano's attempt to imitate ancient art was not yet true progression, although his six reliefs do demonstrate great technical skill and an assured understanding of ancient art's greatness. This "renaissance of classical Antiquity" was premature because there were not yet sufficient nature studies. Nicola Pisano must have felt this lack. In his second major work, the marble pulpit in Siena Cathedral (1265-1268) (see p. 163), he strove for a stronger approximation of nature. Since he no longer strictly followed his Roman models, this attempt naturally led to more imperfections in the execution.

Only his elder son, Giovanni Pisano, who worked on this pulpit as a young man, eventually achieved the principle of naturalism and reached a true expression of life and nature. He did so, however, with youthful impetuosity, and could not restrain the overflowing force of creativity. As a result a wealth of figures is compressed into small frames, which prevents the viewer from gaining an overview and calmly enjoy the artwork. Also among Giovanni Pisano's masterpieces are two pulpits, which in construction and design do not significantly differ from those created by his father. One is in the church of San Andrea in Pistoja and was completed in 1301. The other was produced for Pisa Cathedral, between 1302 and 1311 (see p. 164). The reliefs of the former demonstrate

134. *Tomb of King Edward II*, Gloucester Cathedral, Gloucester (United Kingdom), c. 1330-1335. Marble and alabaster. In situ.
135. *Christ and St. John, Group of Sigmaringen*, c. 1330. Polychrome and gilded walnut. Staatliche Museen zu Berlin, Berlin (Germany).
136. *Röttgen Pietà*, c. 1300. Lime wood and traces of polychromy, h: 88.5 cm. Rheinisches Landesmuseum, Bonn (Germany).

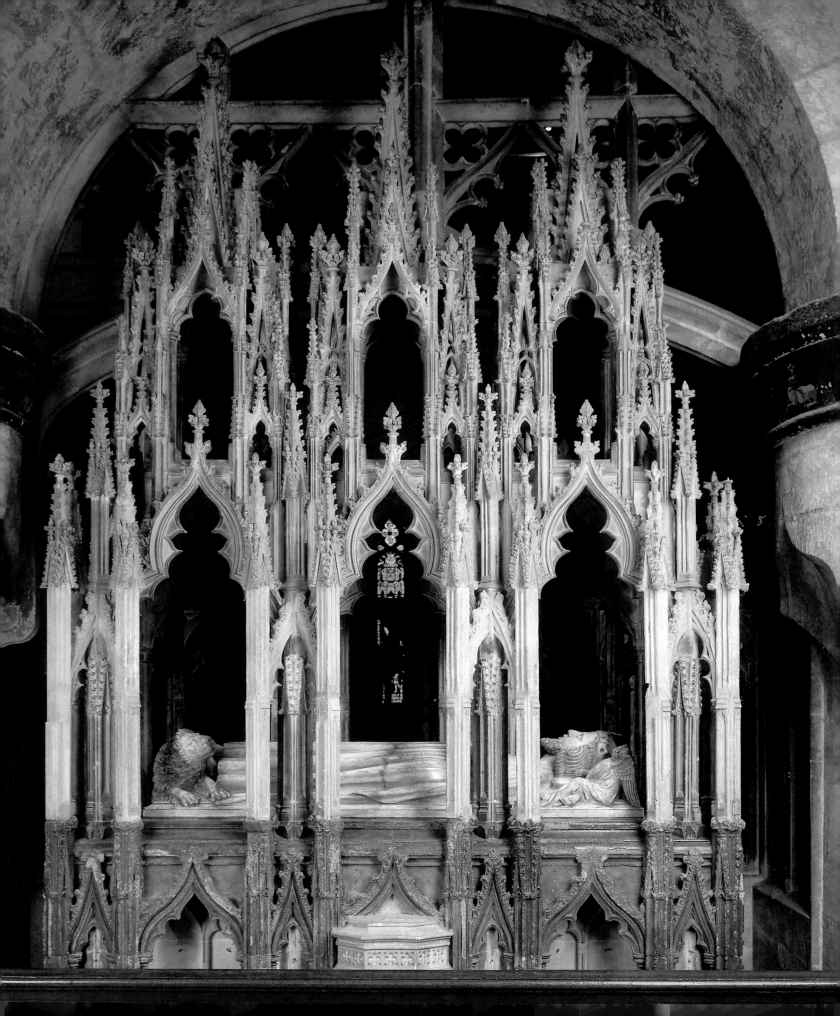

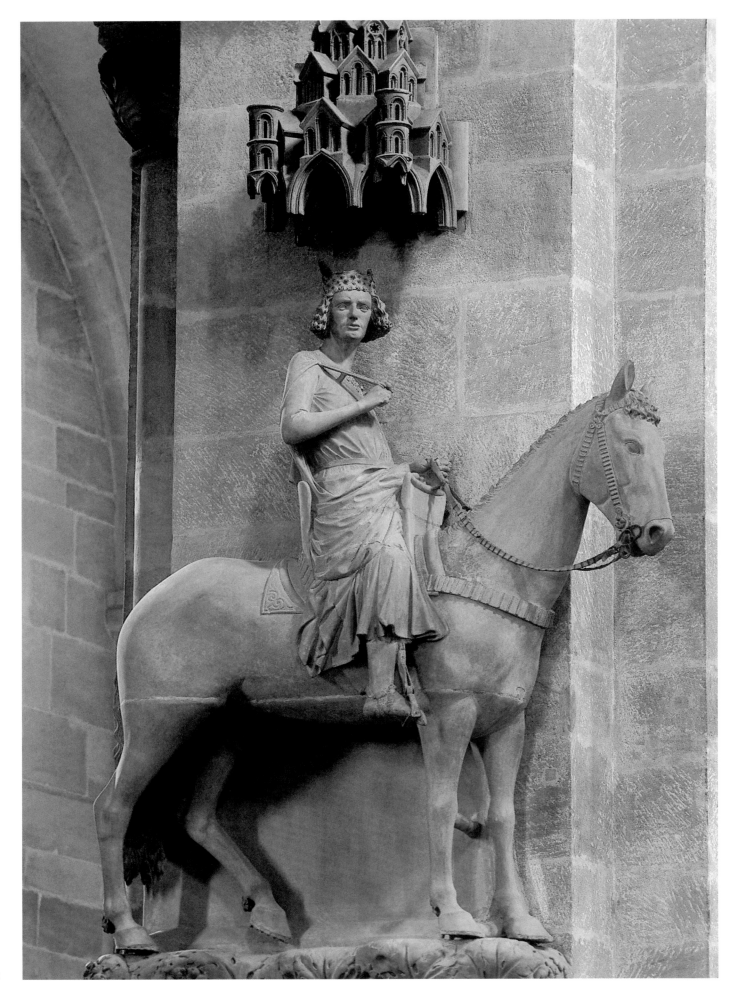

the difference between Giovanni's art and that of his father. The elder's solemnity is replaced by the younger's desire to fully express life. Observations of even the smallest details are noticeable all over; for example in the way a maid carefully checks the water in the bath for the newborn Christ. This delight in observation led the artist to retain little of the results of the latter, to disregard the balance of his depiction. The joy of narration relegates all else to the background and this natural eloquence impressed none more than the young Giotto. His study of Giovanni Pisano's works helped his narrative art reach its monumental simplicity.

Gothic Sculpture in England

English sculpture began in the middle of the thirteenth century when French artists were invited to England. The English taste preferred the bas relief, which was used for decorating buildings. Gravestone sculptures that closely resembled the deceased were popular among the nobility and wealthy townsfolk. A characteristic of English sculpture is walking figures. Typically English are also the magnificent, small works of decoration, carving and stonemasonry that masterfully ornament countless vault spandrels, pillar capitals, arcades and more. English sculpture reached its peak in the middle of the fourteenth century, soon before its demise. This is clearly visible in tomb sculptures; their lively, natural expression became stiff and expressionless.

137. *King on his Horse*, also known as *The Bamberg Rider*, first pillar on the northen face of the chancel, St. Peter and St. George Cathedral, Bamberg (Germany), before 1237. Stone, h: 233 cm. In situ.
138. *Synagoga,* second south-side pillar of the chancel, St. Peter and St. George Cathedral, Bamberg (Germany), 1225-1237. Stone. In situ.

Gothic Sculpture in Germany

The ecclesiastic sculptures that were created in Germany during the Gothic era cannot compare in number or quality to those in France. The reasons for this lie in the over all development of German sculpture, but also because of Germany's political conditions. After the dazzling political period of the twelfth to thirteenth centuries, the country increasingly disintegrated, which significantly curtailed the expenditure for church decoration. Sculpture had reached its highest point in Germany when Gothic architecture first spread. This highest display of strength was naturally followed by a gradual recession, which ultimately ended in utter weakness.

During the initial Gothic phase, which was still close to the Romanesque, a variety of excellent sculptures were created that combined the majestic character of the Romanesque style with the new style's stronger aesthetic sense and natural truth. When Gothic architecture's completed system arrived in Germany, it brought with it a new attitude to sculpture as a subservient art-form. This found acceptance wherever new building forms were adopted, namely in the two big cathedrals of Freiburg and Strasbourg. In their initial phase these new building forms had soulful expression and an inner feeling. Already in the second half of the fourteenth century German sculpture had declined, at least in the use of external church decorations. Artists became craftspeople and art retreated to the interior of churches, where it did not have to succumb to the architectural guidelines as much.

Germany developed its own version of the Late Gothic, which differs significantly from that of France and Italy. An exceptional example is the *Rottgen Pietà* (see p. 171), which an unknown artist created near Mainz sometime in the first half of the fourteenth century. This intimate scene of lament shows the bloody, crucified Christ, with drastically exaggerated stigmata, in the arms of His mother. It is a vivid image of torment that intends to inspire prayer rather than to achieve formal perfection. Its mystical power is typical for the Middle Ages, but its moving depiction of suffering makes it timeless.

German sculpture of these years is further distinguished by the quiet posture of its figures and a weak vitality of expression. Later, however, the statues became more vivid, and the forms softer and more dynamic. There was an increased search for naturalness. Wavy lines became German sculpture's characteristic of the time. Artists' favoured material was wood, which was soft and flexible and could be fashioned into the curved forms of young women and curly-headed girls. The graceful and vivid figures of Bamberg Cathedral bear witness to the great maturity and beauty of German sculpture (see p. 172, 173). The head of Henry II is of particular aesthetic interest.

When the Middle Ages turned into modernity at the end of the fifteenth century, Tilman Riemenschneider was the most significant late Gothic sculptor in Lower Franconia. His artistic expression in different media is of consistent quality. The influence of Niclas Gerhaert's Dutch realism proved defining for Riemenschneider's style and themes. Additionally, he managed to infuse his works with life. The fifteenth century was a time of change; the rise in realism became noticeable in people's attitude towards the human condition and the sacred,

139. **Veit Stoss**, *St. Mary Altarpiece: Death of the Virgin* and *Christ Receiving the Virgin* (central panel), St. Mary Cathedral, Cracow (Poland), 1477-1489. Wood, h: 13 m. In situ.

thus also in Riemenschneider's works (see p. 176). Artists such as Jörg Syrlin the Elder, Adam Krafft and Peter Vischer influenced Riemenschneider, but his art is squarely anchored in the Late Gothic. He wanted to clearly portray Christ's suffering in his works. The Passion and the Deposition of the Cross were his main themes, which he showed with great compassion. His portraits, particularly of knights and women, are characterised by great sensitivity and distinctive naturalism.

Veit Stoss, who had to live through unusual highs and lows, placed his narrative scenes into complex Gothic frames, which he filled with melancholy figures. His altarpiece in St. Mary Church in Cracow is the largest carved polyptych altarpiece in the German Gothic (see p. 175). The folds of the garments clearly show the manner of late Gothic style, his characters express characteristic emotional movement. This kind of expressionism can also be found in late Gothic painting and would be rediscovered by German expressionists in the twentieth century.

Only a few names of sculptors are known from Romanesque times. This changes in the Gothic period, because artists were revered for their own work and no longer seen as henchmen of the church. This is an important symptom for the ongoing discovery of man and the world, and a first sign of the transition to the Renaissance and modernity.

Gothic Sculpture in France

In France, the home of Gothic architecture, sculpture developed in the same direction as the new building style.

After a fast rise it achieved a high, but brief maturation. The astute sense for nature and the liveliness and natural talent inherent in Latin peoples were combined with a high aesthetic that had not been witnessed in the world of sculpture since the Greeks. The large number of sculptures, which spilled not only over the inner walls and the outer arches of the portals, but also over the main façade and the transepts of Rheims and Amiens (see p. 33) Cathedrals (the transepts alone have more than 2000 statues and reliefs) were created in the relatively short period from 1240 to 1300. These figures display the entire development of French Gothic sculpture. Its peak can be witnessed in the larger than life statues at the portal of Reims Cathedral's western façade (see p. 40). The remaining sculptural decoration of the same cathedral already shows the gradual decay that set in at the beginning of the fourteenth century.

Gothic Sculpture in the Netherlands

Dutch sculpture emerged in the Netherlands during the fourteenth and fifteenth centuries; however, it blossomed most impressively at the court of the art- and splendour-loving Dukes of Burgundy in Dijon. Philip the Brave summoned Dutch artists for the decoration of the Chartreuse of Champmol.

Among these artists, the particularly strong artistic individuality of Claus Sluter deserves mention. He worked in Dijon from about 1383 until his death. Among his main works are a Virgin between the kneeling figures of the duke and duchess at the portal of the Chartreuse of Champmol (see p. 186), the *Tomb of Philip the Brave* with forty small alabaster statues of mourners to each side of

140. **Tilman Riemenschneider**, *Holy Blood Altar*, St. Jacob Church, Rothenburg ob der Tauber (Germany), 1499-1505. Linden-wood, h: 900 cm. In situ.

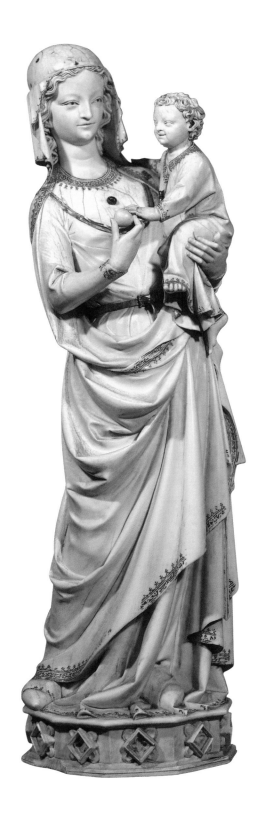

the sarcophagus; and the *Moses Fountain*, erected around 1400 in the court of the chartreuse, of which remains only part of the foundation with six prophet figures, Moses among them. These works differ entirely from the empty standards of Gothic sculpture, with their impressive attitude that tends towards the monumental, the powerful characterisation, and striving for astute, lifelike individualisation, which can be seen in the tomb effigy and mourning figures. These works precede the understanding of nature, which erupted almost concurrently in the Netherlands and in Italy and also completely revolutionised art.

French sculptors covered cathedral façades and portals with a multitude of statues and reliefs to describe entire chapters from the Old and New Testament and comprehensively relate the entire doctrine of salvation to the ignorant. The German stonemasons who decorated the portals and entry halls of Freiburg and Strasbourg Cathedrals proceeded similarly. They also described in great detail the story of Christ the Redeemer with much symbolism and allegory. One of the favoured topics for the local stonemasons was the depiction of the foolish and wise virgins, because they wanted to influence women's disposition in particular. After all, they counted first and foremost on women for the betterment of morals, which apparently left much to be desired at that time.

Gothic Tomb Sculpture

Sculpting arts increasingly focused on tomb sculpture, which offered a new and receptive field. Sculpture for church monuments was lost in mannerisms and a lack of

141. *Madonna and Child*, treasure of the Sainte-Chapelle, Paris (France), c. 1260-1270. Elephant ivory, traces of gold and paint, h: 41 cm. Musée du Louvre, Paris (France).

expression, but the art revived when it began to leave behind the typical and search for individual expression and realistic depiction. The beginnings of sculpted portrait art go back to the first half of the fourteenth century. A major developmental factor was the creation of tombs and effigies, which were at first made of stone or metal plates, but later lay on the lids of sometimes richly decorated sarcophagi. England in particular took to tomb sculpture, since church buildings with their smaller sized portals offered little opportunity for sculpture to blossom. The magnificent tombs of English lords and ladies, which were most likely built during their lifetimes, communicated a proud self-esteem and consciousness of status to later generations. In the period following, this self-love, this fastidious standing out from the masses remained characteristic for all English art, in which portrait sculpture and portrait painting played a major role. The monuments of King Henry VII in Westminster Abbey; Canterbury Cathedral's sculpture of Edward Plantagenet, son of Edward III, who was also known as the "Black Prince" and executed as a young man; and the effigy of Richard de Beauchamp, thirteenth Earl of Warwick, were, however, created in collaboration with Italian and Dutch artists.

Gothic sculpture in Germany had a predominantly feminine character, which may be explained by the effusive adoration of women during chivalric times and the associated cult of Mary, which lasted far into the fifteenth century and shaped all German sculpture. It even re-emerged at the end of the nineteenth century when, for a few years, it served as a model to an age, the art and fashion of which were unproductive and exhausted, stumbling from one imitation to the next.

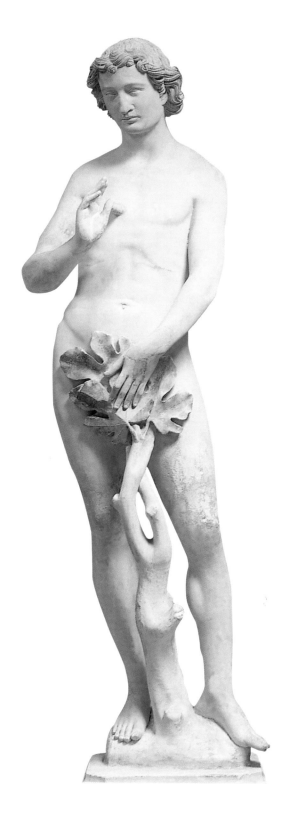

142. *Adam,* south-side of the transept, Notre-Dame Cathedral, Paris (France), c. 1260. Polychrome stone, h: 200 cm. Musée national du Moyen Âge – Thermes et hôtel de Cluny, Paris (France).

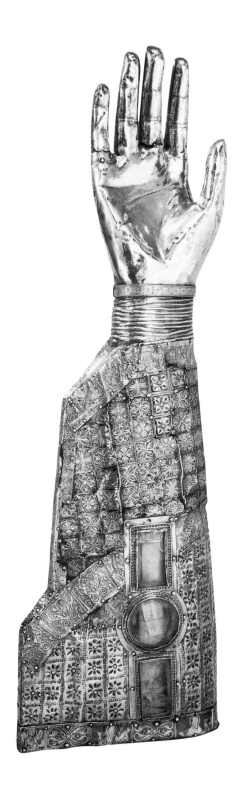

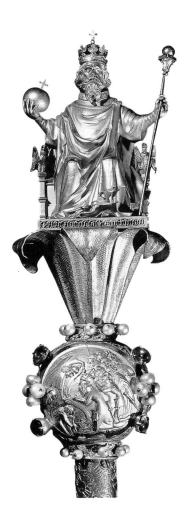

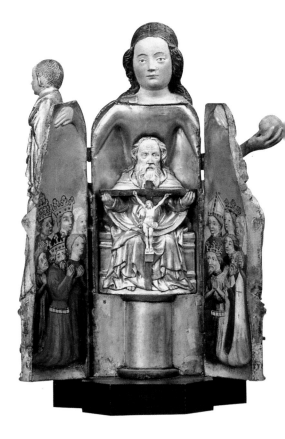

143. *Arm Reliquary of St. Lawrence*, c. 1175. Cedar wood, silver partially gilded. Stiftung Preussischer Kulturbesitz, Berlin (Germany).

144. *Sceptre of King Charles V of France*, from the treasure of the Basilica of St. Denis, 1364-1380. Gold (top), gilded silver (pole), rubis, coloured glass and pearls, h: 53 cm. Musée du Louvre, Paris (France).

145. *Opening Virgin*, c. 1400. Polychrome lime wood, h: 20 cm. Musée national du Moyen Âge – Thermes et hôtel de Cluny, Paris (France).

146. *Virgin with Child* called *Virgin of Jeanne d'Évreux*, 1324-1339. Gilded silver, enamel, gold, stones and pearls, h: 68 cm. Musée du Louvre, Paris (France).

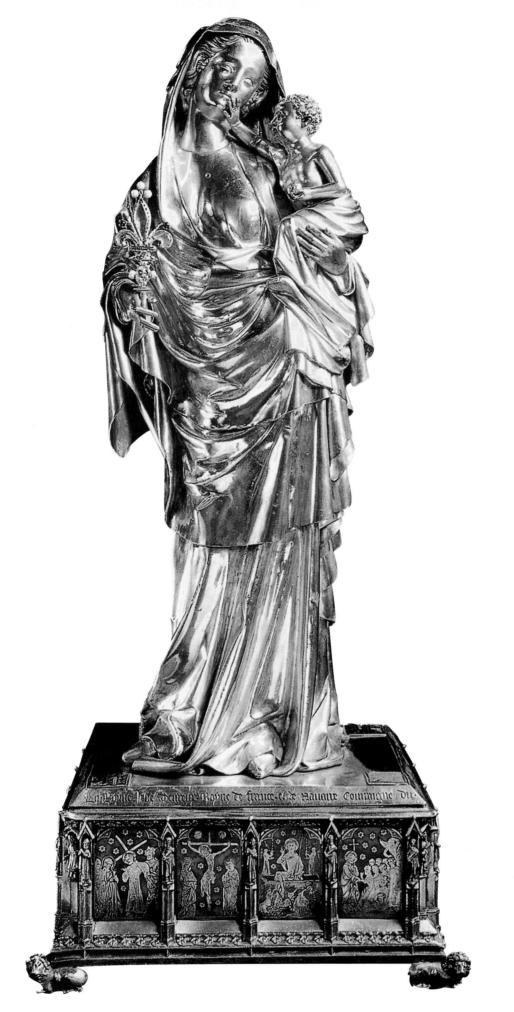

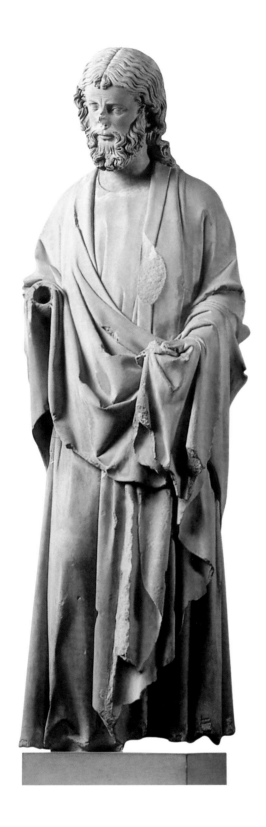

The best sculpture produced in German-speaking countries during the Early Gothic can be found at the cathedrals of Freiburg and Strasbourg (see p. 27). The Freiburg sculptures are artistically more valuable because they are closer to Romanesque art. Strasbourg has more typically Gothic works. On the south transept portal are two figures that exemplify the spirit of Gothic sculpture in its first developmental stage: Ecclesia, the triumphant church, and Synagoga, the vanquished Judaism. The same is true for the statues of the wise and foolish virgins who are offered a jewel by the devilish tempter. They are located at the southern portal of the façade. Their depiction already contains all flaws and virtues: the twisted and bent shapes that contradict the human physique; the conventional treatment of garments; the dresses that completely conceal the body; and the obliging smile that at the time meant something, but soon became a constantly repeated grimace. We could mistake them for aberrations, but the artists of the time surely thought differently. To them, these eternally smiling figures were the symbol of a golden era, which was the highest, yet unattainable ideal.

The period's ideals were satisfyingly portrayed by these sculptures; but artists who were supposed to depict the temporary worked differently. Since the flourishing of cities and townspeople, the tomb, which preserved the image of the deceased for the descendents, was no longer the prerogative of the nobility. Citizens who found wealth in trade and industry and were able to spend money, now found their resting place in churches alongside knights and princes. Naturally, their artistic décor was not supposed to lag behind the nobility, princes and clergy. At first, there

147. *Wistful Apostle*, from the Sainte-Chapelle, Paris (France), 1241-1248. Stone, h: 165 cm. Musée national du Moyen Âge – Thermes et hôtel de Cluny, Paris (France).

were only two kinds of tombs: chest tombs, which were usually placed in the chapels of the choir and in the aisles, and simple grave plates, which were either attached to the walls and pillars, or set onto the ground as coverings marking the crypt. Because the garment folds and the posture of the figures that lie on the lids of the sarcophagi or the grave plates suggest that they are standing, it is safe to assume that they were originally upright wall monuments. This was then imitated for the lying figures. Perhaps there was also the deeper intention to portray the deceased as ready for the resurrection. This would also explain the frequent placement of pointed arches and artful baldachins above the heads of the deceased. They were simply adopted by the artists from the portal sculptures on the church's exterior. At the end of the Middle Ages the chest tomb gradually developed into an extensive architectural construction. The wall graves expanded in a similar way. Both genres found their highest artistic peak in the age of the Renaissance.

In addition to stone sculpture, bronze casting was an early method of production primarily used for simple grave plates. When they were fitted into the church floor, they were exposed to damage, which not even the natural piety of the living could prevent. In northern Germany these considerations may have led artists to produce only smooth brass plates which were furnished with rich architectural edgings, and into which depictions could be carved with great artistic freedom. The grooves were filled with a black substance which resulted in a strong contrast with the background. This invention must have filled a common need, since these northern German grave plates were exported to various countries.

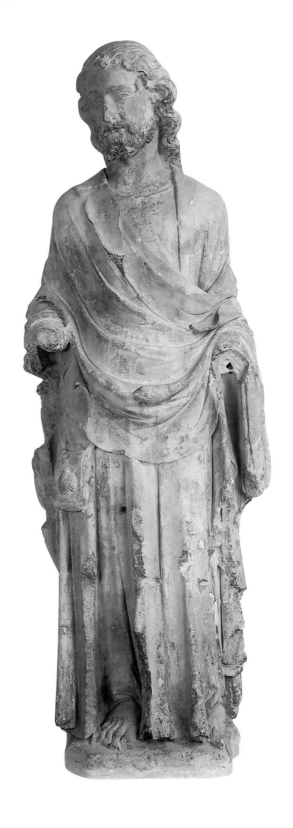

148. **Robert de Lannoy**, *St. James the Great*, Saint-Jacques of the Hospital Church, Paris (France), 1326-1327. Stone, 175 x 58 cm. Musée national du Moyen Âge – Thermes et hôtel de Cluny, Paris (France).

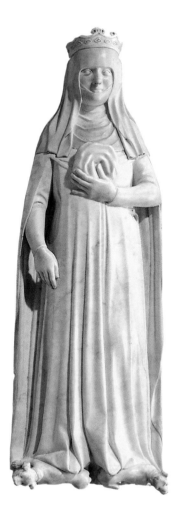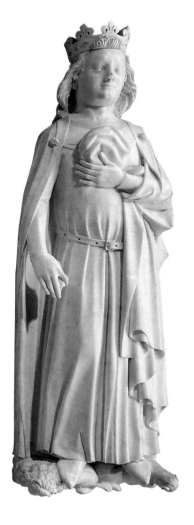

exceptionally laborious ceremony because of the innumerable additions of those involved, the necessity for the interior design of the church rooms likewise grew. Several side altars appeared and there were no restrictions attached to their donations. Further additions included lecterns for evangelical lessons and singers, pulpits, cathedras, tabernacles, confessionals, and choir stalls for the clergy.

It is worth noting that the choir stalls in particular played a major role in the depicting arts and contributed significantly to the development and support of wood carving. Perhaps the loving attention paid to the often hard cushion-less seating for the clergy generated the remarkable artistry that both sculpting and wood carving achieved. The belief that the path to Heaven could only be found through the assiduity of the clergy was so squarely anchored in the populace that artists and laypeople competed to make life more comfortable for the mediators on earth.

The artists and art itself profited from this circumstance. Artists that were sponsored by devout donors could sometimes execute their most audacious ideas. In Germany this happened only as of the middle of the fifteenth century when art blossomed under the influence of a fresh and unbiased understanding of nature, which reached its peak in the sixteenth century. This claim holds true for sculpture and painting; architecture, on the other hand, held on to Gothic construction and décor for a long time, even after the new style crossed the Alps and spread through northern lands.

While the honouring of the dead was a main concern of Gothic church decoration, the devotional needs of the living could not be neglected. The various powers united under the papacy soon understood how to rule over the soul of man by influencing his senses. The church was supposed to be man's first and last thought of the day, and hence it needed to be an inviting and friendly place. In the same way that the service had grown into an

149. **Jean de Liège**, *Recumbment Statues of Charles IV, the Fair, and Jeanne d'Évreux*, 1370-1372. Marble, 135 x 36 x 16 cm. Musée du Louvre, Paris (France).
150. *Charles V and Jeanne of Bourbon*, 1365-1380. Stone, 194 x 50 x 44 cm and 195 x 71 x 40 cm. Musée du Louvre, Paris (France).

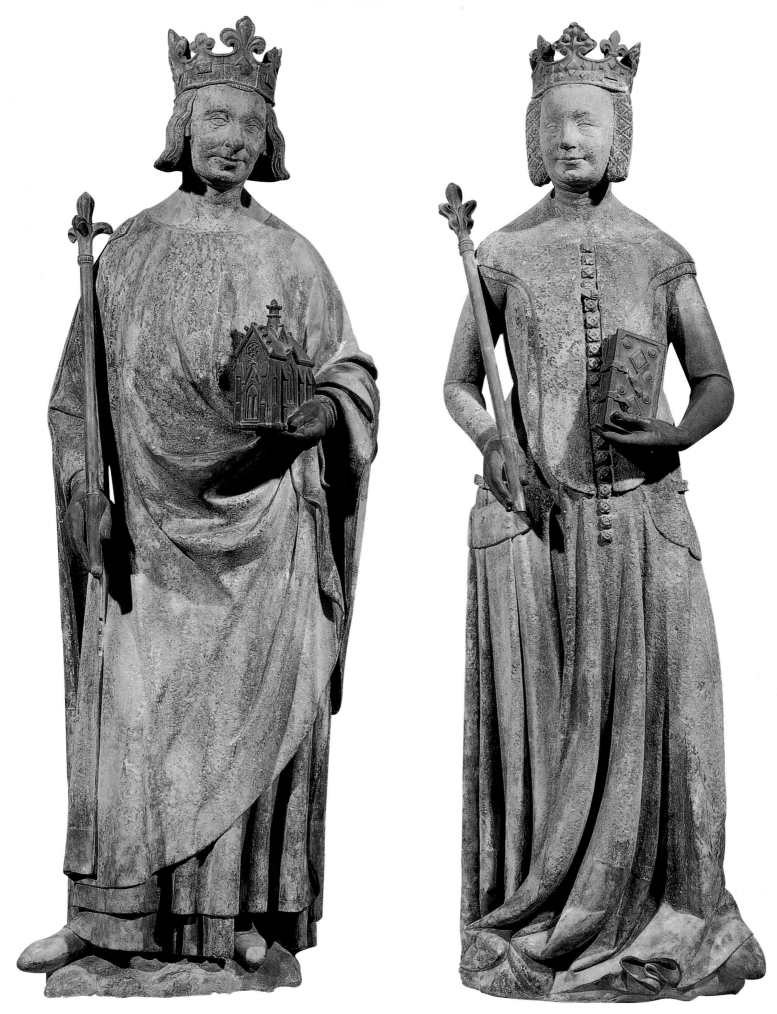

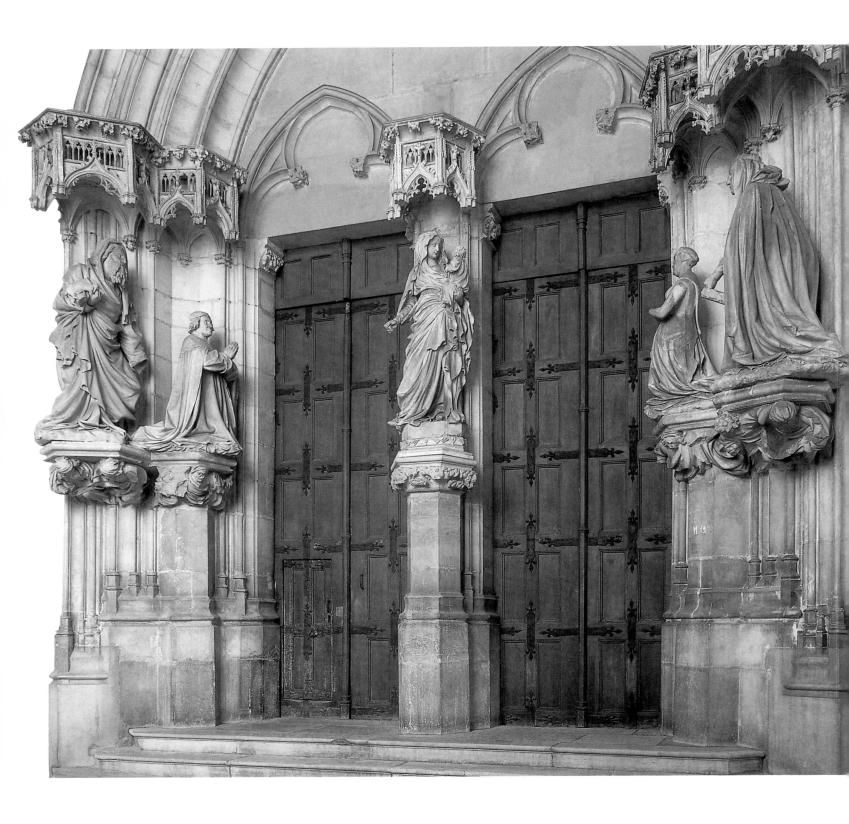

The most beautiful monuments of late medieval bronze, wood and stone sculpture belong therefore to the era in art, which is commonly referred to as the Renaissance. But even during the heyday of the Gothic, wood carving brought forth some excellent works. Among them the small wooden statue of St. Elisabeth in *Elizabethkirche* (Elisabeth Church) in Marburg should be mentioned first. She holds a model of the church in her left hand and in her right there is a loaf of bread, which she offers the lame beggars at her feet.

The garment does not yet show any of the mannerisms that spread from the end of the fourteenth century in the imitations of sharply broken, angular folds. At first the artists imitated the heavy, fashionable velvet and satin fabrics. This depiction of fabric persisted and became thoughtless habit, much to the detriment of the relentless search for naturalistic truth, which was otherwise so important to the artists. This striving for naturalism is the reason that they completely painted their wooden sculptures, mostly in realistic colours. Only the garments of saints were covered with gold as a special sign of honour.

Just as in the Romanesque, the Gothic style meant rich decoration for all items and instruments that belonged to the church inventory: baptisteries, goblets, candelabras, monstrances, censers, crosiers, reliquaries, and so forth. At first, both Romanesque and Gothic decorative forms were used side by side, which corresponded with the development in architecture.

Gothic art spread far beyond the borders of Western Europe into the countries of Eastern and Central Eastern Europe. It often merged with particular regional developments, mainly in countries under Catholic influence, such as Poland and Hungary. The Cistercians were very influential for the architecture and the ornamentation of the churches. Greek Orthodox countries, however, remained faithful to the Byzantine style. These countries mainly used brick for construction. There was, however, no development of independent style.

Krakow's St. Mary Church, which was started in 1226, and Wawel Cathedral (1320-1359) are examples of remarkable Gothic architecture. The steep brick-basilica has a late Gothic helm roof with a golden crown.

A French inspired ambulatory surrounds Posen Cathedral. Both buildings must be considered masterpieces of Gothic architecture in this part of Europe.

151. **Claus Sluter**, *Portal of Chapel*, Chartreuse of Champmol, Dijon (France), 1389-1394. In situ.

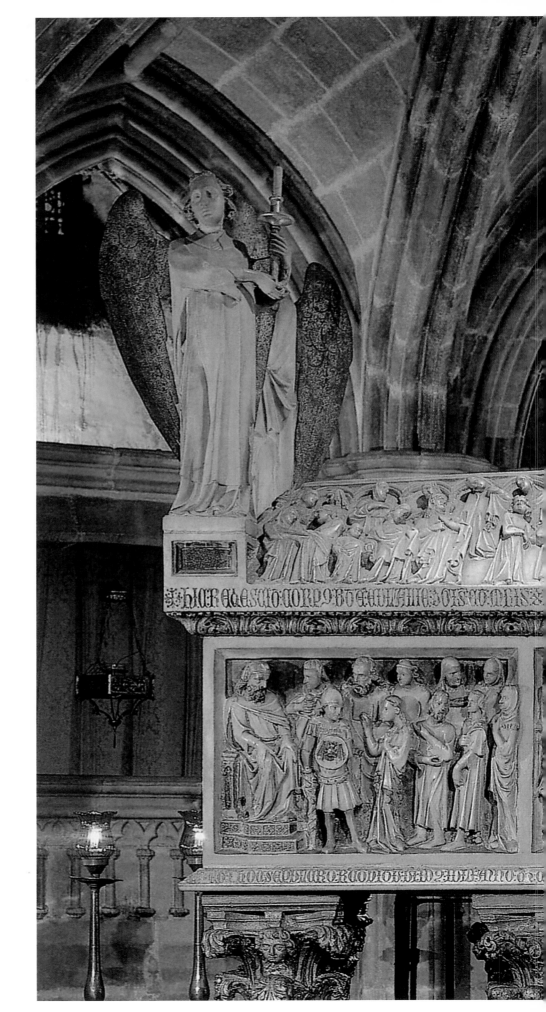

152. **Lupo di Francesco**,
Sarcophagus of St. Eulalia,
Santa Eulalia Cathedral,
Barcelona (Spain), 1327-1339.
Marble. In situ.

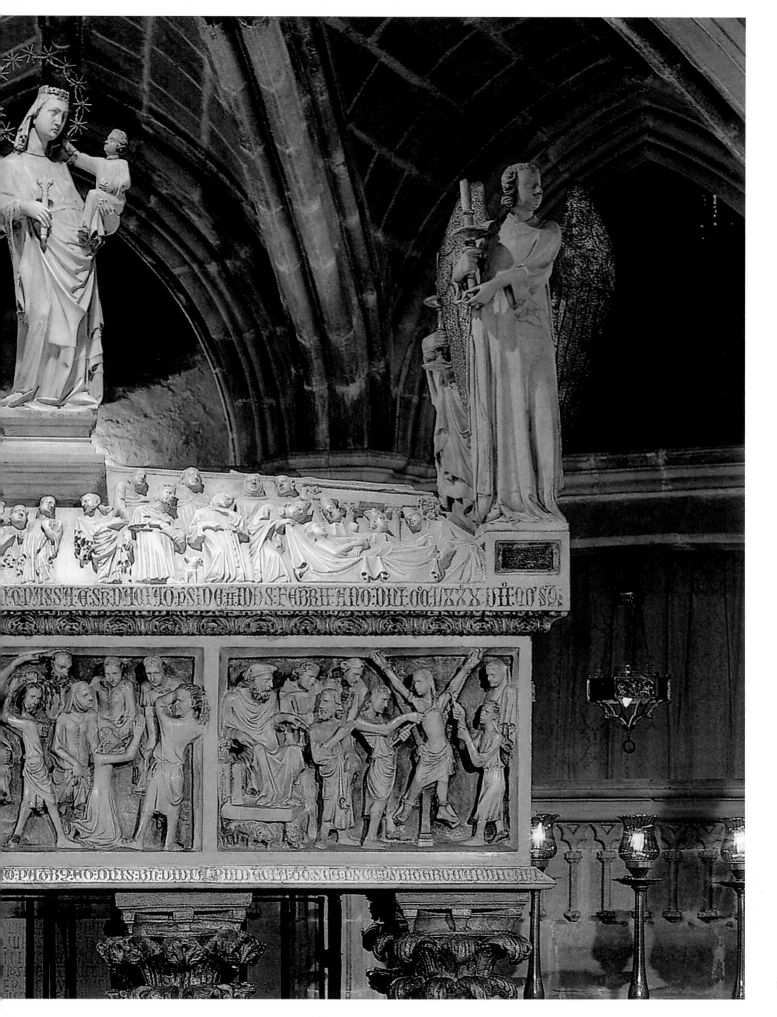

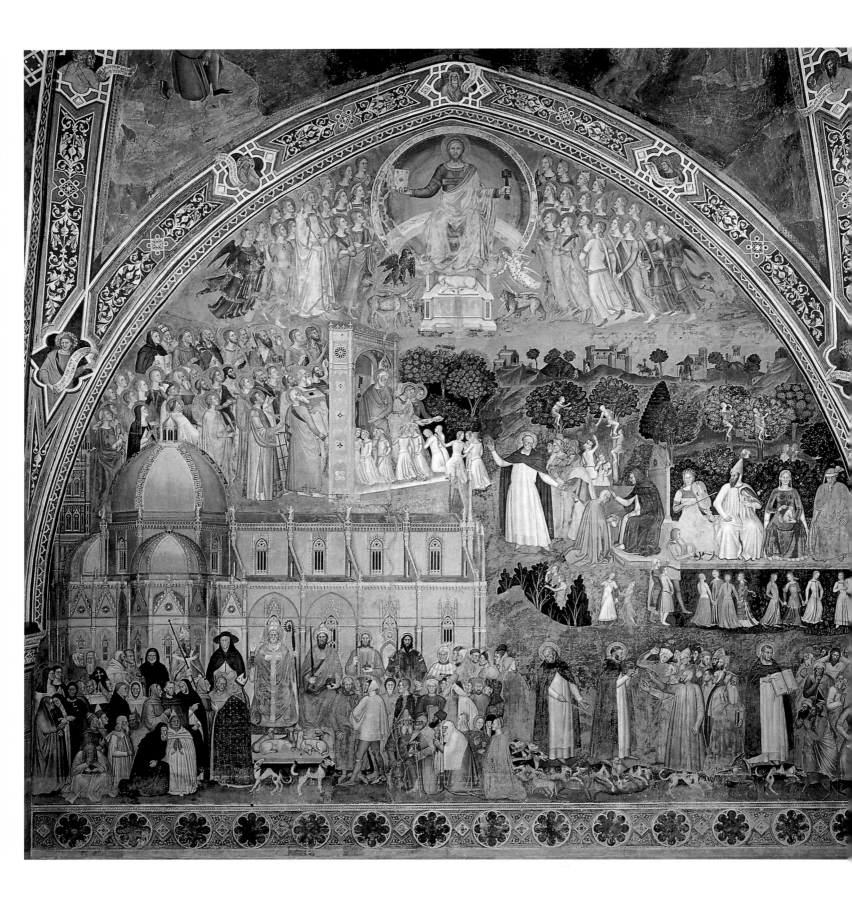

Conclusion

owards the end of the fourteenth century a new spirit was rising. Giotto, a poet, painter, architect and sculptor, and Andrea di Cione, known as Orcagna, were two predecessors of the universal spirits that would combine in Florence in the first quarter of the fifteenth century, and bring about a new art, which started the age of the Renaissance.

In the middle of the fourteenth century a development occurred in Italy (from where it would spread), called *Rinascimento*, or Renaissance This cultural revolution, which separated the Middle Ages from modernity, was accompanied by humanism and the reformation. This development was a return to and rediscovery of the classic arts of Roman and Greek Antiquity. An intensive study of long forgotten poets followed, as did an enthusiasm for sculpture and architectural remains, which were considerable, but mostly in ruins.

Dante Alighieri with his *Divine Comedy*, Giovanni Boccaccio and his *Decameron* and Francesco Petrarca and his poems to *Laura* undoubtedly began this development, which was triggered by man's changing self-image. But long before the poets dared to approach the topic of turning away from the Gothic, the Italian architect and sculptor Giovanni Pisano, who worked in Pisa, was one of the first to make the attempt. He created the sculpture cycles on Siena Cathedral and some marble Madonnas in Pisa and Padua.

Of equal importance to this development were the technological progress and the new findings in the natural sciences, which came from today's Scandinavia, the Netherlands and Germany. This period saw Peter Henlein's invention of a drum-shaped portable pocket watch (about 1510) and Johannes Gutenberg's invention of moveable type book printing (1448). The natural sciences in particular grew through the discovery of

153. **Andrea Bonaiuti** (also called **Andrea da Firenze**), *Allegory of the Active and Triumphant Church and of the Dominican Order*, Spanish Chapel, Basilica of Santa Maria Novella, Florence (Italy), c. 1365-1368. Fresco. In situ.

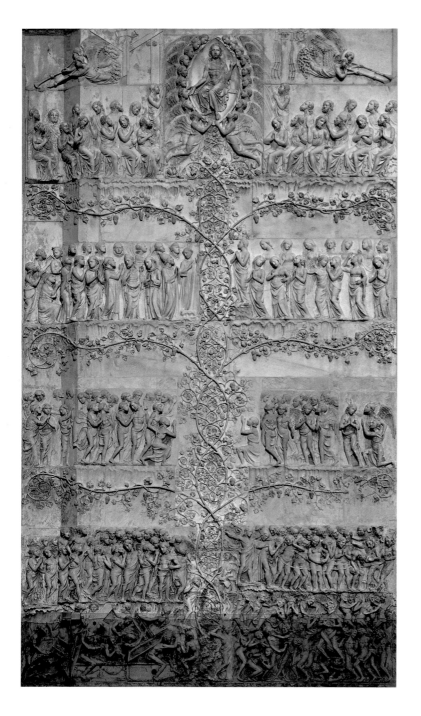

unknown continents by seafarers and adventurers such as Bartolomeu Diaz, Christopher Columbus, Giovanni Caboto, Vasco da Gama and Fernão de Magalhães.

At first, it was Italian architecture that harkened back to classical models. It was later followed by sculpture, which searched for a closer tie to nature. Both arts fought with the Gothic spirit far into the fifteenth century. Classified by the building masters as "barbaric", they considered Gothic architecture to be "bungling" and juxtaposed it with their new art that they derived from Antiquity. The hesitant sculptors permitted the building masters to go ahead: for example, when architect and sculptor, Filippo Brunelleschi went to Rome to excavate, study and measure the ruins of ancient buildings, goldsmith and sculptor Donatello accompanied him only to assist with the work.

It was the sculptures that were recovered in this and other excavations that brought about the rising enthusiasm of sculptors. Towards the end of the fifteenth century this enthusiasm for antiques had become so pronounced that Michelangelo buried one of his works in the ground, so that when it was dug up shortly thereafter it would look like, and be offered as, a "real antique".

154. **Lorenzo Maitani**, *Last Judgement,* cathedral façade, Orvieto (Italy), 1310-1330. Marble. In situ.
155. *Diptych of the "Stories of the Virgin",* second quarter of the 14th century. Polychromatic ivory, h: 29 cm. Museo del Bargello, Florence (Italy).

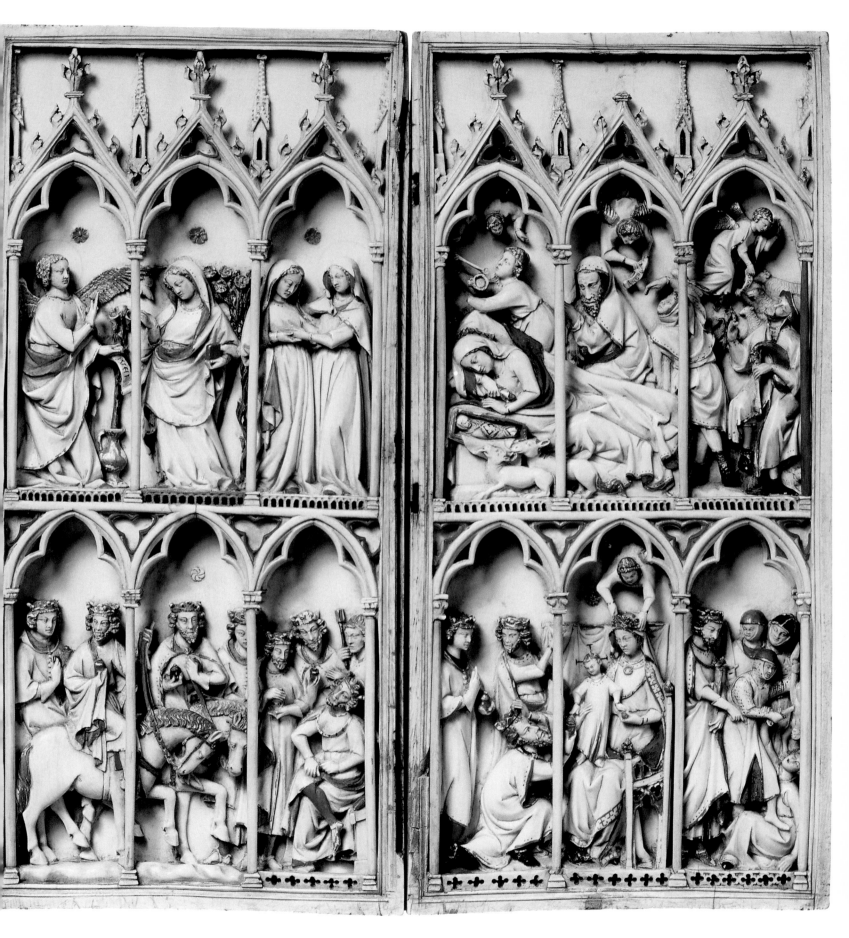

Bibliography

Biographisch-Bibliographisches Kirchenlexikon, Verlag Traugott Bautz, Bd. XXVII BBKL Nordhausen, 2007.

Die virtuelle Galerie der 25.000 Meisterwerke, Frankfurt: Zweitausendeins- Verlag.

Frey, Winfried. *Das jüdisch gsatz Ihn welchem Gott geschicht großer tratz*, Hamburg: Vortrag im Mai, 1992.

Lafort, Remy and **John M. Farley**. *The Catholic Encyclopedia*, vol IV, New York: Robert Appleton Company, 1908.

Müseler, Carl. *Geist und Antlitz der Gotik*, Berlin: Safari-Verlag Carl Boldt, 1940.

Rosenberg, Adolf. *Handbuch der Kunstgeschichte*, Bielefeld: Velhagen & Klasing, 1902.

List of Illustrations

Architecture

Austria

Belgium

France

Germany

Italy

Spain

United Kingdom

Illuminated Manuscripts

Painting

Sculpture

Stained-glass windows